Vancouver Walks

Vancouver Walks

Discovering City Heritage

Michael Kluckner
John Atkin

Vancouver Walks

Cover, interior design and ilustration by John Atkin

Printed and bound in Canada

National Library of Canada Cataloguing in Publication

Atkin, John, 1957-
 Vancouver walks: discovering city heritage/John Atkin and
Michael Kluckner

ISBN 1-894143-07-8

1. Vancouver (B.C.)—Tours. 2. Walking—British Columbia—
Vancouver—Guidebooks. 3. Historic buildings—British Columbia—
Vancouver—Guidebooks. I. Michael Kluckner, II. Title

FC3847.7.A85 2003 917.11'33044 C2003-901764-8
F1089.5.V22A76 2003

*Drifting purposefully is the recom-
mended mode, tramping asphalted
earth in alert reverie, allowing the
fiction of an underlying pattern to
reveal itself.*

Ian Sinclair
Lights Out For The Territory

Contents

Contents

Acknowledgements

Many thanks are due to the staffs of the City of Vancouver Archives and Special Collections, Vancouver Public Library for their usual cheerfulness and assistance, and to our many friends and acquaintances who care about this city and enjoy walking as much as we do.

Introduction

According to conventional wisdom, Vancouverites exist on the edge of a great wilderness and take every opportunity to stride out into the drizzly hinterland in their Gore-Tex boots and coats. But for those of us too wheezy for the Grouse Grind, or bored with the seagulls and sea-scapes on the Seawall, walking through old Vancouver contributes to a healthy body while keeping the mind alive.

We first began to develop walking tours in the early 1990s for Heritage Vancouver, and published a collection of them in 1992 in *Heritage Walks Around Vancouver*. This book ranges much further afield, updating the old tours and adding a number of new ones, some of which are quite lengthy and scenic—ideal for a long, sunny afternoon's ramble. In general, the text is richer in historical anecdote than in architectural analysis; all the walks address cultural rather than natural history. Rather than include an index we have cross-referenced places and people within the body of the text, and we limited the architectural jargon as much as possible in order to avoid the need for a ponderous glossary. The book is divided into sections which relate to the former BC Electric streetcar and interurban systems which was a spur to the city's early development and dismantled in the 1950s.

Michael claims the west side as his turf, plus Stanley Park and the north shore walks, while John writes about the downtown, the West End and the east side. We hope readers who share our fascination with old Vancouver will develop their own curiosity and explore its neighbourhoods with their eyes wide open, looking for that jog in a road or strangely angled building that hints at a story yet untold.

Michael Kluckner & John Atkin
Spring 2003

Downtown

1

Water Street

o tour of Vancouver is complete without a brief look at Water Street, the commercial strip of tiny Gastown before the arrival of the railway.

Start at the CPR station at the foot of Seymour Street and walk the three blocks to Maple Tree Square. The latter is the birthplace of pre-railway Vancouver, while the former (at least the original wooden CPR station, which was two blocks to the west near the Canada Place convention centre and cruise ship terminal), is the symbolic birthplace of the modern city.

The current Canadian Pacific Railway station is the third one in Vancouver, built between 1912 and 1914 to replace a chateau-style building that had stood at the foot of Granville for the previous 15 years. Through these stations came the travelling world, connecting with the CPR's "Princess" coastal ships and "Empress" ocean liners, the wealthy among them staying at the Hotel Vancouver. It is no overstatement to say that they are the most significant buildings in Vancouver's history, for the arrival of the railway in 1887 put Burrard Inlet on the map. The CPR station has retained a role as the core of Vancouver's interurban transportation system, being the hub of commuter rail and ferry services (Vancouver's passenger-rail and bus terminus is the former Canadian National station on Main Street).

Immediately to the east, Water Street angles left from Cordova Street, creating a triangular lot with a flatiron building, the Holland Block. Flatirons exist where one survey clashes with another: in this case, the survey of the original Granville Townsite of 1870 (the Water Street alignment) intersects with the Canadian Pacific Railway's 1885 survey of the City of Vancouver.

Granville, named for the colonial secretary, was the six-block area bounded by Cambie, Carrall, Hastings and the waterfront. Because of the Great Fire in June, 1886—two months after Vancouver's incorporation—there is nothing left of it other than this street grid. Instead, what you see is a circa-1900 commercial district, with a fascinating collection of hotels and warehouses established to service the port and the city. Vancouver's

merchants supplied the coast's outports and outfitted miners headed to the Klondike from these buildings. The coastal shipping companies used nearby wharves, most notably Union Steamships' at the foot of Carrall, and commercial travellers stayed in the hotels and ate in the cafes on Hastings Street.

The Landing at 375 Water Street is the old Kelly-Douglas wholesale grocery warehouse—the home of the "Nabob" brand and the biggest of three Water-Street warehouses. Three blocks to the east, 55 Water, was built by rival W.H. Malkin and Company. A third firm, Oppenheimer Brothers, had its warehouse a block east of Maple Tree Square at Powell and Columbia—it is now a recording studio restored by rocker Bryan Adams.

Walk east along Water Street past the Hudson's Bay Company warehouse at 321 Water, built in 1897, to Cambie Street.

The Edward Hotel at 300 Water is the 1906 replacement for the Regina Hotel—the only building to survive the Great Fire. The Gastown Steam Clock at the corner, created in 1977 by Raymond Saunders, is—like the aquarium and Granville Island—an essential part of most tourists' itinerary. Continue east, admiring older warehouses with tall windows and more modern ones with large plate-glass ones. The Dominion Hotel at the corner of Water and Abbott features the repeating linked arches of the Italianate style, as does the modest and misnamed Grand Hotel at 26 Water Street.

The grandest of the early hotels was the Alhambra in the Byrnes Block at 2 Water Street on Maple Tree Square. Built immediately after the 1886 fire, it charged a dollar a night and had a fireplace in each room—the chimneys are visible from across the street. Across the street is the newest of the Gastown hotels, the Europe, the best flatiron building in the west and the best commercial hotel in the city when it was built by Italian immigrant Angelo Calori. Although it looks old-fashioned, it was in fact "fireproof"—the first reinforced concrete structure in the city, designed by architects Parr and Fee in 1908.

Maple Tree Square had, not surprisingly, a maple growing in it—an *acer macrophyllum*, the native Big-Leaf Maple—that defined the village square of Gastown, the name most people used for Granville townsite. Loquacious saloon-keeper "Gassy Jack" Deighton built Deighton House on the site of the Byrnes Block. The raison d'être? A short walk to the east, at

the foot of modern Dunlevy Avenue, the Hastings Sawmill employed a saloonful of thirsty workers. The sawmill opened in 1865; Deighton arrived and built his first saloon two years later. Two decades later the Canadian Pacific Railway arrived and the frontier town quickly faded into memory.

Astonishingly, all this was nearly lost. Urban renewal plans, and the inevitable downtown/waterfront freeway, were to demolish Gastown and Chinatown in the 1970s. Fortunately, Vancouver's position on the west coast and its lack of political clout meant it was late getting the government funding that had thrown freeways across Toronto and Montreal. By the time the plans were made and the funding was in place, Vancouverites were in no mood to be told what to do by any "experts." The critical year was 1971: following protests and lobbying, the provincial government declared both Gastown and Chinatown heritage areas; the next year, the federal government withdrew its funding from the "Third Crossing" freeway scheme and the citizenry elected a new mayor and city council. Thenceforth, Gastown became a tourist area. Recently, developers have put some new residences on the upper floors of the old buildings and built some sympathetic infills, all of which are adding depth and urbanity to Vancouver's 21-century downtown.

2

Cordova Street: the other Gastown

W ith its decorative paving, street lamps, tourist shops and the unique steam clock, Water Street is what most visitors to Vancouver see when they tour Gastown. One block south, between the bulk of the former Woodward's department store and the towering Harbour Centre Lookout, is Cordova Street, the smart address for business in the 1890s.

Although Cordova lacks the decorative treatment of Water Street the architecture here more than makes up for it. Despite the nastiness of the Harbour Centre parking garage which dominates the south side of the street between Richards and Homer, Cordova possesses a very consistent grouping of late 19th century Italianate buildings.

☞ The tour starts at the intersection of Water, Cordova and Richards Street.

The Holland Block at 350 Water, meets the sharp intersection of Cordova and Water with its own pointed or flat-iron shape. The mid-1890's build-ing's shopfronts are framed with cast iron pillars from the B.C. Iron Works. Look for the raised lettering at the base of each pillar. Next door the two identical buildings respond to the narrow block with fronts on both streets.

The rusticated sandstone building, 342 Water has two entrances on Cordova. Each of the keystones are carved with the face of a man, whose beard becomes a plant leaf at its tip. The Water Street facade has the face of a happy looking woman cut into the keystone. Crane your neck and note the upper two stories which were added to the 1899 building at a later date. For a quick look at the building's Water Street facade, nip through the former Homer Arcade next door. The faces above the door on both streets are the friends and relatives of the developer who renovated the structure in the 1980's.

Across the lane is the elegant building James W. Horne commissioned from the architect N. S. Hoffar. Built in 1889 with some of the fortune Horne amassed from land speculation in Manitoba, the Horne Block at 311

Cordova once featured a small tower at the corner above the little balcony. Horne served as a City alderman the year his building was constructed and was later elected to the Provincial Legislature. In later years, as the Brinsmead Block, the building was noted on fire insurance maps as "oriental rooms".

N. S. Hoffar was a popular architect. The year before Horne's commission he was hired by Captain James Van Bramer—of the *Sea Foam*, the first steam ferry on Burrard Inlet—and Ben Springer to design 301 Cordova at the northwest corner of Cambie. The Masonic Temple once occupied a portion of the upper floors and in the years after World War One the building was home to Moe Koenigsberg's Western Wholesale Jewelers.

N. S. Hoffar's most exuberant design is farther east at 8 West Cordova and worth a look. The Dunn-Miller Block of 1889 takes up almost half a block. Its imposing Italianate facade is crowned with two overscaled sheet metal pediments.

On the south side of Cordova underneath some renovations are a group of late 1880's buildings book-ended by the Merchant Building sitting on the southeast corner of Homer and Cordova. In the 1930's this side of the street attracted the security industry, such as it was, and was home to businesses such as the Norris Safe Company. The Arlington Block at 306 Cordova was built in 1888 by Dr. James Whetham as professional offices but in later years it became a hotel.

Where the original Granville Townsite survey meets subsequent surveys of a different orientation the result is a series of oddly shaped lots. There are none odder than that of the Panama Block, 305 Cambie, which is a shallow wedge in between the Arlington Block and the hotel next door on Cambie. The exceedingly narrow building end can be seen beside the Arlington.

Cross Cordova to the southwest corner of Cambie

Cambie Street from Water Street to Hastings is one of the few spots in Vancouver where both the original cast metal street signs and the warm glow of incandescent lighting in old fixtures survive.

On the northeast corner of Cambie and Cordova, across from the Van Bramer Building, is the strikingly modern or jarring, depending on your

perspective, Canadian Pacific Telecommunications Building. It is one of only two completed pieces of the ill-fated "Project 200" which called for the wholesale destruction of a wide swath of the old downtown. This precast concrete structure was designed by Frances Donaldson in 1968 to replace the 1890's Pacific Hotel. The Woodward's Department store parking garage that was directly east once held the dubious honour of being "the largest parking structure in the British Commonwealth."

Across Cordova at 312 Cambie on the south east corner, the 1899 Carlton Hotel is an early design from the prolific Vancouver architectural firm of Parr and Fee. The duo designed a number of notable buildings in the city including the Vancouver Block on Granville Street (see page 44) and the quirky Glen Brae mansion in Shaughnessy (see page135)

Cross Cambie and walk up the east side of the street to Hastings

The 1896 Commercial Hotel at 340 Cambie was better known to a generation of Vancouverites as the El Cid, where rooms were rented not so much for their ambience but the selection of videotapes on hand. The massive stone and brick pillars on the ground floor once formed a colonnade across the building's front and part of this is still visible in the lane. Across the street 313 Cambie, constructed in 1889, is interesting because of the lower level of shops set well below the sidewalk.

The end of the block at Hastings is bracketed by two huge buildings. On the east side the 1899 Flack Block, built with the proceeds of a big gold strike in the Klondike, was designed by William Blackmore, who captured the fashion for Richardsonian Romanesque. Named for the architect Henry Hobson Richardson, the style revived 11th century French and Spanish Romanesque which featured heavy stone walls and dramatic arches. The Flack Block's own carved arched entrance has disappeared under unsympathetic renovations.

To the west, the architects of one of Vancouver's earliest skyscrapers looked to more recent French influences, that of 19th century Paris, for their inspiration. The 1909 Dominion Building's construction was financed by Count Alvo von Alvensleben and on completion was briefly the tallest building in the British Empire. Von Alvensleben dabbled with his brother in real estate schemes, forestry, mining and fishing. Take a look at the massive columns at the entrance.

The importance of this intersection is underlined by the Carter-Cotton Building at 198 West Hastings constructed a year before the Dominion Building. Francis Carter-Cotton built the steel framed building for his *News Advertiser* newspaper and in later years it was home to the *Daily Province* newspaper. The gilt lettered "The Daily Province" carved above the main office door can be glimpsed from the street. The Edgett Building across the lane and connected by a third-storey bridge once housed the paper's printing presses.

The three buildings overlook Victory Square—once the site of the City's courthouse. After the new Francis Rattenbury-designed courthouse opened at Georgia and Hornby the old one was torn down and the site served as a recruiting depot during the First World War. Money from the Southam family in the 1920's provided the impetus to create the park and in 1924 the elegant but somber Cenotaph was erected to honour the dead of the First World War. Recent upgrading of the park have included a new lighting scheme based on the shape of a soldier's helmet.

From this spot coffee can be found in Gastown and to the west along Pender Street or the intrepid walker can turn to the Chinatown tour on page 34 or Hastings Street Tour overleaf.

3

Coffee Shops of the Downtown Eastside

I n the years around the First World War, the Downtown Eastside was the cultural and civic centre for Vancouver. It supported live theatres with enough seats for over 8000 patrons and some of the largest stages west of Chicago, numerous movie houses, and the main branch of the public library, as well as City Hall.

In the decades since, because of the westward move of today's downtown and the resulting lack of economic activity, the Downtown Eastside has evolved into a neighbourhood that offers an affordable home to many. The hotels, once a stop for travellers, now provide shelter for many of the area's residents and, in many cases, recent construction has been devoted to erecting or converting existing buildings into housing.

Frequently called "skid road" or much worse, the Downtown Eastside makes many Vancouverites uncomfortable, yet it has hidden delights that are often overlooked in the rush along Hastings Street between the modern downtown and the eastern suburbs.

☞ The tour starts at Victory Square at the corner of Cambie and West Hastings. Walk east on Hastings.

The 100 block of West Hastings is overshadowed by the former Woodward's department store on the north side of the street. The subject of much debate since its closure in 1992, Woodward's is a complex building of over 12 different additions and alterations that all started in 1902 with one small brick building at the corner of Abbott and Hastings. The site, which was then a swamp almost eight feet below street level, was chosen by Charles Woodward for his new store because Cordova, the city's principal shopping street, was considered too expensive.

Standing on top of the whole brick pile is one of Vancouver's odder pieces of heritage, the Woodward's "W". Sticking up on the skyline to remind us that this is indeed Vancouver, the sixteen foot tall, six thousand pound red

neon letter, almost three hundred feet above the street, has been above our heads for almost 40 years. It sits on an eighty foot tall replica of the Eiffel tower, erected as an advertising gimmick in 1927, which itself perches on a five storey structure built to house water tanks, elevator machinery and until 1980, a peanut butter factory.

Two years after Charles Woodward moved to Hastings Street, Mr. Bancroft opened the Bismarck Cafe on the southwest corner of Abbott and Hastings at 106 West Hastings. Bismarck's Cafe featured a full orchestra, seating for 115 people, eight private dining rooms for ladies and one electric fountain. A few doors west at 126 West Hastings, the White Lunch was a popular Vancouver institution until it closed its doors in the 1970's. The south side of this block is a remarkable collection of late 19th and early 20th century commercial buildings which have survived—for how much longer is anybody's guess.

One block east, the parking lot on the south side of the street (68 West Hastings) is all that remains of the 1907 Columbia Theatre, a vaudeville house. Across the street, the pink neon "flying pigs" of the Save On Meats store at 43 West Hastings, have been smiling since 1958. A couple of doors farther the Army and Navy store occupies two buildings at 25 West Hastings; the lower eastern one, clad in blue metal panels, is the remains of the Rex Theatre, a lavish venue that is reputed to have been Vancouver's fastest construction job, as it opened for business twenty minutes after the last coat of paint had been applied.

The new housing development designed by Arthur Erickson for the Portland Hotel Society at 20 West Hastings is the site of the fondly remembered Pantages Theatre of 1917. This ornate wedding cake of a building, possibly better known as the Beacon or the Majestic, was torn down in the 1970's after efforts to save the building fell through. The cherubs that once graced the parapet found a home at the Vancouver Museum in Vanier Park.

The Pantages was built on the site of the earlier Panama Theatre and Winter Cafe; look closely at the wall of the Burns Block at 18 West Hastings to see a heavy granite and sandstone column still clinging to the wall, the last vestige of the Panama Theatre.

The former head-office and interurban station of the BC Electric Railway Company is at the corner of Carrall and Hastings. Until the 1950's electric trains left this depot at 426 Carrall for New Westminster and Chilliwack travelling over the Central Park line on one of the most extensive interurban systems in Canada. The station was important for the area because of the immense foot traffic that passed through each day. When the system shut down almost 10,000 pedestrians disappeared from the streets leaving many small businesses without enough customers to survive. The problem was further exacerbated when the North Shore Ferries, docking at the foot of Columbia, stopped running. A blow from which the neighbourhood never fully recovered.

Across the street is Pioneer Square, better known as Pigeon Park, once part of the old CPR right-of- way connecting the False Creek railyards with the mainline on Burrard Inlet. Look northeast to see the "cut" through to Gastown which is still visible, while the view southwest to False Creek is terminated by the International Village mall. The CPR shunted trains along the track, creating monumental traffic tie-ups on Hastings until the 1930's, when it dug the Dunsmuir Tunnel, now the route of SkyTrain. Although imposing as it stands, the Merchants Bank at 3 West Hastings, which fronts onto the park is merely the base of a projected seven storey building; it was built in 1913 to the designs of Somervell and Putnam, who the previous year had completed the BCER station across the street.

In the lane on the west side of Carrall between Hastings and Cordova, look up: the faint painted letters on the wall of the former Louvre Hotel still advertise the saloon and a bed for 20 cents a night.

The southeast corner of the block is taken up by the 1906 Pennsylvania Hotel, which has lost its corner turret and most of its charm. A few steps east is the Holden Building at 16 East Hastings, (Carrall Street is the dividing street for east and west downtown) designed by W.T. Whiteway as an office building and bank and constructed in 1910. Between 1929 and 1936 it served as Vancouver's City Hall; as the city administration expanded with the amalgamation of Point Grey and South Vancouver the old hall on Main

Street could not cope. In the 1980's the building was restored and reno-
vated to provide affordable housing by the Downtown Eastside Residents
Association, and renamed Tellier Tower as part of the process.

The Only Seafood Cafe at 20 East Hastings is a Vancouver institution which
has been serving some of the best fish and chips in the city at this loca-
tion since 1924. Before the Only, the Mexican Jewellery Palace and the
Vancouver Oyster Saloon occupied the restaurant space. Nic Todas bought
the Oyster Saloon, renaming it after himself; it became the Nic and Gus
in 1923 when his brother joined him and finally in 1924 the Only. Seating
is limited to about twenty along a curved counter and in two booths. The
heavily painted tin ceiling is original, and the 1940's neon sign outside is
a local landmark.

Next door at 30 East Hastings a new housing complex has replaced the English
Kitchen which, prior to their purchase of the Only, employed the Thodas
brothers. In the same location years later the Wo Fat Bakery was a ten-
ant, and is fondly remembered for their steamed pork buns.

In 1935 this stretch of Hastings offered a number of opportunities for
refreshment at establishments such as the Common Gold Cafe at 50 East
Hastings, the Log Cabin Lunch at number 54, the Savoy at number 66 and
the Empire Cafe at the corner of Columbia and Hastings.

The parking lot across the street at 65 East Hastings was the the site of the
popular Lux movie theatre, where patrons could enjoy a feature film,
cartoons and the newsreels. The theatre ended its days offering an odd
variety of entertainment including wrestling matches, before it was de-
stroyed by a fire in the 1990's.

On the southeast corner of Hastings and Columbia, at 100 East Hastings, is an
unexpected survivor, one of the few wood-frame buildings on the street.
The building dates from 1887 and was home to the St. Andrews and Cal-
edonian Society. Earlier tenants on the ground floor included the Horse
Shoe Barber shop and the Deluxe Fruit and Vegetable Company.

The Sunrise Hotel across the street on the northeast corner has undergone a
renovation which has restored some of the former elegance to what was,
in better days, the Hotel Irving, touted as "the newest and finest" hotel
in town when it was erected in 1906. 105 East Hastings was once home to

"Vancouver's Deluxe Cafe", the Broadway Cafe, which featured potted palms and white-aproned bow-tie-wearing waiters.

On the south side of the street a cup of coffee could have been had at either the Radio Lunch, the New Glasgow or—the best of all—the Blue Eagle at 130 East Hastings. The cafe opened in 1944, taking over from the New Atlantic Cafe and occupying the space of one of the original White Lunches. The interior of the Blue Eagle is quite a treat with ornate green-tinged tiles on the walls and a floor laid with hexagonal tiles in a floral pattern. At the entrance the cafe's name is spelt out in tile, and the neon sign with its animated arrow still hangs out front. Until it closed in the late 1990's the Blue Eagle exhibited a rare over-the-entrance neon sign which has, sadly, been smashed.

152 East Hastings is Alexander Pantages' first Vancouver theatre. Built in 1907, it was only his second purpose-built theatre and his first in Canada. To-day, this modest theatre building is the oldest existing Pantages theatre in North America, the oldest theatre in Vancouver, and one of the oldest intact purpose-built vaudeville interiors in Canada. The relatively bland exterior hides a jewel box of an interior with plaster garlands and musical instruments along with a proscenium arch originally lit with a display of light bulbs; Pantages' initials decorate the entrances and balconies throughout the building.

The theatre has had a checkered history: after ownership passed from Pantages the theatre changed names seven times; a Workers Unity League meeting was bombed in 1933 causing little damage; in 1952 the cops busted a performance of Erskine Caldwell's Tobacco Road as "indecent, immoral and obscene", arresting cast and crew and making international headlines in the process.

Just up the block at the corner of Main and Hastings is Vancouver's busiest community centre. Built as the Carnegie Library in 1903, it served as the city's main library until 1957. In the 1970's the building was renovated and expanded into the much-needed community resource it is today. The stain glass in the stairwell designed by Toronto artist N.T. Lyon shows full length portraits of Shakespeare, Milton, and Spenser; below these are head and shoulder portraits of Burns, Scott and Moore.

Also worthy of note, not because of any real architectural or historical significance but because it is there, is one of the city's two underground

public conveniences, in front of the Carnegie Centre (the other is at Victory Square on Hamilton Street). While it might seem rash to venture down the stairs, those who do are pleasantly surprised to find some of the cleanest bathrooms in Vancouver overseen by dedicated, full-time caretakers.

At the corner, the former importance of the area is evident in the surrounding architecture. The monumental Dawson Building is to the northwest, the Bank of Montreal's essay in Neo Classicism on the northeast corner, and the solid granite of the Royal Bank's East End branch on the southeast corner. This was the business and civic centre of the city for many years.

On the north side of Hastings across Main Street, the simple design of the Empress Hotel at 235 East Hastings gains in stature due to the narrow 25 foot width of its lot. The hotel retains the neon for the Ladies and Gents entrances just inside the main doors. In this block a cup of coffee could be found at either the New Star Cafe, the Economy Cafe or the Crescent Cafe, but the best place to stop was, and is, the Ovaltine Cafe at 251 East Hastings. Since 1942 the Ovaltine has dispensed coffee, and of course Ovaltine, at its long counter or, on the other side of the central service area, in a booth. The cafe serves standard coffee shop fare—pies, burgers and coffee—but they seem to taste better here surrounded by the cafe's ambiance which is further enhanced by the glow of the window neon.

Pull up a stool here for coffee and pie before heading off on the Strathcona Tour.

Neon

"...that garish jungle of neon and cheap tile that marks the loggers' end of Hastings Street" was Pierre Berton's description of the Downtown Eastside in a 1950's article in *Mayfair*, "Canada's Smartest Magazine."

Fifty years later, Hastings Street still has the vestiges of the spectacular neon display the city was once known for. In the 1950's streets like Hastings and Granville were a blaze of colour and light as Vancouver went nuts for neon. With over 19,000 individual neon signs Vancouver was, for a brief period, the neon capital of North America.

Neon itself was perfected by Frenchman Georges Claude who was looking at ways to distill pure oxygen for use in hospitals. As a result of his experiments he ended up with large amounts of other noble gases such as argon and neon. He was familiar with earlier experiments that had shown that gases all had their own distinct colour when excited by electricity. Early displays of this principle were even on show at Queen Victoria's Diamond Jubilee Celebrations in London.

Claude did not invent neon but refined the process of passing electricity through glass tubes to provide a stable current. With his perfection of the electrode and determining the optimum diameter of the glass tube, Claude patented his work in France in 1910 and five years later in the United States.

At first all neon was made by the Claude Company in Paris—the first neon signs in North America were shipped over for a Packard Dealership in Los Angeles—but he soon licensed the patents to others for a very healthy sum, plus royalties!

Vancouver's first made-in-Vancouver neon sign appeared in 1927 and from that modest start the city never looked back. New signs were public events and crowds gathered to watch their first illumination. City officials encouraged the "beautifying greens and pinks of neon" on their streets. But

it wasn't to last. In the mid sixties "city beautiful types" began complaining about the clutter on the streets and by the 1970's anti-billboard laws and beautification efforts began to specifically target neon. As business districts declined and their nature changed, neon became the scapegoat for a variety of social ills—everything from prostitution to the litter problem.

In Vancouver many of the best signs were lost in the effort to clean up the streets. However, the new problem of lifeless downtown streets can be partially attributed to the lack of ambient light, which used to be provided by neon signs, especially on rain-soaked nights when the reflections provided a colourful display on the pavement. This has been partially recognized by city planners where the sign bylaw for Granville Street now, 30 years later, encourages the same types of sign so long shunned as inappropriate.

Hastings Street still has a number of excellent signs, such as the 1928 Balmoral Hotel, Save On Meats, Empress Hotel, Only Seafoods, BC Collateral, the Patricia Hotel and the wonderful mid-40's Ovaltine Cafe. They are an important though often overlooked heritage resource in the city which should be appreciated, preserved and enhanced.

4

Strathcona

T he neighbourhood of the lumberman and the mechanic," as the 1891 Williams Directory described it, took its name from the school named for Lord Strathcona, the president of the Canadian Pacific Railway. Ironically, this oldest of Vancouver's neighbourhoods was developed on land owned by the CPR's biggest competitor: the Vancouver Improvement Company, controlled by David and Isaac Oppenheimer. Houses began to appear soon after Vancouver's Great Fire of 1886. A typical lot cost $500.

In 1891, the East End School opened at the corner of Jackson and Pender, the highest point of land in the neighbourhood, adding to the city's Central, West End and Mount Pleasant schools. On the surrounding streets, individual property owners, without the "benefit" of modern planning or zoning ideas, built a neighbourhood of homes, rooming houses, apartment buildings and grocery stores—sometimes two or more buildings to a 25 by 80 foot lot. This hodge-podge of buildings, occupied by a United Nations of races and cultures, came to be thought of as a slum that could be improved by rational planning. Visible in the neighbourhood today are the city's only examples of 1950s and 1960s urban renewal: in the Maclean Park and Raymur Park housing projects.

In the late 1960s, the neighbourhood mobilized under the banner of SPOTA (Strathcona Property Owners and Tenants Association) to fight further redevelopment which included a plan for a Vancouver freeway system, linking the TransCanada highway with a proposed tunnel under Burrard Inlet. Not only Strathcona, but Gastown and Chinatown, were to be largely demolished and renewed, but opposition from a broad-based coalition of citizens eventually convinced the federal government to withdraw its support. Subsequently, in 1972, the conservative city and provincial governments were defeated, ushering in Vancouver's modern era of relatively sensitive planning.

☞ Start at the corner of East Pender and Jackson

The 1891 Strathcona School building was demolished in the 1920s. Today, the oldest part of the school is the 1897 wing, designed by William Blackmore, facing Keefer Street. Although it has lost its tower roof and the Keefer Street entrance is no longer used, it is the oldest brick school building still standing in Vancouver. The Senior Building facing Jackson Street opened its first eight rooms (it was designed to be completed as a 16-room school) in 1915 and was completed in 1929. Bricks from the demolished 1891 building were recycled into the nicely proportioned Primary School, designed by F.A.A. Barrs in 1921 on the Pender Street side of the complex.

From this corner, Ferrara Court, the imposing 1912 apartment building at the corner of East Hastings and Jackson, can be seen to the north. Erected by the restaurateur and Italian consul Agostino Ferrara, it was a wrong guess at the direction in which the city would expand. Although worn by time and missing its lions'-head decorated cornice, it is still one of the largest buildings in the area, and has a minor claim to fame: comedian Jack Benny, on tour on the vaudeville circuit, met his future wife Mary Livingstone there while visiting friends of Zeppo Marx.

☞ Walk east on Pender to Princess, then walk south through the schoolyard to Keefer

At the corner of Princess and Pender, the St Francis Xavier Chinese Catholic Church is quite reflective of the changing nature of this neighbourhood. It opened in 1912 as the First Swedish Evangelical Lutheran Church, later it became St. Steven's Greek Catholic, then St. Mary's Ukraniane, before settling down to its current role.

The brightly coloured house at 602 Keefer, built in the early 1900's, belonged to Gregory Tom, the principal of Strathcona School. According to school lore, he supervised the school grounds from the turret. The vice principal, James Dougan, lived at 729 Princess. Across the street at 603 to 621 Princess, the positive effects of restoration can be seen on the southern pair of houses in comparison to their neighbours. Large houses like this were built in response to the population boom which began in Vancouver following the Klondike Gold Rush of 1898 and continued through to the First World War. Vancouver's population quadrupled from about 25,000 to more than 100,000 in that 15 year period.

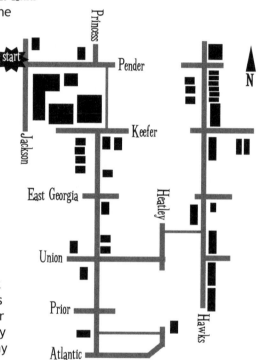

Cross Keefer and continue down Princess

By 1895, some of the first cottages in Strathcona were being demolished to make way for grander homes. J.G. Vickers, an employee of the Royal City Planing Mills, moved from Pender Street to his new house at 620 Keefer in 1895. The stone facing of the house is an early renovation and is nothing more than printed asphalt shingles.

630 Princess, built in 1898, is a well-preserved example of the Queen Anne style. Behind 700 Princess is a rarity: the one-room house sitting in the yard was built before the larger home on the front of the lot was erected. Later, the majority of these "shacks" were torn down. Across the lane on Princess are 750 and 752 Princess, two excellent recent restorations. The houses were built by the builder William Cline for Henry Lovegrove, who owned many properties in the area.

Bennys Italian Market at the corner of Union and Princess is a neighbourhood institution, opened in 1912 as a grocery store and icecream parlour, during the years when the Italian community was clustered along Union Street. The store's original marble counter is still there.

The majority of the houses on the 500-block of Union Street were built by 1892, home in the early years to a diverse group of people including a steam-tug engineer, mariners, printers, painters and even an architect. Look out for 549 Union with the sawtooth gable.

 Cross Prior Street to Atlantic; walk east on Atlantic to Heatley.

The first house on this short stretch of Princess was 921 Princess which was moved from its original location on Prior in 1899. It was built in 1895 for William MacDonald who was the power house superintentent for the BCER and a Vancouver alderman in 1898. The view southward from Princess and Atlantic takes in warehouses, the Canadian National Railway yards, and the upslope of Mount Pleasant in the distance. The flatland was the eastern, tidal extension of False Creek until 1915, when the Canadian Northern Pacific and Great Northern railways filled it, using material excavated to make the Grandview Cut, to provide room for their stations and operations.

 Walk to the lane between Atlantic and Prior. Take the lane to Princess.

The land at the end of Heatley Street behind Fire Hall No. One, now the site of the Strathcona Community Garden, was a city dump in the 1920s and became, in the summer of 1930 at the begining of the Depression, a "Bennettville" shantytown for a few hundred transient, unemployed men. In the 1980s nearby residents cleaned it up and created a remarkable three-acre garden with allotment vegetable plots, an apple orchard, a herb garden and a wildlife area.

Much of the railyards in the 1920s and 1930s were a grassy meadow, and residents who kept cows grazed them there, then brought them home along "Cowshit Alley"—the lane between Prior and Atlantic. Look for top-hung sliding doors and upper levels, originally for hay storage, on some of the former barns, now garages and sheds, along the lane.

Walk north on Princess to Union, turn east and walk to Heatley; turn left, then right onto the lane between Union and Georgia, walk to Hawks.

Due to street-levelling programs begun in the 1890s, houses on Union Street have ended up at least twelve feet above the street. At the northeast corner of Heatley and Union in the 1970s, architect Joe Wai built some modest infill houses, an early attempt to provide affordable housing and sympathetic design in new construction, not long after the experiments in highrise urban renewal were abandoned. Dubbed "Joe Wai Specials," they were a great improvement over the "Vancouver Specials" that were the usual infill style throughout the city at that time. These

show how adaptable the design was as they are grouped as a triplex. Other examples include single, duplex and quadraplex variations.

Walk north on Hawks to MacLean Park

At the crest of the hill in the lane the dramatic drop of the original land-scape is clearly evident. The 700 block of Hawks Avenue has been built up by the original property owners with rowhouses. The one on the east side of Hawks at the lane between Union and Georgia is a 1905 building, reno-vated drastically in 1974. On the west side, 701 to 725 was built in 1907 and renovated in 1984-5. To the south of it are two 1905 buildings, referred to on early fire insurance maps as "cabins," with nine units each on a 25 x 122 foot lot. Other sets of cabins, at 848 Union and 727 Keefer, had a long hallway running the length of the building, so that from the street it looks like an ordinary house.

Note, on the southeast corner of Hawks and Georgia, the grocery-store addition to a house; the corner entry on the last unit of rowhouses at 725 Hawks identifies it as a former store, too. East Georgia and Campbell Av-enue both had streetcar lines, along which stood a number of grocery stores which gradually closed as the routes were concentrated onto Hastings Street.

MacLean Park, named for Vancouver's first mayor, was originally at Union and Jackson until it became the site in the early 1960s of a public-housing project; to replace it, the city demolished this block of houses, including a couple of apartment buildings and a bakery, bounded by Hawks, Heatley, Georgia and Keefer. The city's plan was to relocate residents into the new project, demolish a block, build a new project, demolish another block, and continue until the entire neighbourhood was happily renewed and improved.

Go east on Keefer for half a block, then return to Hawks and continue north

Note the very tall houses at 856 and 860 Keefer, built from the same plans in 1892 and 1894, respectively, unfortunately the renovations have erased much of their original character and charm. Mr. Zanon's Montreal Bakery, at the southeast corner of Hawks and Keefer, stood across the street from the Zitco family's National Bakery, marked by the large trees at the cor-ner of the park which once stood in the front garden of the family house.

Koos Garage, a neighbourhood institution, has been replaced with a striking modern development that retains a portion of the original garage at the lane.

The six houses numbered 502 to 520 Hawks were built as a rental-property investment in 1900 by a drygoods clerk named Walter Scott. Four of the six had survived into the 1980s, when a group of adventurous potential homeowners restored them, replaced the missing two, strata-titled the property and finally bought back the individual houses themselves. The resulting tableau of small houses is much-photographed and admired. Although they were small houses, they were too big and elaborate to be "workers' cottages"—one-room cabins—surviving examples of which can be found on Princess Avenue just north of Hastings.

Across the street, the houses at 507, 515 and 521 Hawks are historically signifi-cant, as they are the earliest-known examples of the BC Mills, Timber & Trading Company prefabricated building system. Note the board panels separated by vertical battens—the prefabricated wall panels easily as-sembled into a quality home. Stanislaus Brereton, the yard foreman of the Hastings Mill, erected them in 1903. Edwin Mahony, manager of the Royal City Branch of the company, is credited as the inventor of the sys-tem, which was introduced to the public at the 1904 Dominion Exhibition in Winnipeg. BCMT&T houses and commercial buildings, especially banks, were once common all across western Canada.

At the northeast corner of Hawks and Pender is the 1928 Ukrainian Labour Temple whose membership was, and is, dedicated to progressive causes.

At the end of the tour wander through the neighbourhood and find re-freshments at the Union Market at Union and Hawks or head back to Benny's for their homemade sandwiches.

5

Chinatown

hinese have been in British Columbia since the 1850's when many were brought in to build much of the early road infrastructure in the crown colony of British Columbia. In the 1880's, thousands of Chinese labourers were contracted to build the treacherous Fraser Canyon sections of the Canadian Pacific Railway line. As construction neared completion many of the workers found themselves at the end of the line in Vancouver where they joined a small community that had settled near the foot of Carrall at Pender on the north shore of False Creek.

The community grew and prospered, expanding east along Pender Street, despite the unfriendly climate of the times. Chinese entrepreneurs such as Chang Toy and Yip Sang erected some very substantial buildings and these and the balconied headquarters of the numerous benevolent societies give Chinatown much of its character today.

From the beginning, there have been numerous attempts, including the construction of a train station on Pender and a major freeway proposal, to dislodge and disperse the community. However, after about 127 years Chinatown is still very much part of the fabric of the city. The impressive Chinatown Millennium Gate spanning Pender Street at Shanghai Alley is a sign of the continuing vitality of this community and serves as the starting point for this look at the area's unique architecture.

☞ Start at the south west corner of Shanghai Alley and Pender.

The gate, designed by Chinese-Canadian architect Joe Wai, was erected after an extensive two-year fundraising effort by the community. Drawing on ancient Chinese sources and modern influences, the gate now provides a formal entrance to this historic district.

The brick structure built between Shanghai Alley and Taylor Street has re-established the historic Canton Alley as part of an internal courtyard. Shanghai and Canton Alleys were largely residential with businesses on

the ground floor of the buildings which created a bustling and exciting environment. Today, Shanghai Alley remains, though a shadow of its former self. At the end of the alley a number of interpretive panels give an insight into it and some of the significant members of the Chinatown community.

👉 Walk east to Pender and Carrall

The 1913 Sam Kee Building on the southwest corner of Pender and Carrall is only six feet wide at the ground floor, making it the narrowest commercial building in the world, according to Guinness. It is the result of the City expropriating most of the property for road widening. The landowner, Chang Toy, one of Chinatown's richest businessmen, turned to the architects Brown and Gillam to design a building that fit the remaining six feet. Underneath the sidewalk they included an extensive basement which housed a public bath lit from above with glass blocks set into the pavement. (It is basements like these that give rise to the myth of a maze of tunnels running under Chinatown's streets.) In 1986, the building was renovated and the sidewalk over the basement was rebuilt and reinforced using new glass blocks.

In 1910 and 1911 the revolutionary leader and "father of modern China", Dr Sun Yat-Sen, visited Vancouver to garner support for his attempts to overthrow the ruling dynasty. While here, it is reputed that he stayed at the Chinese Freemason's Building at 1 West Pender which at the time was owned by the Chee Kung Tong (later known as the Chinese Freemasons), supporters of the 1911 Chinese rebellion.

Carrall Street is the dividing point between the east and west downtown streets.

👉 Cross Carrall, turn south, walk past the Chinese Cultural Centre and turn left. The entrance to the Dr Sun Yat-Sen Chinese Classical Garden is midway down the wall on the right.

Tucked in behind the Chinese Cultural Centre is the quiet oasis of the Dr. Sun Yat-Sen Chinese Classical Garden. Based on the private classical gardens of the City of Suzhou, it took 52 Chinese artisans a year to construct the garden using almost 950 crates of material especially imported from China. That included carved wood work, hand-fired roof tiles, limestone rocks and the pebbles for the courtyard floor. Special permits were granted by the

Chinese Government to cut the rare and endangered Camphor wood which is used in the pavilions. When it opened in 1986 it was the first full scale classical garden ever constructed outside of China. Appropriately for the Vancouver climate, the garden's roof tiles are designed so that as the rain falls a 'crystal beaded curtain of rain drops' is created.

Next door to the Dr. Sun Yat-Sen Garden is the larger, but separate, Dr. Sun Yat-Sen public park. The park and garden have been designed to utilize borrowed views from each other but the park's materials come from sources other than China.

👉 **Walk out to Pender through the courtyard and the Chinese Cultural Centre.**

Before getting to Pender, check out the large Chinese Zodiac in the courtyard with mosaics created by artists from the Downtown Eastside.

Standing opposite the Cultural Centre is the curious complex of buildings at 51 to 69 East Pender, begun in 1889 by the entrepreneur Yip Sang. The original 1889 building—the oldest building in Chinatown—was incorporated by architect T.E. Julian into his 1901 addition which extended the building east along Pender Street. The addition added shopfronts on the ground floor while the upper floors provided a classroom, communal dining hall and accommodation for Yip Sang's growing family. Eventually, with four wives and 23 children, further construction was needed and Mr. Julian was called back to design a six-storey residential building on the lane, connected to the earlier buildings by a third floor bridge.

Yip Sang was a labour contractor, CPR Steamship ticket agent, and real estate developer. He owned at least 16 properties in or around Chinatown amongst his other holdings, helped found the Vancouver branch of the

Chinese Benevolent Association, the first Chinese hospital and school, and was a governor of the Vancouver General Hospital.

W. H. Chow, a well-known and successful builder and contractor, over-came a number of hurdles and registered as an architect with the Architectural Institute of BC in the 1920's. The Yue Shan Society at 33 to 37 East Pender was one of his Chinatown commissions.

☞ **Walk east on Pender, cross to the northeast corner of Pender and Columbia**

To help provide a voice for the Chinese community, a branch of the Victoria-based Chinese Benevolent Association opened in Vancouver in 1889. In 1909, Chinatown celebrated the opening of the association's new headquarters building at 108 East Pender. It incorporates the distinctive recessed balconies commonly found in Hong Kong, Macao, and many subtropical cities in southern China.

These balconies provided a place for the family to live and survive the hot and humid climates; they were places to live, sleep, dry the laundry, and cool off the house. In the new world the balcony took on a ceremonial role where officials could watch over the various parades and celebrations.

☞ **Walk east on Pender Street**

Stop at 129 to 131 East Pender. Stand next to one of the cast iron columns of this building and look up. What becomes apparent is that the facade is only a free-standing screen which is attached to the building behind it. The bulk of the Lee Building was destroyed by fire in 1972. Architects Henriquez and Todd saved the 1907 facade while constructing a new building to fit behind it.

☞ **Cross the street and face the Lee Building**

From this vantage point the similarities between the 1907 Lee Building and the 1921 Wong's Benevolent Association building are quite apparent. Since 1925, the Wong's building, designed by architects J. A. Radford and G.L. Southall, has been home to the Mon Keang School. After regular school many students, instead of playing with friends, headed here to attend Chinese language classes. In 1947 the school was the first in Canada to offer high school- level Chinese courses.

Benevolent societies such as the Wong's were set up to provide new immigrants and existing residents with assistance in the strange and sometimes incomprehensible world of Vancouver. The associations, based around a family name or clan, erected prominent buildings which had meeting spaces, accommodation, and commercial space for rent on the ground floor. Many of these organizations were active in fighting the ridiculous and repressive City bylaws aimed at the Chinese community.

156 East Pender may not look like much but behind the plaster facade is the last house in this part of Chinatown. From the lane the outline of the roof and the rear of the house are just visible. Pender was a street of tidy Victorian houses in the 1890's but as the district expanded they were quickly converted to commercial uses and the parlours and dining rooms became the shop space for a variety of businesses. Over time, they were replaced with newer and larger commercial buildings. The 200 block of East Georgia, now part of Chinatown, still has a couple of early houses hanging on behind commercial facades.

Next door at 160 East Pender, the Chin Wing Chun Tong Society towers over its neighbours. The society was founded in Vancouver in 1918 and several years later commissioned architect R. A. McKenzie to design the building. The result is an intriguing blend of western and Chinese elements. The society sponsors a Boy Scout troop among other activities in Chinatown.

The monumental Canadian Bank of Commerce, designed by V. D. Horsburgh in 1915, occupies the southwest corner of Main and Pender (501 Main). The bank is not dressed in cut stone but rather terra cotta glazed and fired to imitate the real stuff. Despite what some architectural guides say about the apparent un-Chinese flavour of this imposing building, its character suggests that it was lifted off Shanghai's Bund and dropped at this corner. The bank competes nicely with the imposing group of structures a block north at Main and Hastings, which include the Carnegie Centre of 1903, the Royal Bank's granite East End branch and the Neo Classical temple originally built for the Bank of Montreal.

Cross Main Street. Walk up Pender to Gore.

Across Main Street the area takes on a very different feel with sidewalk displays of produce, dried fish, vegetables, hardware and household goods. At the top end of Pender at Gore on the southeast corner sits the home of

the Kuomintang (KMT) or Chinese Nationalist League. The KMT were sup-
porters of Dr. Sun Yat-Sen and his rebellion against the Qing Dynasty and,
a generation later, Chiang Kai-Shek and his resistance to the Communists.

The KMT commissioned W. E. Sproat to prepare drawings for their new
headquarters at 296 East Pender in 1920. What Sproat designed was the most
exciting building in Chinatown. The four-storey building, with recessed
balconies on the top floor set behind a series of broad arches, was crowned
with an octagonal pagoda roof and tall spire at the corner. Canadian au-
thor Wayson Choy attended Chinese School in the building in the 1940's
and relates in his memoir, *Paper Shadows*, how he hated school and tried
to burn the building down. Luckily he failed in the task.

Chinatown has continued to expand over the years (it is the third largest
Chinatown in North America) and now stretches south 3 blocks to East
Georgia Street. The streets are busy and the sidewalks are crowded most
days, the sound of music practice and mah jong games echo on the streets.
All of which makes Chinatown worth exploring further. Restaurants are
numerous and the food is good. The oldest surviving restaurant in
Chinatown is Foo's Ho Ho at Columbia and Pender where 'village Canton-
ese' cuisine is served in a 1940's decor.

6

Downtown Loop

I n 1884 when the CPR was still pretending that it wasn't going to terminate its transcontinental rail service in Vancouver, the provincial government arranged for a generous land grant—about 400 acres of the downtown peninsula and a further 6000 acres to the south of False Creek—to convince them to come to town. Once in town the CPR set about developing its vast downtown holding with the aim of shifting the business district west and out of Gastown. The land was quickly cleared and surveyed, lots were ready to be sold. To entice business they hired some of the architectural stars of the day, such as American Bruce Price, the architect of the Chateau Frontenac in Quebec City, to supply plans for commercial buildings to be built along Granville Street.

By the late 1890's, the business district had in large part moved to the CPR side of town.

Starting at the former Canadian Pacific Railway station on Cordova Street, this tour loops up through downtown before returning to the waterfront.

☞ Start at the CPR station at 601 Cordova Street

Following the demise of transcontinental passenger service in the 1970's, the CPR's rather grand station lapsed into a genteel decay. With the station's concourse a vast dark and empty space only illuminated by some buzzing neon lights, demolition, it was felt, could not be far away. However, Barott, Blackader and Webster's 1912 creation found new life as the transportation hub for the SeaBus, SkyTrain and West Coast Express services.

It is the third CPR station in Vancouver. The first, not much more than a decorated shed next to the tracks, was followed by a building in the railway's trademark chateau style. That station, grand as it was, was replaced by the present one just before the First World War. Look up to see the painted scenes of the trip through the Rockies which starts at the southeast corner of the concourse.

☞ **Leave the building by the stairs at the western end of the station.**

At the top of the stairs leading to the plaza next door, stop and look back over the station concourse. In the early 1970's the CPR station was not expected to survive and the developers of the office tower next door just slammed their plaza podium up against the building. When the station underwent an extensive restoration and rehabilitation in the late 1970's instead of the expected demolition, the stairs were inserted to provide a much needed connection with the office tower. Hence the mistake has been turned into an unexpected vista.

Once out on the plaza, Granville Street can be seen stretching off to the south with the understated Art Deco of the Federal Building to the west and the skyscraper Deco of the Royal Bank to the east. On the plaza, directly to the north, is 200 Granville Street, the one of only two pieces of the immense 1970's redevelopment scheme "Project 200" to be built. The plaza does offer great views out over the Burrard Inlet, the back of Gastown and the cruise ships docked at Canada Place.

☞ **Walk across the pedestrian bridge spanning Cordova.**

The pedestrian bridge across Cordova provides an excellent viewpoint. To the east, the streets of Gastown and the Woodward's "W" in the distance which towers over the neighbourhood, to the west, in contrast, a modern forest of condominium construction filling in the former railway freight yards along Coal Harbour.

The footbridge also brings the pedestrian to eye level with the carved Art Deco panels of McCarter and Nairne's 1935 Federal Building. Its understated Art Deco contrasts nicely with the Department of Public Works' 1905 beaux-arts design for the former main post office next door. That design by architect David Ewart was used across Canada and built from local materials—for instance, Moose Jaw, Saskatchewan has a version rendered in sandstone.

The Post Office and Federal Building are part of the four-building Sinclair Centre complex which includes the 1907 Winch Building and the former Customs Warehouse on Howe Street. All four are linked by an internal courtyard.

Walk south on Granville

In 1929 the Royal Bank of Canada wanted to make their mark in the city and to that end its Montreal-based architect, S.G. Davenport, drew up plans for the Deco skyscraper at 675 West Hastings. Launched on the eve of the Depression, only the western half of the tower ended up being constructed. Inside, the banking hall is stunning. The highlight is the elaborate painted ceiling. Look up and find medallions with words of wisdom such as, *No Labour, No Bread*. Note the fantastic creatures in the entrance arch.

Directly across the street the Toronto firm of Darling and Pearson are responsible for the temple-style Bank of Commerce building at 640 West Hastings. Darling and Pearson were one of Canada's preeminent architectural firms. Pearson is perhaps best known for the design of the Peace Tower in Ottawa. In the mid 1990's, the 1908 building was revamped as the new location of Birks Jewellers. The Birks Clock, a Vancouver institution in its own right, was moved along with the store from its long-time

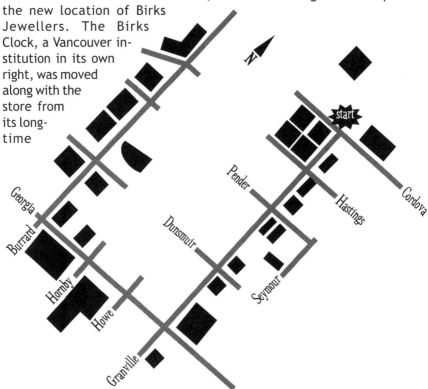

location at Granville and Georgia—sort of a homecoming for the clock since it was first erected by Trorey Jewellers outside their store across the street on the site of the Royal Bank.

The east side of the block is dominated by the gleaming white terra cotta of the 1912 Rogers Building at 470 Granville. Its owner, Jonathan Rogers, had an immense effect on the city. He was a builder, developer, Parks Board chair, and philanthropist. His wife Elisabeth was instrumental in the founding of the Vancouver Art Gallery in 1925. Rogers liked to claim that he was the first passenger to step off the first transcontinental passenger train that rolled into Vancouver.

The Rogers Building was designed by the Seattle firm of Gould and Champney. It was fairly common to see Seattle- based architects working in Vancouver; for example, across Pender is the work of another Seattle firm, Somerville and Putnam.

Their 1916 design for the former Bank of Montreal at 580 Granville was quite modest as banks go. In 1924 the bank was doubled in size and the rather grand columned entrance was added. The bank and its wonderful banking hall are now part of the downtown campus of Simon Fraser University. Somerville and Putnam's earlier London Building stands next door at 626 West Pender. But their most interesting building is just around the corner at 525 Seymour where their 1912 design is rendered in Skyscraper Gothic.

Continuing up the block, the west side of Granville is taken up with the extension of the Pacific Centre shopping mall. In this section the architects have incorporated a couple of facade fragments saved from the site demolition. The shopping centre extends over three city blocks and incorporates three office towers and a hotel into its overall plan and was built on land assembled by the City of Vancouver.

At 586 Granville on the corner of Dunsmuir, McCarter and Nairne's crisp modern 1958 design for the Canadian Imperial Bank of Commerce features a Venetian glass tile mural by local artist B. C. Binning celebrating the industry, commerce, and natural resources of the province. A recent renovation has turned the upper floors into hi-tech office space.

Across Dunsmuir is the former B. C. Electric Showroom at 600 Granville where the modern wonders of all things electrical were showcased. The build-

ing is slated, at the time of writing, to be incorporated into a redevelopment of the east side of the block which will include the 1890's facade next to the Hudson's Bay Company store. The west side of the block is again dominated by the bland shopping mall architecture of Pacific Centre, a complete contrast to the exuberant Hudson's Bay Company at Georgia and Granville.

Toronto-based architects Burke, Horwood and White designed three flagship stores for the Hudson's Bay in 1913. Their design borrows heavily, to the point of copying, the design of Selfridges on London's Oxford Street. That store, designed by the American architect and planner Daniel Burnham in 1907, revolutionized the retail trade so it is not surprising that the design of the Bay follows it so closely. The Vancouver store broke ground in 1913 and has had three seamless additions over the years.

Behind the uninspired bulk of the Scotia Tower is Parr and Fee's 1912 Vancouver Block topped off with the marvelous over-scaled rooftop clock. The clock face has been lit with blue and red neon since the 1930's.

👉 Turn west on Georgia Street, walk to Burrard.

The southwest corner of Georgia and Granville was the site of the CPR's magnificent Hotel Vancouver. The Mission Revival and Itanianate style building was the architectural highlight and social centre of the city until it closed in the 1930's. It was demolished in 1949 and the site sat empty until the 1970's and the construction of Pacific Centre.

Between Howe and Hornby streets the Vancouver Art Gallery lawn and fountain provide a much-need green space in the heart of the city. Designed by Francis Rattenbury in 1906 as the Provincial Courthouse, with a later addition by Thomas Hooper, the Art Gallery inhabits a drastically renovated interior by Vancouver architect Arthur Erickson. The two happy lions resting on either side of the former entrance are modeled on Edwin Landseer's lions at the base of Nelson's Column in London. They gaze out across the lawn to the Hotel Georgia's pleasant Georgian Revival facade. The hotel, designed by Graham and Garrow (more Seattle architects), completed a major overhaul and restoration in the 1990's which returned the public spaces to their former splendour.

Dominating the skyline at Hornby and Georgia is the Hotel Vancouver, built by

the Canadian National Railway to the designs of Archibald and Schofield starting in 1929. The hotel's steel skeleton had been erected before work stopped because of the Depression. It sat as a ghost on the skyline for eight years before being rushed to completion in time for the Royal Visit of 1939. In exchange for building it, the railway was allowed to fill the eastern end of False Creek for freight yards. Not wanting to compete in the hotel business, the CNR and the CPR reached an agreement whereby the CPR's hotel at Georgia and Granville would close and the two railways would manage the new hotel jointly.

The architects of the Hotel Vancouver certainly enjoyed themselves because the building is festooned with all sorts of creatures. Look out for dragons coiled up under balconies, goats, lions, deer and other creatures that inhabit the outside. On the Georgia Street side overlooking the front entrance the god Hermes sits; as the god of commerce and traders he seems like an appropriate choice, except that he is also the god of thieves!

Cathedral Place at 925 West Georgia displays replicas of the well-known nurses, known as the Rea sisters, Dia, Pia and Gonna, taken from the Georgia Medical Dental Building which used to occupy the site. Other Art Deco details from the original building, most notably the lions that flank the entrances add interest to the new building. At the rear of the building the architects have created a garden reminiscent of a cathedral close which offers a quiet respite from the city.

Cathedral Place takes its name from Christ Church Cathedral next door. The little church at 609 Burrard dates from 1889 when the area was primarily residential. Today it is the oldest surviving church in the city though it only became a cathedral in the 1920's and since then has survived attempts to redevelop the property. In the 1980's an agreement was reached with the developers of Park Place at 666 Burrard to ensure the future of the church by allowing them to buy the air rights from it. Between the two buildings is a very successful green space.

☞ Turn north on Burrard Street and walk to Hastings Street.

Between the Hyatt Hotel tower and the Bentall Centre on Burrard Street lies the Burrard SkyTrain station. The entrance to the trains is sunk below street level in a landscaped park and in early spring it takes on a magical appearance when the flowering cherries bloom, carpeting the sidewalks

with blossoms. The shopping mall under the Hyatt connects to the Bentall Centre's mall through the concourse of the station, making it possible to walk underground from Georgia to Pender. The Bentall Centre development between Dunsmuir and Pender is over five acres in size and consists of four office towers, the first being constructed in 1965. A fifth tower across Burrard was completed in 2003.

The new Federal Government building tucked into the narrow block between Hastings and Pender recalls the 1957 C. B. K. van Norman design which preceded it. The van Norman building, occupied by the Customs Department was an elegant essay in Modernism.

At the lower end of Burrard Street at Hastings, many of the CPR officials and other well-off Vancouverites constructed grand homes which overlooked the inlet. Enough wealth and prestige was contained in these few blocks that the area became known as "Blue Blood Alley". But it did not take long for the business district to push westward and have the manicured lawns and gardens disappear under office buildings.

In 1929 the Stimson Company started construction on the Marine Building at 355 Burrard. The architects McCarter and Nairne conceived it as a "great crag rising from the sea, clinging with sea flora and fauna, tinted in sea green, touched with gold." The ornamentation is indeed wonderful. Look for the zeppelins, biplanes, submarines, and warships and look way up to see King Neptune. The lobby takes its inspiration from a Mayan temple and the design is carried out in tiles created by the noted California tile maker Batchelor. Once again the Depression played havoc with plans and the company went broke. The Marine Building was offered to the city but they turned the offer down so the Guinness Family stepped in and purchased it. It has remained a popular building with tenants despite the rocky start.

At the foot of Burrard the Canadian Pacific's graceful Empress ships once tied up at Pier B - C. Today the pier has been reconfigured into Canada Place with the Pan Pacific Hotel, Trade and Convention Centre, and cruise ship terminal. Some two million cruise passengers pass through each year on their way to Alaska. A walk around Canada Place offers some great views of Stanley Park, the harbour, and the north shore mountains.

7

Yaletown

On the eastern edge of downtown, squeezed in between the emerging condominium neighbourhood of Downtown South and the bright new towers that line the north shore of False Creek, is Yaletown. This area of narrow streets and tightly-packed brick warehouses was built next to the Canadian Pacific Railway's freight yards and until 1986, when the World's Fair displaced the trains, boxcars lined the streets waiting for goods. What started out as a collection of shacks and houses built on the shore of False Creek is now one of the city's trendiest neighbourhoods.

The city's warehouse district once stretched along the the eastern edge of the downtown peninsula above the extensive railway freight yards that reached the edge of Chinatown. But as the creek's industrial past has been tamed by marinas and condos the once continuous wall of warehouses has been broken up by new development and demolition.

Yaletown takes its name from the town of Yale situated up the Fraser River which was the site of the CPR's workshops. When the rail line reached Vancouver the shops were reestablished on the north shore of False Creek, men from Yale erected houses and nicknamed the place "Yaletown."

The tour starts at the corner of Robson and Cambie on the northern end of a surviving block of warehouses a block or two away from what Vancouverites now know as Yaletown.

☞ Walk south on Cambie to Smithe

The stripped down Neo Classical building of brick and cast stone at 150 Robson, formerly the Northern Electric Company, is home to Catholic Charities which has provided much needed shelter to Vancouver's needy over the years. The grey concrete of the CBC studios dominate the view north up Cambie Street. Designed in the 1970's by Paul Merrick, the building was known by staff as Britannia Mines South given the underground depth of the studios, and a design, which recalls a copper mine.

Walk down Cambie to the lane and halfway down look south to see the dramatic elevation change between Robson and Smithe. Until 1985, box cars could be seen lined up in the lane below. Many of them would be off loading into the former Canadian Safeway warehouse at 840 Cambie which takes up most of the block. Others would be bringing booze into the Beatty Street store rooms of the B.C. Government's Liquor Control Board.

 ## Walk to Smithe, turn west.

These warehouses have followed the trend in Yaletown as they have been converted into new uses such as hi-tech office space and artist's live work studios. For example, on the northwest corner of Cambie and Smithe the former Brodie Broom Factory now houses an art gallery and restaurant. On the site of the two tall glass condo towers on the opposite corner of Smithe and Cambie, Imperial Oil opened their, and Canada's, first service station—a crude affair consisting of a kitchen water heater tank propped up on some wooden blocks. Imperial Oil's operation included their general offices, warehouse and oil storage tanks on the site. In later years the Vancouver School of Art had classroom space in the old offices.

Continue west on Smithe to Homer. Turn south, walk to Drake

Across Cambie from the condo towers is the massive bulk of the former Hudson's Bay Company warehouse which takes up an entire city block. It is now home to a hi-tech firm which has broken up the facade with new window openings helping to relieve the formerly blank fortress-like walls.

Just up Hamilton Street on the west side of the street are four houses looking decidedly out of place sandwiched between the condo towers. Now restored and moved back from the street they are all that remain of the residential area which once made up most of the downtown peninsula. Today's explosion of condo construction is really returning the area to its original function.

One block up Smithe at Homer is another reminder of the early residential district, the elegant Edwardian era Homer Apartments standing in contrast to the Bing Thom-designed condominium tower across Homer on the opposite corner.

On the southeast corner of Smithe and Homer the ground drops away to

the parking lot several feet below the sidewalk. This slope was built to accommodate the seats of the grandstand of Recreation Park which occupied the site in the years before W.W.I. Both baseball and soccer were played here before enthusiastic crowds. The view east from the grandstand seats would have been of grain elevators on Hamilton Street and an array of box cars sitting on the tracks.

While the area still had a scattering of houses it had largely succumbed to industrial uses by the late 1920's. Across the street from the former park the printing firm of Bulman Brothers occupied a half block long complex. Only the corner building designed by Dalton and Everleigh in 1912—retained and restored as part of the Savoy condominium project—remains today. Across the lane offices now occupy the former Pioneer Steam Laundry building. The stack which used to billow steam 24 hours a day is still visible in the lane.

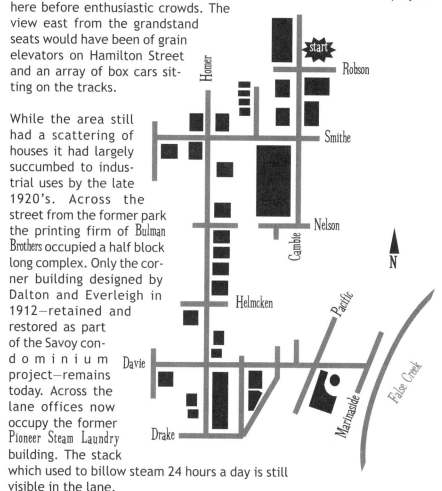

The former Barber Ellis paper warehouse at 950 Homer now converted to offices and retail uses displays a interesting mix of streamlined Art Deco and Gothic architecture. At the end of the block their competitors, the Columbia Paper Company, built a six storey concrete warehouse at the corner of Nelson and Homer. Until the early 1990's and its demolition the

Green Mill Cafe at 997 Homer was a neighbourhood institution. An old fashioned cafe with a long coffee counter and few booths, its menu offered the once common combination of Canadian and Chinese dishes all which could be washed down with some pretty lethal coffee.

The west side of Homer is now almost entirely condominium projects, replacing the old wooden houses which used to line this side of the street, while the other side retains the early warehouse configuration. Because of the steep drop to the east towards Hamilton Street the warehouses along Homer have quite deep basements which opened out to the loading docks and the CPR's railway sidings. Along Homer the warehouses are of brick and concrete, little in the way of architectural ornament is evident as these buildings were largely utilitarian, though 1014 Homer built for General Motors in the 1930's has a slight Art Deco feel to the facade. Farther down the street, W.T. Whiteway, better known for his design of the Sun Tower at Beatty and Pender, turned his hand to the design of 1070 Homer in 1910. That same year the Canadian Westinghouse Company built their new five storey warehouse at 1090 Homer at the corner of Homer and Helmcken.

The former Hobbs Manufacturing Company building at 1105 Homer was one of the first warehouse conversions in Yaletown long before it became "the" place to live. The building's concrete exterior hides the massive timber structure that holds everything up. The size of the timber is indicative of the quality and quantity of the forest that once covered the city. Many of the warehouses in the area are held up by this style of impressive timber work which has been left exposed in many of the shops and businesses. Across the street is 1138 Homer designed by Honeyman and Curtis in 1910, the former Front and Darling Company building. Today its unique courtyard is used for outside dining by the restaurant. The store fronts are special because the prismatic glass in the upper portion of the windows has been retained. These squares of glass set in lead are actually small prisms designed to magnify the light and throw it to the back of the ground floor, to compensate for the poor quality of early electrical lighting. 1190 Homer is the elegant looking Smith Davidson and Lecky building , another paper warehouse—note the grand looking safe in the lobby. On the Davie Street side, the loading docks have been removed to widen the street. On the west side of Homer at Davie, the architects of the condominium project have made a nod to the warehouse district and its characteristic canopies by placing their version of them high up on the tower roof and along the row of townhouses fronting on Homer.

On the southeast corner of Davie and Homer is the Gray Block, better known to Vancouverites as the Murchies Building. Constructed in 1912 to the designs of the respected architect Thomas Hooper it was home to a variety of wholesale firms who advertised their presence on the outside of the building with painted advertisements. In the mid-1990's the building followed the prevailing trend in the area and was renovated and converted to a residential building. One block west on Davie Street at 1238 Richards is the former Canadian Linen Company laundry constructed in 1928 to the designs of Townley and Matheson, who are probably best known for their Art Moderne City Hall at 12th and Cambie (see page 76.) The laundry building facade was retained in the new condominium development.

Back on Homer Street, 1241 Davie is a two storey wood frame building constructed in 1910 as a rooming house. In the intervening years it has been used as offices, gained some additional Victorian-style wood work, and was once home to the Grocery Hall of Fame. Next door is the rather curious new building festooned with some rather gothic gargoyles which stare down from the roof at passersby.

☞ Turn east on Drake, walk to Hamilton, turn north, walk to Davie

The corner of Drake and Hamilton is interesting because of the intersection of Hamilton and the lane which creates the flatiron shaped warehouse between them. This stretch of Hamilton gives a good sense of what early Yaletown would have looked like. Here many of the large canopies have survived and the loading docks haven't yet been prettified. The new buildings on the Homer Street side of the block have been well designed and fit into the existing street wall.

At Davie and Hamilton the Opus Hotel was built on the site of a brick warehouse destroyed in a large fire and the design reflects the bulk of the former building but is decidedly new. Straight ahead on Hamilton is a view of the Vancouver Public Library and the continuous line of warehouses and loading docks, while on Davie the view east is of a landscape created in the few years after the 1986 World's Fair.

☞ Walk to Pacific Boulevard, cross to the Roundhouse Community Centre

In the courtyard of the community centre complex the remnants of the CPR's workshops and engine house is evident. The original 1886 building

and the 1950's diesel shop were all that was retained of the roundhouse complex and these were restored for Expo 86. It is now part of a popular Roundhouse Community Centre where basketball and plays are performed in spaces once occupied by steam and diesel engines. At the end of the building there is a new structure that houses Engine 374 which pulled the first trans-continental passenger train into the city. Once on display in a public park, the engine is now protected and volunteers are on hand to explain its history.

In front of the roundhouse is the turntable used to move the train engines in and out of the building. It is now a static display and pedestrian bridge.

The walk ends at the edge of False Creek at the end of Davie Street under a sculpture which illustrates some of the history of the creek and where the massive redevelopment of the entire north shore can be seen.

There are many restaurants and coffee places in the area where the view can be appreciated and the feet rested.

8

Stanley Park

Vancouver has a very complex geography, with the Stanley Park peninsula delineating the entrance between Burrard Inlet's outer and inner harbours. As it commanded the First Narrows, and was clothed in a primeval forest that could be harvested for ships' masts, the Royal Navy declared it a Military Reserve in 1860. Five years later, Captain Edward Stamp and Jonathan Miller began to log the peninsula from a base just west of Brockton Point—practically on top of the Squamish Indian village Khwaykhway. However, instead of establishing a sawmill there as he first intended, Stamp took heed of the strong tides and the antagonism of the villagers and instead established his Hastings Sawmill at the foot of Dunlevy Street.

Concurrently, "The Three Greenhorns"—John Morton, Samuel Brighouse and William Hailstone—had purchased District Lot 185, the modern West End adjoining the Military Reserve, and were attempting to exploit the coal seam that navy surveyors had found along Coal Harbour. Then, in 1867, "Gassy Jack" Deighton founded his Globe saloon, commencing the development of Gastown.

With the pending arrival of the railway in the mid-1880s, Gastown incorporated itself as the City of Vancouver. The CPR's surveyor Lauchlan Hamilton was an influential member of the first city council, and proposed the creation of a park on the Military Reserve—this at a time when the few settled blocks were far to the east. In 1887, the federal government leased the peninsula to the city. Mayor David Oppenheimer officially opened the park on September 27, 1888; the Governor-General, Lord Stanley (the namesake of the hockey trophy) dedicated it the following October.

A longer yet simpler route, which is perhaps the quintessential Vancouver experience, circumambulates the park via the seawall. The loop described here, of approximately five kilometres, takes in more of the historic and cultural sites.

Start at the Beach Avenue entrance to the park, on English Bay

The statue of David Oppenheimer, mayor of Vancouver from 1888-1891, sits in the median at the entrance to the park. Known as the "Father of Vancouver," Oppenheimer and his brothers owned a wholesale grocery and drygoods business (see page 14). More significantly, he was a skilled real-estate speculator and led a syndicate of investors which established the first streetcar system and made the east side of downtown along Hastings Street the centre of the old city.

Note the beautifully espalliered Atlas Cedar on the side wall of the Parks Board offices, and the sequoia (California Redwood) in its garden.

Depending on the season, you should consider which route to take from here. If it is spring, walk north along Lagoon Drive, keeping the tennis courts on your left. Once past them, cross the grassy triangle and watch for the pathway descending downhill through the Ted and Mary Grieg rhododendron garden, which is spectacular in late March and April. The Griegs owned Royston Nurseries on Vancouver Island; about 4,500 rhododendrons and azaleas fill the area around the western end of Lost Lagoon and the pitch and putt golf course.

The pathway through the rhodos ends on the south shore of Lost Lagoon; from there, bear right and proceed along the shoreline, through the underpass beneath Georgia Street, across the causeway and up the hill to the Lord Stanley statue. (This route is slightly shorter than the alternative one below.)

If it is summer, fall, or winter, continue walking along Stanley Park Drive, with English Bay on your left. From the upper pathway there are views of the lawn bowling club, started in 1919 on what had been an elk paddock; the Fish House restaurant, originally opened as the Sports Pavilion in 1930; and the "par 3" golf course, opened in 1932. This pathway is marked for the exclusive use of roller bladers, an entreaty accepted by some park users, so be alert if you walk on it. The alternative route is the Seawall on the bank below, with a view only onto English Bay.

Eventually you will arrive at Second Beach and Ceperley Playground. Henry T. Ceperley was a realtor and parks board commissioner in the early days of Vancouver whose mansion, "Fairacres," is the centrepiece of Burnaby's

Deer Lake park. In 1918, his wife bequeathed funds from the sale of the home to the creation of the park and picnic site here.

Take the pathway crossing the playground and passing through the tunnel underneath the roadway. The low land here used to flood at high tide and during storms, isolating Stanley Park from the city (Captain Vancouver's survey map of Burrard Inlet in 1792 shows the park as an island). The stabilization of Lost Lagoon and the filling of this land began with the construction of the Stanley Park causeway in 1916.

Follow the path across the grassy sward, heading in an easterly direction toward the trees and footbridge in the distance. Admire the rhododendrons and fine trees on the right on the edge of the golf course, and despair of the land on the left, overgrazed by marauding Canada geese. Cross the concrete arch bridge over the little stream that drains Lost Lagoon, and bear right onto the pathway along the north shoreline of Lost Lagoon.

The poet Pauline Johnson (who occupies the only marked gravesite in the park, at Third Beach) is responsible for the pond's naming. Known also by her stage name, Tekahionwake, she was the daughter of a Mohawk chief and toured North America and Europe for nearly 20 years reciting her poems. She moved to Vancouver in 1909 and fell in love with paddling her canoe across what was then a tidal inlet connecting Coal Harbour with English Bay. She called it The Lost Lagoon—a poem in her book *Legends of Vancouver*, published in 1911 two years before her death.

Lost Lagoon was first crossed in 1888 at its eastern end (the causeway) by a trestle, which served the dual purpose of allowing pedestrian and carriage access into the park and supporting the pipeline that carried water from the newly constructed Capilano Reservoir across Burrard Inlet, through the park along Pipeline Road and into Vancouver via Georgia Street. The causeway replaced the trestle following a controversial 1912 vote, with some Vancouverites in favour of filling the lagoon to create a playground and others wishing to create an artificial lake. Lost Lagoon was for many years decidedly artificial, with groomed edges and the 1936 Jubilee fountain (now a seagull perch); there were plans to develop it and Georgia Street as a grand "Champs Elysées" boulevard. Recent changes, reflecting the environmental sensitivity of the modern city, include the re-establishment of native plants and wetland habitat on the north shore.

Cross underneath the causeway, which now connects Georgia Street with the "car-strangled spanner"—Lions Gate Bridge—and walk up Pipeline Road on the left sidewalk. Cross at the first crosswalk, climb the few stairs and walk along the pathway to the Lord Stanley statue. Along the way inspect the massive cedar stump, now a "nurse log" for a Western hemlock tree, left from logging operations a century and a half ago and demonstrating the enormity of the original forest. The notches cut into the trunk were for "springboards," on which the loggers stood, one on either side of the tree, while cutting it down with a crosscut saw and broadaxes.

The Stanley statue, with its upraised hands, was quickly parodied by cartoonist Len Norris, who suggested that the Governor-General was trying to determine whether it had started to rain.

Take the path on Lord Stanley's right, and walk deeper into the park. From the knoll, look down onto the lawn in front of the Malkin Bowl (slated for demolition at this writing), a bandstand and stage given to the city during the Depression by mayor and merchant W.H. Malkin in memory of his wife. For decades in the summer, Vancouverites have enjoyed "Theatre Under the Stars" there.

Note also the grand memorial to a decidedly minor US. President, Warren G. Harding, which was sponsored by Kiwanis and sculpted by Charles Marega. Harding passed through Vancouver in July, 1923, returning from a trip to Alaska, and died a week later, poisoned, fortunately, by an American shellfish.

Walk down the hill and along the front of the gardens of the Stanley Park Pavilion, a splendid 1913 "Swiss chalet" by architect Otto Moberg, past the ornamental pool with its large-leafed Gunnera, and turn left as if to walk along the side of the Pavilion. When opposite the side of the Pavilion, bear right, crossing the grass between the huge beech trees and heading for the path that crosses a small stream. There is an allée of Kwanzan cherry trees here, framing a view of the Japanese War Memorial. Plan to walk here in April, when the trees are completely engulfed in blossom.

The Japanese War Memorial is a beautiful and poignant object, like a lotus flower with the names of First World War battles incised onto the petals. It was unveiled in 1920, a time when anti-Oriental feeling was rampant in B.C.; two decades later, following the Japanese attack on Pearl Harbour, all Canadians of Japanese descent were rounded up, stripped of their property, and exiled from the coast.

Continue down the hill, following the allée of plane trees; the large tree trunk leaning on the crossed support is Lumberman's Arch, the successor to a grand, temple-like arch that stood at the site from 1912 to 1947. Cross the road and walk east along the seawall toward Brockton Point. This is the site of Khwaykhway, one of two permanently occupied Squamish nation villages in "Vancouver" at the time of contact—the other being Sun'ahk at the south end of the Burrard Bridge. A midden once covered more than four acres here, a portion of it becoming the surfacing material for the first Stanley Park road in 1888.

There is an excellent view from the seawall here of the City of North Vancouver. Lions Gate Bridge and the British Properties, and the second Brockton Point lighthouse, a 1914 structure that marks Burnaby shoal. The yellow piles are sulphur scrubbed from natural gas in northeastern British Columbia, transported by train to Vancouver and shipped overseas primarily for steel and fertilizer production. Cross the Stanley Park Road and examine the collection of totem poles, continuing through to the seawall which this time allows a spectacular view into Coal Harbour and Vancouver's downtown.

The forest of highrise buildings recall the 300-foot tall Douglas fir trees that once lined the waterfront. At the point where distinctive Canada Place, with its white "sails," touches the shore, the first transcontinental train arrived in May, 1887, fulfilling the destiny of this superb natural harbour.

It is a pleasant hike back along the seawall to Stanley Park's entrance, past Deadman's Island, a former burial ground that is now occupied by the naval reserve, and the Vancouver Rowing Club. Coal Harbour is cluttered with boathouses and the yachts of some members of the Royal Vancouver Yacht Club, headquartered at Jericho (page115). Note, near the park entrance, the Westin Bayshore hotel—its construction in 1960 on the site of a sawmill began the transition of Coal Harbour from an industrial backwater, catering to the marine and coastal aviation industries, into the gleaming "executive city" of today. Be thankful the park is public, as everything else has become very expensive here.

Streetcar Suburbs

9

West End

The West End neighbourhood on the edge of the downtown peninsula is surrounded by the waters of English Bay and Burrard Inlet, the forest of Stanley Park and the office towers of the downtown. With a population approaching 50,000 people it is a diverse and vibrant community.

One hundred and forty years ago just three men, John Morton, Samuel Brighouse and William Hailstone—dubbed by local papers as "three green-horn Englishmen" —owned most of what is considered the West End to-day. They had visions of making it rich by turning the local clay into bricks. However, the cheap and abundant lumber of the local forests coupled with a lack of good transportation to the Victoria and New Westminster markets quickly killed their dream. Real estate developer and entrepreneur David Oppenheimer and his brothers stepped in to help promote an ambitious plan for the future metropolis of "New Liverpool", which ended up as a city on paper alone.

The area gradually developed as a residential neighbourhood just west of the emerging business district which the Canadian Pacific Railway was encouraging on its land holdings (the railway received over 400 acres of the downtown peninsula in return for the guarantee that their tracks terminated in Vancouver).

The West End is often portrayed as the city's elite neighbourhood and it was home to many of the city's well-heeled, but it was like other neighbourhoods in the city where elaborate homes stood side by side with ordinary ones and sawmill managers lived next to sawmill workers. CPR officials built impressive homes along the bluff overlooking Burrard Inlet and the company's wharves and station, attracting others who built lovely homes along Georgia Street and on the English Bay slope on Harwood and Burnaby Streets. In amongst these great homes were the builder's specials purchased or rented by store managers, accountants and other fairly ordinary people.

Until the CPR's Shaughnessy Heights subdivision opened in 1909 there had not been a really exclusive residential district in the city, but the idea must have appealed because many West End residents packed up and moved to newer and grander homes. One of the attractions of the new subdivision was the estate-like qualities of the lots which were much larger than the West End could provide. By the advent of the First World War many of the old mansions had become reasonably elegant rooming houses or were converted into private schools or hospitals. Purpose-built apartment buildings started to make an appearance offering spacious suites and a quick commute to downtown. A zoning change in the 1950's removed the six storey height limit, irrevocably altering the skyline.

While much of the area's early architecture disappeared underneath the bulldozers in the construction boom of the 1960's and 70's, the West End still retains a number of fine homes and apartment buildings. It is also a great place to stroll, not only on the edges with the waterfront but along the heavily treed boulevards flanked by the generously landscaped gardens of the many apartment towers.

One of the earliest residents in this part of the West End was Henry Mole. In the 1880's, he retired from farming down on the Fraser River, on the site of Point Grey Golf Course, and chose the highest point on the downtown peninsula, just west of Burrard, on Comox Street to build his new house. He was soon followed by others like Ernest Cooper who arrived in town in 1887 and was a partner in the construction firm Cornish and Cooper. His property at 1062 Comox now lies under St. Paul's Hospital. By the 1890's there were enough residents in the surrounding area to warrant the construction of the West End School at Burrard and Barclay Streets. It was the school which eventually lent its name to the district.

☞ Start the tour at the northwest corner of Thurlow and Comox on the edge of Nelson Park.

Opposite Nelson Park is one of the largest restoration projects ever undertaken in the City of Vancouver. This city-owned block of Comox, Thurlow, Pendrell and Bute, known as Mole Hill in honour of Henry Mole, was originally purchased for the expansion of Nelson Park, itself once a block of homes and apartments. However, the passage of time between purchase and the planned demolition meant that this block had become the last remaining, intact, period grouping of houses in the West End. After a significant lobbying effort by the tenants of Mole Hill, local residents and

heritage advocates, the City relented and now each one of the city-owned houses has undergone extensive upgrading and restoration, including authentic paint schemes, rather than being demolished for basketball courts.

All of the Mole Hill houses deserve a look since many of them have emerged from layers of stucco and have thrown off additions and porch enclosures, revealing some delightful, original vernacular architecture underneath. But the following three houses on Comox are quite representative of the variety of styles found on the block. Midway along the street is 1150 Comox, a charming little 1903 Queen Anne cottage with double sunbursts in the gable ends built by the contractor John P. Matheson. Matheson built a number of homes in the West End and later went into partnership with his architect son, Robert. Together they built homes in the West End and Shaughnessy. Robert Matheson would later go into practice with Fred L. Townley; their partnership, Townley and Matheson, went on to design a number of notable buildings, including the Art Deco-inspired City Hall at 12th and Cambie, portions of Vancouver General Hospital and Tudor Manor on Beach Ave.

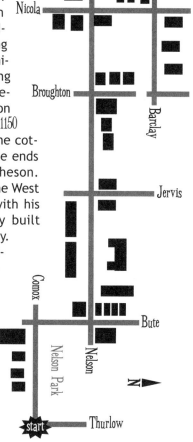

A couple of houses along the street at 1160 Comox is the eclectic 1888 home carpenter and contractor William Allen Mace built for himself and his family. It is the oldest house on the Mole Hill block and one of the few remaining houses in the city built before 1890. Mace lived on in the house after his wife Frances died in 1895, until selling it to a Mr. A. J. Mowatt four years later.

Right next door, 1164 Comox was home to customs agent Frank Bowser. Along with his customs duties he dabbled in real estate and after moving out to Kerrisdale, got into local politics, serving a one year term as reeve of

Point Grey in 1910. (See page 173.) His brother William, living over on Harwood St., had loftier ambitions and was the attorney general, minister of finance, and eventually in 1916, the premier of B.C. He was later forced from office because of a variety of scandals involving railways and by-elections. Frank Bowser's house sits squarely on a full 66-foot city lot, something of a rarity in the West End where many of the large lots were later subdivided.

At the end of of the block is the monumental 1909 Strathmore Lodge at 1086 Bute. It was constructed by the Lightheart brothers who were busy throughout the West End. As the Royal Alexandra Apartments, the building suffered a severe fire in 1927 where nine residents lost their lives. In the process of rebuilding, some of the building's Edwardian stuffiness was lifted as the damaged cornice was replaced by a rather fashionable castellated top.

Throughout the West End, apartment buildings such as this were growing in popularity; their names, usually culled from English and Scottish references, conveyed elegance and solidity to prospective tenants. Prior to 1905 apartment buildings were designed to look much like a large house— a good example of this is at the corner of Haro and Bute.

Turn north on Bute walk towards Nelson.

Richard.V. Winch made his fortune in salmon canning and timber and set out in 1894 to build a house at the northwest corner of Comox and Bute. This extravagant home cost $75,000 dollars at the time to build and outfit. Its lavish interior featured, among other things, adjoining billiard and ballrooms 40 feet in length. In the bathroom, space was found for a 600-pound marble bathtub. Winch left his mark on the city with the substantial granite-faced building completed in 1909 at the corner of Howe and Hastings. (See page 41.) The architects, Hooper and Watkins, must have made a good impression because they were hired in 1911 to design over $11,000 worth of additions to Winch's home, including a garage to house his freshly imported pair of Rolls Royces. Winch lived in the house until his death in 1952. Unfortunately, three years later the house was pulled down to make way for the boxy apartments seen today.

At the southwest corner of Nelson and Bute sits the modest Mayfair Apartments of 1910. On the opposite corner the 1913 red brick Berkeley Apartments at 990 Bute is another of the Lighthearts' buildings. The May-

fair was home to people like the Camp sisters who were stenographers with the Royal Bank; or A. E. Bain, an engineer for the telephone company, lived at the Berkeley. In contrast, the four houses across the street at 975 to 995 Bute, built in the 1890's, reflect what many of these early apartment buildings replaced.

989 Bute, the brightly coloured bed and breakfast, was home to the accountant Andrew Rudolf in 1908 and is one of the few protected heritage buildings in the West End. The house on the corner of Nelson and Bute, the home of miner John Christie in 1899, has been heavily renovated over the years to accommodate its conversion to a rooming house. The hint of a turret still lingers in the roof line.

 Turn west on Nelson.

In 1899 the Foster brothers, William, Thomas, Fred, and Joseph all lived in a house on the site of the charming neo-Georgian Beverley Apartments built in 1925. It is a deceptive building: while its facade is a nicely proportioned two storey affair, a glance down the side reveals a building three storeys high and almost 130 feet long.

A couple of steps along the street the Queen Anne Gardens at 1235 Nelson, built at roughly the same time as the Beverley, displays an uncertainty about its style. The panels under the windows are certainly Gothic but the details above the entrance are straight out of the Art Deco textbooks. Fragments from the Tweedsmuir Apartments, a smaller version of the Queen Anne Gardens, survive in an architectural folly (on wheels no less) attached to the Richard Henriquez-designed condominiums next door.

The north side of Nelson is overlooked by the massive bulk of the 1970's, Massey - Erickson designed towers at 1230 and 1260 Nelson, which replaced everything on the south side of the street, including the Altamont Apartments at 1284 Nelson. Originally the home of 'cannery man' George Alexander, it was converted into a nine suite apartment building in the 1920's. Folks such as Kathleen Boughtwood, who worked for the J. W. Kelly Piano Company on Granville Street, in suite no. 5, called it home.

Across the street from the Altamont site, Rothsay Hall, 980 Jervis, deserves a look for its black Carrera-glass entrance. Carrera or Vitrolite reached its heyday in the 1930's with the popularity of the Art Deco and Art Moderne styles. It was prized for the slick, streamlined surface it could provide.

Rothsay Hall and Sherwood Lodge, across Jervis at the northwest corner of Nelson, display the fashionable streamlined architecture of the 1920's. Gone are the heavy cornices, architectural references to bygone styles and the grand entrances; however, building owners couldn't let the English and Scottish names slip away.

In this block nothing remains of the original development, but it's interesting because the modern buildings illustrate the West End's post war development. The houses that once occupied this block were constructed in the first years of the 20th century by builders and contractors such as J.B. Mathers, Peter Agren and William Cline. The home of D. F. Hewett that once stood at 1345 Nelson was built by Mr. Cline in 1904. It was replaced by an example of the smaller scale late-50's buildings. Ocean Park Place at the corner of Nelson and Broughton, built just a few years later, would not look out of place in Miami while 1337 Nelson, built on the site of the Crofton House Girls School annex, is typical of the buildings erected in the 1980's as a result of the tinkering done to the West End's zoning reflecting antagonism toward further highrise construction. The most recent on the block, the Anduluco—a vast neo-Tudor construction on the south side of Nelson, again looks to the past for inspiration.

☞ Continue down Nelson, cross Broughton

993 Broughton is a lovely Prairie school-inspired Craftsman home which, along with its neighbours to the north, was built by William Geary in 1908. In 1916 it was briefly the home of Reverend William Smith of St. John's Presbyterian (United), just a block away on Comox. That 1906 Gothic Revival church, designed by West End resident and architect John Honeyman, was destroyed by fire in the 1980's. Services today take place in a handsome replacement. Next door to Reverend Smith at 985 Broughton, Mr. Geary chose to live. Later James Lawson, a partner in the prominent Vancouver law firm of Bodwell, Lawson and Lane moved in. The original house is still there, though not entirely evident given the tacky apartment-house front stuck on to it. Step to the side to see the original house with its deep eaves and cedar shingles. The third house in this row was home to John Clegg, described as a traveller (probably a travelling salesman)—appropriate since today his home is the Nelson House Bed and Breakfast.

These substantial buildings have generous front yards but note how they all sit on the back property line.

☞ Continue along Nelson to Nicola

At the southwest corner of Nicola and Nelson is the Mission Revival-inspired Fire Hall No. 6. This 1907 design by the firm Honeyman and Curtis was the first fire house in North America to be purpose-built for motor-ized equipment. The architect, John Honeyman, lived for a number of years behind the fire hall at 1039 Nicola. Across the street is another of the Lightheart brothers' apartment buildings. The Nicola Apartments at 1020 Nicola cost $25,000 to build in 1910. It is a good bet that the Lighthearts also financed The Clifton, squeezed in next door at 1004 Nicola.

☞ Turn north on Nicola, walk on the west side of the street to Barclay Street

Standing at the northwest corner of Nelson and Nicola, it's just possible to see the gable end of a cottage sticking out of the centre of the group of shops on the corner at 994 Nicola. These oddball things start out simply enough: a storefront is added to the house which takes up the front gar-den, as business improves an expansion is built and eventually after a few years the house disappears from view. There are a number of these struc-tures around Vancouver. In the West End, a row of houses on the south side of Denman at Comox have been raised to sit above the shops, and on the south side of Davie, between Burrard and Thurlow, a large house has all but been consumed by a night club.

The Barclay Grocery at 941 Barclay still has its mid-1950's neon sign, while next door the gap between the two buildings provides space for a long narrow shop, originally a cleaners. On this part of the block some of the surviving houses retain their front yards while 953 Barclay has been pulled forward on the lot and altered on the ground floor to provide shop space.

Across the street from the grocery is Barclay Heritage Square, a unique combina-tion of heritage conservation and passive recreation space. Similar to the Mole Hill site, the buildings on the block of Nicola, Haro, Barclay and Broughton were purchased by the Park Board with the intention of knock-ing them down. Considerable efforts by a variety of community groups convinced the Board to try a different approach to the park's design. In the final compromise a group of typical Vancouver builder's houses at the northeast end of the park were kept for affordable family housing and the three significant structures on the Barclay Street side were retained and given over to community use.

On the corner of Barclay and Nicola is the mid-1890's Weeks House, home of the Hudson's Bay Company manager George Weeks. The Friends for Life manage the house as an AIDS Hospice. Barclay Manor next door was the home of accountant Charles Tetly. Since its construction in 1890 it has been a private home, the West End Private Hospital, a rooming house and now, with additions removed and details restored, a seniors' centre. At the end of the street is the elegant Roedde family home built in 1896. The house is cautiously attributed to architect Francis Rattenbury primarily because of the corner turret's shape—it is similar to the domes on the Parliament Buildings in Victoria, Rattenbury's best known commission—and because he was a family friend.

Roedde House has undergone a careful restoration and is operated as a house museum, exhibiting furniture and artifacts typical of an 1890's family home. Check the sign board out front for opening times.

The tour ends here at Barclay Heritage Square. There's a lot to see in the West End, the streets constantly surprise with interesting apartment buildings and carefully restored homes. To the north is the bustle of Robson Street, with coffee shops and restaurants galore. It's a good place to take a break before continuing to explore the area.

10

Fairview to Granville Island

T he walk begins at 15th and Oak Street in Fairview, perhaps after taking on fuel at the legendary Max's Deli, and heads generally northward and downhill to Granville Island. Rather than attempt a formal tour of the Island, we suggest that you wander to the limit of your endurance before heading back uphill. Those who complete the entire walk will get a good workout, which may be negated by the many opportunities to snack and drink along the way. There is good bus service from Granville Island and up the hill to higher ground for anyone daunted by the return journey.

All the streets south of False Creek between Cambie and Vine, with the exception of Granville, were given "tree names" by Lauchlan Hamilton, the CPR surveyor who laid out the city in 1885. Most of the streets on Granville Island got their names from federal government officials responsible for the National Harbours Board, which administered the island when it was an industrial enclave.

☞ **Walk west on 15th from Oak Street.**

The area south of Broadway is called Fairview, while the blocks to the north are the Fairview Slopes. The house at 1075 West 15th appears to be the oldest on the block, built in 1911 and scarcely altered; 1065 is a 1913 house by the carpenter Joseph Thompson. Its turreted neighbour to the east, 1055, is new but retro-styled.

The big multifamily house at the corner of 15th and Spruce, with its front door at 3048 Spruce, was built in 1912 by Elmer Eugene Crandall, a manufacturer's agent who moonlighted as a builder-developer, living in his houses for a while before moving on. A member of an old Rhode Island family, Crandall's main business was representing a New Brunswick line of enamel stoves and "the Lundy Shovels and Tools, Axes, etc." (His next house, on 49th at Marguerite, was demolished in 1989, and was the subject of one of the paintings in the book *Vanishing Vancouver*. I received a call from Mary Crandall, his last surviving daughter, who was born years later in yet an-

other house on Cartier Street. She told me her father had 11 children by his first marriage, then three by his second, and was almost 70 years old when she was born!)

The big Craftsman house at 1104 West 15th belonged to William Curtis Shelly from the time of its construction in 1912 until the late 1920s, when he moved "up" to Shaughnessy Heights. Shelly was a baker, his firm Canadian Bakeries becoming the largest in British Columbia. He built the Shelly Building at 117 West Pender Street, developed the Grouse Mountain highway and built the first modern tramway, lodge and ski area there in the 1920s. As chair of the Park Board from 1922-1927, he thwarted a developer who wanted to build an apartment building at Brockton Point in Stanley Park. During the Squatter Eviction Trials, a native woman named Aunt Sally was able to prove she had lived in Stanley Park for more than 60 years and successfully claimed an acre of land. She was about to sell to a developer when Shelly stepped in and bought it for $17,500 of his own money. City council later reimbursed him, but refused to pay him interest. In the late 1920s, he served as minister of finance in the Tolmie provincial government; although he lacked political magic, going down to defeat in the next election, he was considered to be the most gifted amateur magician on the west coast.

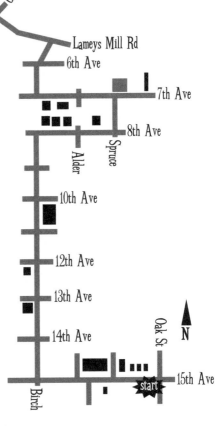

Across the street is Cecil Rhodes School, named for the Imperialist, diamond magnate, and namesake of Rhodesia, now Zimbabwe. It is one of many brick schools erected in Vancouver just before the First World War.

☞ Turn right at Birch Street and walk north

The blocks between the Shaughnessy bluff and Broadway are a melange of apartment buildings garnished with a few early houses. Note the 17-suite Chateau Apartments at the southwest corner of 13th and Birch, built in 1936 by Montrose Apartments Ltd., an apartment-management company owned by W.T. Walker (the namesake Montrose Apartments are a block away, at 1190 West 12th, also built in 1936). The large Tudor house at 1306 West 12th still has the formal landscaping, including the monkey puzzle tree and stone wall, of the Edwardian period when it was owned by lawyer A.L.P. Hunter. Two blocks farther north, Shaughnessy Lodge at 1298 West 10th was apparently also built in 1912—a very early apartment building for Fairview.

The district became accessible after the first bridge was completed across False Creek at Granville (then known as Centre Street) in 1889. The next year the Canadian Pacific Railway auctioned off lots on the slope. In October, 1891, the Vancouver Electric Railway & Light Company began a regular streetcar service on a belt line from downtown across the Granville Bridge, along Broadway, returning via an improved bridge across False Creek at Main Street. With a deep recession affecting Vancouver in 1892, the company was soon bankrupted, partly because it spent five times the original cost estimate crossing the seven gullies between Granville and Main. But two years later the belt line was back in business under new ownership.

Jonathan Miller, a constable of Granville in the pre-railway days and Vancouver's first postmaster, moved to the southeast corner of Birch and 8th in 1895, buying an unfinished house from H.R. Morse, a lumber-mill owner. He evidently moved there because his friend, shipping agent Charles Gardner Johnson, lived on the next block east across from the "Steamboat House" (Gardner Johnson, known as the "father of Vancouver's shipping industry," later built "Oakherst," the estate whose main house survives on 58th Avenue east of Oak Street). Miller's house, a grand turreted Queen Anne, together with a barn, carriage house, paddocks and gardens, occupied the entire block; it was later the Salvation Army's Mayhood School for Girls.

☞ Turn right onto 8th Avenue and walk east

By the 1970s, Fairview Slopes had become a derelict area of rooming houses and abandoned buildings, the atmosphere long since spoiled by

pollution from the mills and factories on False Creek. As the latter was cleaned up and redeveloped for housing and recreation, the Slopes also redeveloped, with block after block of low-rise townhouses giving it an urban, "San Francisco" feel. One of the rare surviving groupings of old houses stands at 8th and Birch. The one at the corner, 1295 West 8th, is the oldest, built in 1904 for Russell Grant, a clerk at the B.C.Electric Railway car barn. Cabinet-maker H. Sanderson built 1285 in 1908, and 1269 was finished in 1911.

A block to the east, the "Steamboat House" at 1151 West 8th is the oldest building on Fairview Slopes. Nicknamed for its elaborate woodwork, it was built in 1891 for Sir John Watt Reid, but a later occupant, lieutenant governor and *Province* publisher Walter Nichol, is better known. Nichol moved to a Shaughnessy Heights home before the First World War (page 133); the house, according to city records, had "apparently more than 2 families" by 1933.

Turn left on Spruce and walk north to 7th Avenue

Choklit Park, on the steep slope below the T formed by Spruce and 7th, recalls the long-time presence of the Purdy's Chocolate factory. Purdy's, founded in Vancouver in 1907, operated for decades from a 3,000 square foot factory kitchen on the east side of the park. The city allowed the company to expand in the early 1970s in return for developing the park. In the mid-1980s, expanding business and changes to the neighbourhood pushed the venerable firm into a much larger plant on Kingsway.

Walk east on 7th Avenue almost to Oak Street to see a unique tenement at 1017. Called the Takehara Apartments, it was built in 1912 by G. Yada, who may have been a relative of the Japanese consul Chesanuko Yada. Behind its modest facade, gangways extend along the side of what is a very large building descending the steep slope. Constructed evidently to provide housing for Japanese workers at the nearby sawmills, it appears to have been part of a Japanese enclave. There was a "Buddhist church" in a converted house a block to the east at the time.

Walk west now on 7th Avenue to Hodson Manor, at 1254 West 7th. A very old Fairview house, it was built in 1894 and added to (the right-hand bay) in 1904; however, that all happened at 8th and Hemlock, as it was moved to this lot in 1974. Owned by the city, it provides offices for cultural

organizations. On the corner of 7th at 2300 Birch is a big Queen Anne, built in 1910 for James England—a poor real-estate decision, given the tenement built two years later a couple of blocks away.

 Descend the hill on Birch and walk east one block on 6th, then cross 6th and go west onto Lamey's Mill Road, continuing to Fountain Way Court. Walk through the apartment courtyards onto Birch Walk and then cross onto Granville Island.

Both sides of 6th Avenue and the waterfront land along False Creek were heavily industrial until the early 1970s. A huge fire in the summer of 1960 started just to the east of here, in B.C. Forest Products' sawmill, and destroyed a number of businesses, many of which were outdated and becoming uneconomic anyway. They were never reopened, and the city decided that False Creek itself ought to become a recreational asset rather than an eyesore. The 1970s saw the cleanup and development of the south shore, largely done by the city with lowrise housing for families; in a subsequent, complicated land swap, the CPR vacated its railyards on the north shore, leaving only the 1886 Roundhouse now restored as a community centre (page 52). Following Expo '86, private developers completely renewed the north shore into a highrise community.

Vancouver Iron and Engineering Works occupied the waterfront at the foot of Alder Street, with millwork companies and sash-and-door factories to the west. The railway beneath Alder Crossing was a CPR branch line laid in 1902, later taken over by the BC Electric Railway and connected to downtown Vancouver by the Kitsilano Trestle, which crossed False Creek just west of Granville Island. A historic tram, run by the city, uses the track now to connect Granville Island with Science World at Main Street.

Another long-vanished landmark was the baseball field known as Athletic Park, renamed Capilano Stadium, on land now occupied by the Hemlock Street on-ramp of the Granville Street bridge. It opened in 1913 and survived until the current Granville Bridge was built in the 1950s; a new baseball stadium opened near Little Mountain in 1950 (page 104). On Granville Island, there is Old Bridge Street, which follows the alignment of the second (1909) Granville Street Bridge, from 4th Avenue to Pacific Street. The name Lamey's Mill Road was adopted in the post-industrial age, referring incorrectly to the Leamy & Kyle sawmill that once stood east of Cambie Bridge.

Granville Island is one of the city's extraordinary success stories. Originally a sandbar that was a favourite tidal fish trap for the natives at the nearby village of Sun'ahk (approximately the location of the Burrard Bridge's south footings), the island was created with dredge spoil from the creek, an effort promoted by federal politician Harry Stevens (page 80) during the First World War to create more industrial land. A number of industries, making chain, cable, saws and a myriad other specialized pieces of equipment for the resource industries, thrived there. However, like most of the other industrial sites on False Creek, it was outmoded by the 1960s. The federal government, led by local MP Ron Basford, transferred the island from control of the National Harbours Board to the Central (now Canada) Mortgage and Housing Corporation, and established a Granville Island Trust which, together with architect Norman Hotson, oversaw its redevelopment. Most of the buildings, including the extremely popular Public Market (formerly Wright's Ropes and B.C. Equipment), are recycled industrial sheds, and new construction has respected that style. The Creekhouse, a former Monsanto Chemical Warehouse directly beneath Granville Bridge, was the first building redone, by developers Mitch Taylor and Bill Harvey, in 1971. Note the interlacing of railway tracks that once connected with the BCER's freight lines, and the surviving Ocean Cement batch plant—a dose of reality amidst the organic carrots and crafts.

Cross back onto the mainland on Anderson Street beneath Granville Bridge.

One route from here is to veer right and follow Fir Street north, crossing on the way the tracks from the BCER's Vancouver-Steveston interurban line. There is an interesting cluster of old buildings at 7th and Fir, almost beneath the Fir Street offramp of the bridge, all developed in 1906 and 1907 by a man named S.G. Purkis and, in their deteriorated state, very evocative of the "hippie" Vancouver of a generation ago. At 15th Avenue, there

is a relic from a more elegant era, the arcaded 1920 Terminal City Lawn Bowling Club. All of the streets between Fir and Hemlock have interesting apartment buildings from the 1920s and 1930s in a variety of styles from Mission Revival to Tudor.

An alternate route is directly up Granville Street along "Gallery Row." Landmarks include the former Royal Bank building that is now the Heffel Gallery at 7th and the 1929 "Commercial Gothic" Dick Building at Broadway, still sporting its rotating neon sign. Two blocks south is the Stanley Theatre at 2750 Granville Street, designed in 1930 by H.H. Simmonds to present local live theatre as well as films; following a huge controversy in the early 1990s over a redevelopment plan that threatened to leave only its facade standing, the city agreed to restore it and convert it for live theatre. Note also Douglas Lodge at 12th and Granville, one of the city's prestigious early apartment buildings, and compare it with Hycroft Towers, the large modernist apartment building between 15th and 16th on the east side of the street. Designed by Semmens and Simpson, architects of the Burrard Street public library, it was in its day (the 1950s) an equally prestigious address. The blocks to the east of Granville, especially 14th and 15th around Hemlock, have many other fine apartment buldings from the 1920s and 1930s.

11

City Hall to Brewery Creek

B eginning at Vancouver's Golden Jubilee masterpiece, the 1936 City Hall, this walk ranges through Vancouver's oldest neighbourhood outside the downtown peninsula. The blocks closest to Cambie Street are an Edwardian jewel of Queen Anne turrets, monkey puzzle trees and stone walls, while the Main Street area is diverse and urban, the surviving heritage being mainly industrial sites and commercial buildings.

Mount Pleasant, as the community south of False Creek on Main Street came to be called, was like a small town at the turn of the 20th century. H.V. Edmonds, the municipal council clerk in New Westminster who had bought the cleared land in 1869—more than a dozen years before Burrard Inlet's destiny was affirmed by the pending arrival of the railway—named it for his wife's Irish birthplace. An ancient trail which was soon upgraded into the Westminster Road connected the well-established colonial capital, New Westminster, with the sawmill and saloons of Gastown. In the 1870s, a trestle crossed False Creek near its low-tide shoreline, directly south of Gastown.

Seventh Avenue was the first east-west road. A few settlers bought lots and built modest houses in the area in the 1880s, although the only significant landmarks were roadhouses on the Westminster Road: the Junction Inn at the intersection with the North Arm Road (Fraser Street) and the Gladstone Inn a mile or so farther southeast. When Vancouver burned to the ground in May, 1886, refugees streamed across the bridge to safety in Mount Pleasant, and aid from New Westminster arrived by the wagon load.

The oldest house in the community stood until recently at 243 East 5th Avenue. Built by Thomas Clark in 1888, it was on the bluff beside the Native Education Centre. A developer is scheduled to move it onto a lot on West 10th and restore it as a lane house in 2003. Apartment buildings have replaced the other small houses from those early years that once dotted the hillside east of Main Street.

 Start at the corner of 12th and Yukon

Before the 1930s, the hillside along Cambie Street above False Creek was a very refined neighbourhood, as witnessed by houses such as 410 West 12th, built in 1909, a Parr and Fee design with a single turret rather styled like those on "Glen Brae" (page 135). Most owners built in the Queen Anne style, using decorative turrets, stone and brick detailing, bay windows and picturesque profiles, complementing the designs with low granite walls and formal landscaping. For example, a monkey puzzle tree imported from Chile and a magnolia adorn the lawn of the house at the southeast corner. Note the coach house behind 410 West 12th—in order to retain the maximum number of old houses in the neighbourhood, the city in the 1980s created a progressive zoning schedule to allow infill buildings.

Another classic is the house at 2740 Yukon, built for Truman S. Baxter, mayor of Vancouver in 1913-1914, when City Hall was still downtown in the Market Building on Main near Hastings Street. Baxter was a teacher and merchant who served in office during the serious economic depression that ended Vancouver's greatest boom, and oversaw the establishment of the city's first Charities and Relief Commission. A designated heritage building, his house was recently repainted in its original colours by the Vancouver Heritage Foundation.

City Hall, built in the next economic depression, was the brainchild of Mayor Gerry McGeer (although Baxter claimed to have had the idea first to move City Hall to Mount Pleasant). The son of

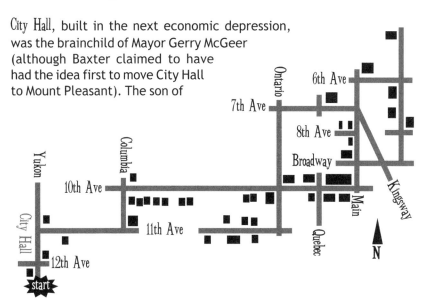

a dairyman, McGeer was born on a farm across the road from the Junction Inn, but became an ironworker, then a lawyer, and soon drifted into politics, helped by his marriage into the wealthy Spencer department-store family, his bombastic manner, and his championing of "western-alienation" issues such as inequitable freight rates. He was an MP, MLA and Senator, and Vancouver's mayor (during the time he was a Liberal MLA and subsequently a Liberal MP!) in 1935 and 1936. Unfazed by the deep Depression—he "read the Riot Act" to disperse crowds of unemployed—he used the 1936 Golden Jubilee as a reason to commission a lavish new City Hall. Rather than build it downtown, he sited it in Strathcona Park, not far from 16th and Ontario, the boundary Vancouver had shared with the municipalities of South Vancouver and Point Grey until the 1929 amalgamation. Architects Townley and Matheson designed the structure in the fashionable Art Deco/Art Moderne style. McGeer served as an MP until appointed to the Senate in 1945, then ran for mayor in 1947 and won, although he conducted much of his "anticorruption" campaign from a hospital bed. He died in office six months after he reassumed the mayor's chair.

☛ Turn right and walk east on 11th Avenue to Columbia

Admire the widow's walk and sleeping porches on the 1911 house at 2646 Yukon (the northeast corner of Yukon and 11th), designed for contractor James Mutch by architects Townsend and Townsend; and the turret, fine brickwork, stonework and period landscaping on the McLean house at 356 West 11th, designed in 1910 by architects Campbell and Bennett.

☛ Turn left and walk north on Columbia, then turn onto 10th and walk east

The Metropolitan Tabernacle at the corner of 11th and Columbia is the westernmost of a set of large churches in Mount Pleasant. Built in 1931 and designed by architects Bowman and Cullerne, it presents a rather dour, stuccoed face to the neighbourhood but has a splendid open interior. It is a popular venue for chamber concerts, especially for Early Music and baroque ensembles.

The block of 10th Avenue between Columbia and Manitoba is an extraordinary enclave of old Vancouver houses and exuberant modern gardens, due primarily to the efforts since the 1970s of the Davis family. The Garden Club of Vancouver named it the most beautiful block in the city for 1999-

2000, and it was on the route of every tour bus company in the city until the residents rebelled and the city responded by "calming" the traffic with tight roundabouts (many of which have been gardened by the residents). John and Pat Davis and sons John and Geoff began to restore 166 West 10th in the mid-1970s. Subsequently, they moved onto the block and bought most of the rest of the houses, which were badly deteriorated, their owners anticipating new apartment zoning. Over the next decade the Davises restored them all, inspiring others in the neighbourhood to do the same. 166 West 10th, originally the home of teamster Robert Moore, is the oldest, having been built at the corner of 11th and Columbia and moved onto 10th Avenue in 1891. Note also the circa-1900 "granny cottage" next door at 156, the pair of Edwardian houses from about 1907 at 148 and 150, and the Queen Anne cottage for the grocer Fred Walsh at 144. Other significant houses on the block are the 1899 home of stained-glass artist Henry Bloomfield at 2532 Columbia, and the concrete-block house at 124 West 10th, built in 1907 by carpenter Thomas H. Best and renovated in the late 1980s by Richard Fearn, who added the "Isis Cottage" at the back of the lot. The above-mentioned Clark house is scheduled to be relocated behind 130 West 10th.

These blocks of 10th Avenue were attractive for suburban purchasers early in the city's history because of the Fairview Belt-Line, constructed in 1891 to connect Vancouver with Fairview Slopes and Mount Pleasant via the Granville Street and Main Street bridges.

The next block east, between Manitoba and Ontario, has lost more of its old houses, but 42 and 46 West 10th, Edwardian "boxes" from 1911 built by contractor Thomas Angus (who lived at 28 East 8th), have been restored and were painted in 2000 with assistance from the Vancouver Heritage Foundation's True Colours program.

The two early apartment buildings at 10th and Ontario attest to the lack of strong zoning controls in the area around the First World War years. View Court Apartments at 12 West 10th and the Algonquin Apartments at 5 East 10th are pre-World War One buildings. There is also an interesting rowhouse a block to the east at the corner of 10th and Quebec, attached to the Federal store—named because of its proximity to the federal government building. The store began in 1922 as a bakery, run by Mrs. J. Colville "with three employees."

Mount Pleasant Baptist Church at the southeast corner of 10th and Quebec is a 1909

structure by Burke, Horwood and White, and replaced an 1890 congregation hall from the pioneer days of Mount Pleasant. At the same time, these architects designed First Baptist Church at Nelson and Burrard downtown, using the same tower design, although the Mount Pleasant church has more of a neighbourhood feeling due to its Tudor half-timbering.

 The large Mount Pleasant Presbyterian church at the northwest corner is a 1909 design by the architects Parr and Fee, most of whose legacy is turreted houses and commercial buildings in the downtown area including the Europe Hotel in Gastown. For years known as the Evangelistic Tabernacle, the building was turned into condominiums in the early 1990s. The Ukrainian Orthodox Church just to the east is the newest of the trio of churches.

The aforementioned federal building on the northeast corner bears the name of H.H. "Harry" Stevens, an influential and venerable Conservative politician who first came to the public's notice as a crusader against moral corruption (opium smoking and gambling) in Chinatown a century ago. As a cabinet minister in the Robert Borden government during the First World War, he anticipated the potential of shipping grain in bulk from Vancouver through the newly opened (1915) Panama Canal. The grain elevator he built on the Vancouver waterfront was initially dubbed "Stevens' Folly." His subsequent efforts on behalf of the Port of Vancouver include the construction of Granville Island. Disillusioned by the Conservatives following nearly 20 years as an MP and by the plight of many Canadians during the Depression, he formed and led the radical Reconstruction Party in the 1935 federal election, but won only his own seat. He retired in 1940.

☞ **Turn left and walk north on Main Street to Broadway, then turn right and cross Main; walk east on Broadway and then turn north at Scotia Street**

Main Street was Westminster Avenue and Broadway was 9th Avenue until, in 1909, promoters convinced the city to change the names. The old Westminster Road was improved between Main and Knight and named Kingsway in 1906 in honour of King Edward VII; the remaining stretch as far as New Westminster, concrete-paved for the automobile age, became Kingsway in 1913. The Lee Building, at the northwest corner of Broadway and Main, is the most dramatic survivor of those prosperous years.

The earliest substantial building in the neighbourhood, the Mount Pleas-

ant School, stood in the acute angle formed by Kingsway and Broadway until the early 1970s, when it was demolished and replaced by Kingsgate Mall. Built in 1891, when the city was only five years old, it was the fourth school in the city, the others being the Central School (demolished—the Vancouver Vocational Institute site south of Victory Square), the West End School on Burrard at Barclay (demolished) and the East School (now Strathcona Elementary, see page 29).

The large wooden building at the northeast corner of 8th and Scotia started life in 1922 as a Knights of Pythias hall, and has been celebrated for the past 30 years as the home of the Western Front artists' collective. Contractor Ira C. Jones signed the water-application permit on 22/2/22—perhaps a date of some significance to himself or his clients.

Scotia Street more or less follows the line taken by Brewery Creek, which descended from the Mountain View Cemetery area around 33rd and Fraser, flowed into a low spot known as the Tea Swamp (for the Labrador Tea, *Ledum groenlandicum*, that grew there), crossed Broadway beneath a wooden bridge just east of Main, and descended the Mount Pleasant hill before draining into False Creek. It was an excellent water source for the early years of beer and soda making in Vancouver. The historic brewery and bottling operations are well-explained by the cairn at 6th and Scotia. Admire the autobody shop at 263 East 7th, an excellent example of industrial architecture with a clerestory: it began life in 1913 as the Boiler and Engine Room for the Mount Pleasant Breweries, its water permit signed by the legendary brewer and distiller Henry Reifel (page 108). At the time there was a stable and wagon shed behind the building tenanted by Samuel Garvin, a well-known dairyman who delivered milk in Mount Pleasant in the pioneer years.

The solid stone and brick building directly across the street from the cairn at 280 East 6th, now converted into condos, is the oldest survivor of the brewery operations. It was converted into "artists' studios" in the 1990s. Walk as far as 5th to see the Native Education Centre, designed to reflect the post-and-beam building traditions of coastal communities. Then return to 6th.

☞ Walk west on 6th Avenue toward Main, then turn left and walk south to the crosswalk at Kingsway. Cross Kingsway and then Main Street

There are a number of fine buildings here, dating from the prosperous years before the First World War. The 1912 apartment building called "Ashnola" at 6th and Main—named for the area around Merritt in the BC interior where fortunes were being made in ranching and coal mining—has a cafe on its 6th Avenue side that might make a good pit stop, as this is the midpoint of the walk.

Walk north on Main turn left at 7th Avenue, walking west to Ontario Street. Turn left and walk south on Ontario, crossing Broadway continuing to 11th Avenue.

The flatiron lot formed by the intersection of Kingsway and Main is the site of the old Bains Chocolates building, a streamlined version of traditional flatirons such as the Europe Hotel in Gastown. (Bains, the long-time tenant, continues to operate out of a curious old house at 151 East 8th, built by a man named Pencier and connected to the water mains in 1892.) Note also the two buildings on opposite sides of 8th Avenue—the Royal Bank Building built in 1912 and the former Woolworth's Store, now used by Architectural Antiques.

This slightly long and noisy diversion is to permit inspection of the Quebec Manor apartment building at 7th and Quebec; noted for its nude maidens holding up the pediment over the main entrance, it is also interesting for its decorative brickwork and the combination of lightwells and bay windows to illuminate the inner apartments. Designed by architects Townsend and Townsend in 1911 and known for years as the Mount Stephen Block (after the mountain in eastern B.C. named for CPR financier George Stephen), the building was one of three similar structures: the Simpson Apartments at Davie and Denman (demolished) and Shaughnessy Mansions at 15th and Granville.

The walk returns to its starting point along quiet 11th Avenue, an interesting street although not as well restored as its neighbour to the north. Notice, as you're passing along, 25 and 31 West 11th, houses with mirror-image facades built about 1896; 42 and 46, mirror images built in 1913 by J. M Callaghan; and 64 and 78, a complex built in traditional style to complement the neighbourhood.

In the next block, don't miss the house at 104, a well-decorated Queen Anne built in 1894 for grocer Charles Philp, behind the holly hedge and best viewed from Manitoba Street. 133 and 137 are 1912 houses by builder

James Lumsden, who lived nearby at 53 East Broadway. There is an interesting backyard cottage behind 134 to 136. The little cottage at 145 was connected to the water system in 1904 for the illiterate C. Stapleton (his X, together with the clerk's note "his mark," appears on the permit).

There is much to explore in the adjoining streets, with more houses restored every year in what is one of Vancouver's most successful heritage neighbourhoods.

12

Grandview

A state-of-the-art transportation system—the interurban electric railway connecting Vancouver with New Westminster—opened the Grandview neighbourhood for settlement in 1891. The route followed Park Drive, a trail from Hastings Street to a parksite donated to the city in 1889 by E.J. Clark, now Clark Park at 14th and Commercial.

Some early property owners were settlers buying single lots, others property syndicates acquiring entire blocks, subdividing them and building houses "on spec." The city's water system arrived on Commercial Drive about 1904, at the same time as the BC Electric Railway Company began a local streetcar service. A later spurt of development began in 1912 when the BCER completed its Burnaby Lake interurban line which, from a terminus at 6th and Commercial, followed First Avenue eastward before swinging southeast, following the route of modern Highway 1 before looping around to New Westminster.

Grandview today is a combination of cabins, middle-class houses and a few mansions. The British working-class ambience of its early years got an Italian flavour in the 1950s and 1960s, an overlay of downmarket hippies and social-service agencies in the 1970s, with punks and upmarket yuppies adding further colour in the 1980s and 1990s. Like many of old Vancouver's neighbourhoods, it is gentrifying.

☞ Start at the corner of 1st Avenue and Commercial Drive

The little sundries store at 1721 Commercial with the neon "Star Weekly" sign was connected to the city's water system in May, 1909, by a man named Leon Melakov.

In 1910, a contractor named Herbert Crawford built the substantial building at the southeast corner of 1st and Commercial. It originally had a pointed metal turret. Around the time of the First World War, it was a typical mixed commercial and residential block, with a drygoods shops and a

confectioner on the main floor and upstairs tenants. The building adjoining it to the south was originally the Grandview Theatre, which commenced operations about 1913 during the silent era.

The northeast corner, now site of a drab Bank of Commerce building, was once home to a branch of that bank housed in a rare prefabricated structure by the BC Mills, Timber & Trading Company. Two other BCMT&T prefab banks in the Lower Mainland, surviving today, are the museums at Mission and Steveston.

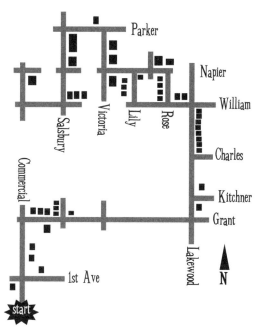

Walk east to 1735 East 1st a few steps to see a BCMT&T prefab, a model "OOO" gambrel-roofed house erected in 1905. Regrettably it has been much altered, the old windows having been replaced with aluminum ones, the distinctive modular wall units smothered by the "vinyl solution."

☞ Walk north on Commercial Drive to Graveley Street

The first home in Grandview stood at 1617 Graveley (now an apartment building). The Grace Chinese Methodist Church, just east of Commercial, started out in 1922 as the Grandview Lodge of the International Order of Odd Fellows, then the largest fraternal society in the world with 1,622,100 members at that time in the USA alone.

☞ Walk north on Commercial Drive, turn right on Grant Avenue

Carpenter Isaac Russell's cottages, 1721 and 1723 Grant built in 1908 and 1907 respectively, are successors to the first pioneer cabins. Slightly more elaborate, and the oldest surviving building on this block, is contractor H.E.

French's house, completed in 1905 at 1747 Grant. Although substantial, it is small compared with the Edward Odlum house, "Hillcrest," completed the following year at 1774. With its octagonal corner tower and bellcast eaves, it is an elegant example of the Queen Anne style, and once stood resplendent on a much larger piece of property, now infilled by small stucco bungalows. Edward Odlum was a member of a distinguished military and business family, his name surviving in a Vancouver brokerage company.

Developers promoting Grandview real estate built a number of the houses near the corner of Salsbury and Grant. The National Finance Company, a division of the B.C. Permanent Loan Company (whose building survives at 350 West Pender) built the three identical houses at 1505 to 1523 Salsbury. The Grandview Land and Trust Company, controlled by two men who lived at Central Park in Burnaby and doubtless sensed Grandview's potential while passing through on the interurban on their way to their downtown office, built 1528 Salsbury in 1905.

Continue east on Grant Avenue. In the park on fine days, the local Italian men play bocce. The house at 1860 Grant is another BCMT&T prefab, erected in 1906 for Odlum's son Edward Faraday, one of several family members who lived on Grant during the 1920s.

Note contractor James Ball's turreted Queen Anne-style house on the corner of Lakewood and Kitchener, built in 1909.

Turn north (left) at Lakewood Drive

Kitchener Street was known as Bismarck Street until 1915. It was renamed for the British Secretary of State for War as part of the Empire-wide purging of German names (Berlin, Ontario, becoming Kitchener, for example) during the First World War. The 1931 Foster house, at 2111 Kitchener, is a rarity in East Vancouver—a Georgian Revival-style building, a style very common in the southern parts of Shaughnessy and in Kerrisdale. Foster was a physician with a practice on East Hastings near Nanaimo.

The eight-house row on the east side of Lakewood between William and Charles had two different builders: the southernmost four were built in 1910 by the aforementioned James Ball; the others were built in 1909 by Storer J. Wing, aka Chin Wing, one of the rare Chinese contractors of that

era, who had been living at 1570 Bismarck but moved into 1204 Lakewood. With its river-stone porch piers and half-timbering in the gable, it is a more elaborate house than the other three. The house at 1210 Lakewood, occupied by Evelyn Harris and her family from 1919-2002, was one of the least-altered heritage buildings in the city.

🖚 Turn west (left) on William Street, then north (right) on Rose Street

Rose and Lily streets were subdivisions into the street pattern between the older Victoria Drive, William, Napier and Lakewood streets, inserting some of the more dense single-family housing in the city onto small lots close to the large properties along Napier and Victoria Drive.

The houses at 2061 and 2065 William with the Juliet balconies were built for speculator James Laird Northey in 1909. Contractor J.A. Chisholm built the identical plain boxes at 2050 and 2058.

Rose Street is one-sided—that is, its east side is lined with houses all on 25 x 96 foot lots, while its west side has the back fences of Semlin Street houses. It is an intimate block, with signs tacked to lampposts cautioning motorists to watch for children and respect crossing felines. The industrious Chin Wing completed the houses at 1128, 1122 and 1118 in September, 1909, while a speculator named J. Lennox Wilson built 1112 Rose the following year.

🖚 Turn west (left) on Napier, then south (left) on Semlin

Napier Street is dominated by the Franciscan Church and friary. The latter—the large house at 1020 Semlin—was from the time of its construction in 1908 until the early 1920s a private estate occupying the entire block, just under two-and-a-half acres with trails, gardens, a tennis court and a stable. The large house, designed by architects Beam and Brown and restored in the 1990s for the church, was originally called "Wilga." Note the rusticated concrete blocks forming the centreposts for the elaborate fence and the supporting walls for the staircases, which were a common replacement for stone in Vancouver.

"Wilga" was built for William Miller, one of four brothers who moved to Vancouver from Australia in 1905 and briefly became very wealthy in the real-estate and building boom before the First World War. William's brother John, known as J.J., built the equally large house called "Kurrajong,"

seen later on the tour. Driven out of Australia by drought, both brothers named their houses after shrubs that were useful, drought-resistant fodder in New South Wales. Both brothers had lost nearly all their money by the end of the First World War; ironically, a fifth brother who stayed in Cootamundra ultimately was the most successful.

Semlin Street, named for a B.C. premier in the chaotic period around 1900, is lined with the same kinds of small houses seen on Rose and Lily streets. Note the former grocery store in the middle of the block that began operation around 1920 and closed a few years ago.

☞ **Turn west (right) on William, north (right) on Lily, and finally west (left) on Napier to Victoria Drive**

The 10-year-old house by Tom and Megan Otton at 1992 William fits well into the neighbourhood. The two Queen Anne-style houses, one of which is unaltered, at 1970 and 1972 William were built by a carpenter named J. Gruning in 1909, about a decade after the style had gone out of fashion elsewhere in the city. On Lily Street, all the buildings on the west side are on 90 foot-deep lots and were built in 1910 by a contractor named A. McLellan. At the southeast corner of Lily and Napier there is a Craftsman-style house, a rare example of that style in Grandview where, even as late as 1910, the preferred style for large houses was the Queen Anne. Kitsilano is Vancouver's Craftsman neighbourhood.

The house at the southeast corner of Victoria Drive and Napier was built in 1909 for the realtor W.H. Copp by the architect J.P. Malluson. Its formal evergreen landscaping and holly hedging were the Edwardian period's high style. The garage matches the house, like the coachhouses of old Shaughnessy. Copp paid extra on his water-permit application for a fountain for his front garden, since removed.

The two houses to the north of Copp's, on the block facing Victoria Drive between Napier and Parker, were built by a contractor named John C. Hawkins. The older, built in 1906, is 1090 Victoria Drive, a private hospital since the First World War years; it was extensively renovated in the early 1990s, leaving little of its original fabric intact. A few years later Hawkins built 1020 Victoria Drive—a fascinating amalgam of 19th-century building tastes that is probably best described as Shingle Style. (In 1913 he built a similar, more elaborate, house for himself at 1927 West 17th Avenue in Shaughnessy.)

☞ Turn west (left) at Parker Street

Lumber-company owner W.W. Stuart built the large, dilapidated house at 1829 Parker in 1909 as an investment. The house has an exact duplicate at 364 West 10th Avenue in Mount Pleasant, leading to speculation that they were built from a design in a house-pattern book. Long-time Vancouverites recall the turreted, bay-windowed Stuart Building at Georgia and Chilco at the entrance to Stanley Park; Stuart demolished his house there in 1909 and erected an apartment building as he felt the land to be too valuable for a single residence. It was torn down in 1982 after prolonged protest.

There are great contrasts further down the street: two little bungalows on the northwest corner of Parker and Salsbury erected in 1909 for the aforementioned speculator J. Lennox Wilson, and the 1911 apartment building called Salsbury Court, a wood-framed structure with a brick veneer by Arthur Julius Bird, the former City Architect who a few years previously designed the extension to Fire Hall Number 6 on Nelson Street in the West End. Before giving up his private practice to become the city's building inspector, he also designed the Afton Hotel on East Hastings Street.

☞ Turn south (left) on Salsbury Drive

The aforementioned "Kurrajong" stands directly south of Bird's apartment building. Unlike his brother, J.J. Miller built in 1907 in the Queen Anne style, using an architect whose identity has eluded researchers. Like the Copp house, "Kurrajong" retains an Edwardian feel with its clipped holly landscaping and massive retaining wall built of concrete blocks. After eight decades as a private hospital the entire complex has recently been renovated, with new infill buildings surrounding the main house.

Across the street from "Kurrajong" stands the Robertson Presbyterian Church, erected in 1908 by the BCMT&T and certainly one of the largest prefabricated buildings ever done by that company. A 1984 renovation raised the church and added metal windows and the wheelchair ramp.

At the northeast corner of William and Salsbury, an unknown contractor built three "Vancouver Specials" in the late 1950s—very early examples of that most ubiquitous design for affordable family housing. Characteristically, they are built on slabs, have a boxlike shape, low-pitched roofs of tar and

gravel, stucco facades, downstairs bedrooms and upstairs living and din-
ing areas; however, these houses lack the narrow balcony with thin
aluminum railings typical of the mature style.

☞ Turn west (right) onto William and walk to Commercial Drive

Commercial development began with the arrival of the streetcar lines
around 1907. The Florida Market on the corner of Napier opened in 1908.

These blocks of "The Drive" are excellent for drinking cappuccino and
observing the fashion scene. Today, almost no public behaviour raises an
eyebrow on what may be Vancouver's hippest street.

13

Beacon Hill

Surrounded by major traffic arteries whisking the commuter hordes home to the suburbs, the quiet neighbourhood of Beacon Hill sitting on the rise between Nanaimo and Renfrew Streets is easy to miss.

In 1863 in anticipation of the development that was sure to come to Burrard Inlet, the colonial government set aside a huge parcel of land stretching from the Inlet to today's 29th Avenue and from Nanaimo to Boundary. Nothing much happened except for the tiny settlement of Hastings on the site of New Brighton Park on Burrard Inlet. Even this was soon bypassed because the establishment of the Hastings Sawmill and the growing settlement around Gassy Jack Deighton's saloon farther west prompted the government to survey a new townsite: Granville, the birthplace of Vancouver.

Development didn't really take off in this part of the Hastings Townsite until it was annexed by the City of Vancouver in 1911. The previous year almost 68,000 people rode the B.C. Electric's new streetcar service to Hastings Park for the inaugural Vancouver Exhibition. Many fairgoers saw the residential possibilities of this part of the city for the first time.

Real estate promotions extolled the virtues of splendid views over the inlet and the ease of access to the city. By 1913 on the eve of war, the streets were lined with the latest in California-inspired bungalow designs. Regular streetcar service on Eton, McGill and Hastings provided quick and cheap transportation into the city. Real estate promotion efforts picked up after the war and a large number of tidy English-inspired stucco bungalows joined their earlier Craftsman cousins.

While the modern, uninspired, stucco box is beginning to creep into the neighbourhood, the area still has some of the best Arts and Crafts architecture outside of Kitsilano and the awareness and appreciation of it will continue to grow.

☞ **The walk starts at the southeast corner of Cambridge and North Kaslo Streets at Callister Park.**

In its peaceful state today it's hard to imagine Callister Park was once the home of a 10,000-seat grandstand filled with cheering lacrosse and soccer fans. The park was built by Con Jones, sports entrepreneur, ex-bookie and owner of a chain of tobacco shops known by their famous motto: "Don't Argue Con-Jones Sells Fresh Tobacco". Con Jones Park opened in 1912 and was home to the Minto Cup-winning Vancouver Lacrosse Club and a Pacific Coast Soccer League team. The grandstands which wrapped around the western end of the park were torn down in the 1970s. After Jones' death the park was deeded to the City and renamed for a John Callister.

☞ **Head west on Cambridge**

Just west of Kaslo, contractor Thomas Borgford's wonderful 1913 Craftsman Tudor at 2770 Cambridge stands out against other houses on the street. Look up to the peak of the house to see his intials. It was home to "theologist" William Miller in 1923. On the north side of the street are a pair of houses, 2763 and 2757 Cambridge, which feature sleeping porches on the second storey. Porches such as these were often made large enough to hold a bed for the full benefits of sleeping in the fresh air. Neil McLeod, foreman of the Joint Sewage Board and living at 2763 in 1916, might have appreciated the fresh air.

☞ **Return to Kaslo, turn south to Oxford. Walk west on Oxford.**

This block of Oxford is an interesting mix of pre-World War One, 1920's and late 1940's houses. George Thompson got local contractor W. F. Barker to build a traditional Edwardian Box at 2748 Oxford in 1912. Across the street, the Mission Revival style was the height of fashion when 2751 Oxford was built. Mission Revival swept up the west coast of North America from California in the 1920's and in Vancouver the style was picked up in everything from apartment buildings to gas stations.

Back across the street is Thomas Peck's unusual house at 2724 Oxford. Built in 1912 before the water mains reached this far on Oxford, the house had a water connection through Peck's property to the south on Dundas Street. When city water service finally arrived in the 1920's, Peck complained he couldn't afford to change connections and it took sometime for the City to get the house onto the Oxford water main.

👉 **Cross North Slocan**

The Bungalow was another popular style that came up the Pacific coast from California. In the 2600 block of Oxford it was certainly the style of choice. While many of the homes have been renovated over the years there are some real gems here. 2683 Oxford with its shallow roof pitch and clinker brick porch piers must have been wonderful to come home to. Clinker bricks were actually the rejects from the firing process where impurities in the clay caused the deformation of the brick. With the Arts and Crafts movement's aesthetic, bricks such as these, because of their imperfections, were much sought after.

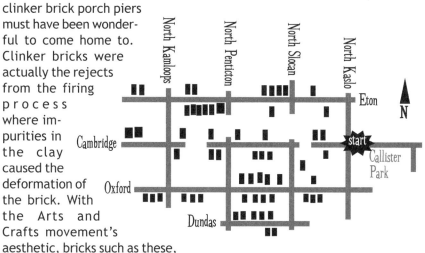

2675, 2666, and 2660 Oxford displaying different degrees of modification, are all end-gable bungalows, also known as the Pasadena Bungalow. It was one of the more popular styles in North America and there are a quite a few excellent examples in the surrounding neighbourhood. 2640 Oxford the home of garage mechanic John Esson, was built in 1918 and was a recipient of a Vancouver Heritage Foundation True Colours grant. This granting program encourages authentic period paint schemes for heritage homes. The Ellesworth House at 2620 Oxford, next door, was also a participant in True Colours. This unusual gambrel-roofed house was constructed in 1923 by carpenter James Ellesworth.

On the north side of the street, 2659 Oxford recalls the "Belmont" bungalow design issued by the Sears Roebuck Company in the 1920's. Note the front door and its large brass hinge straps. In contrast, the Miller family had local resident and builder Delbert Nunn put together the house at 2641

Oxford. As a carpenter, William Miller probably worked on the house in between jobs, while George Miller, also living in the house, handled the money down at B.C. Sugar as a cashier. The design of the Miller's house comes from a builders' plan book and is duplicated a number of times in the neighbourhood. Delbert Nunn is responsible for a few of them.

When George Hardy moved out to Beacon Hill in 1911 he bought three lots and erected the large Edwardian at 2625 Oxford. Hardy and William Calder, who was a block away at 2666 Cambridge, were the owners of Merchants Cartage Co.

☞ Turn north on Penticton. Walk to Cambridge and turn west.

North Penticton was once Clinton Street and this name can still be seen stamped into the concrete of the sidewalk near the corners of the intersections.

Just in from the corner of Penticton and Cambridge are the twin houses at 2586 and 2580 Cambridge built by George and Charles Westwood in 1912. Morris (or Maurice) Blott, a salesman, moved into 2586; his neighbour was Kathleen McKenzie. Blott, a long-time resident, was consulted by Major Matthews, the City Archivist, in the 1940's on the origins of the area's name. The Westwoods' must have had the same plan book as Delbert Nunn since the house he built for local contractor William Barker at 2575 Cambridge is almost identical. Along with William, his brothers John Barker, a clerk with the CPR, and George Barker, dredge master with the Canadian Klondike Mining Company, lived in the house. Delbert Nunn lived just a couple of streets over at 2456 McGill.

☞ Turn around and head east on Cambridge, crossing North Penticton.

Real estate ads in local newspapers were advertising lots on Cambridge for about $600 in 1910. Sales were brisk and most of the eastern end of the block had been built on by the First World War. The western end was slower to develop and has a number of post war houses—the best example being 2647 Cambridge— in between the earlier ones. Mid-block is a grouping of houses, 2666, 2672 and 2680 Cambridge, which all look like more houses from Delbert Nunn but he's only responsible for the one in the middle. Built in 1912, it was the home of Finley Rose, the proprietor of the Fashion Livery Stables downtown at 145 E. Cordova. And to get to work all

Finley had to do was walk over one block north for the streetcar that went straight to the stable's front door. 2673 Cambridge across the street is of a similar design.

 Walk to North Slocan, turn south and walk to Dundas.

Just before the First World War, the Vancouver Fire Department built Fire Hall number 14 at the northeast corner of Slocan and Cambridge in response to the area's rapid growth. The wooden structure had outlived its usefulness by the late 1970's and it was replaced by a newer building to the south on Venables.

One of the quirkiest buildings in the neighbourhood is the wondrous house James Wartman built for himself at 110 Slocan. At the time of its construction in 1911, sitting all by itself on four lots, the view out and over the Burrard Inlet from the tower would have been spectacular. The tower appears on early plans of the house and would seem to be original to the design. Wartman was a plasterer, which might account for the interesting exterior finish used on the building.

Turn west on Dundas and walk to North Penticton.

From the top of the rise at Slocan, Dundas Street offers some great and unexpected views of the downtown office towers. In contrast to the quiet tree-lined streets a block away, Dundas is a major traffic artery, but this block has some lovely Arts and Crafts homes. On the south side at 2634 and 2630 Dundas are a couple of perfect little "Pyramid" Bungalows—so called because of the shape of their roofs. On the north side at 2633 Dundas, building contractor Wilfred Lindsey created a neat little bungalow for himself using river rock for the porch piers. His neighbour, fireman Angus McLeod, had bigger ideas for his home at 2627 Dundas, though with today's traffic the sleeping porch might not get all that much use. Three Pasadena Bungalows at 2603, 2607 and 2615 Dundas complete this side of the block.

Turn north on North Penticton, walk to Oxford. Turn west on Oxford, walk to Kamloops.

Albert Forrest, a linotype operator for L. D. Taylor's Vancouver *World* newspaper had the shingled house at 2576 Oxford built in 1911. Forrest worked on what was the most advanced typesetting equipment of its day—Thomas Edison called it the eighth wonder of the world. Its introduction in

1886 allowed the rapid spread of newspapers worldwide since typesetting was no longer the laborious and time consuming handwork it had been. Farther down the street John Botten, built a similar house to Forrest's in 1912 at 2526 Oxford.

Mixed in with the other homes on the block are some "Americanized English" homes loosely inspired by the English Arts and Crafts movement. The dominant feature is the curved, high peaked gable over the front entrance, such as 2578 Oxford. Also on the block are some late-1940's houses on the north side-quite evident because of their small size and box shape.

Cross North Kamloops

Two Pasadena Bungalows from the 1920's sit at the corner. 2498 Oxford with its filled-in porch was the home of William Bugeden while his neighbour was L. H. Donaldson, the secretary of the Yukon Fur Company. Thomson Coal Company driver George Davidson had the pleasure of living in the delightful pyramid bungalow at 2478 Oxford. Across the street at 2469 Oxford, on what is now the school grounds, was the East End Dairy. The dairy operation was in the rear of the property while across the street on the southeast corner of Cambridge was the dairy's workshops.

Return to North Kamloops turn north and walk to Cambridge.

At this location, 2516 Cambridge, the dairy shared or rented space from the Currie Brothers, Alban and Donald, who owned the Beacon Hill Stables and operated their teamster contracting business from there. They lived up the street at 2559 Cambridge, just a couple of doors east from building contractor Isaac Haw and his music teacher wife, Lillia, at 2533 Cambridge. One block west, James Currie (a brother?) lived in the large Edwardian at 2403 Cambridge. Next door to Currie, Edwin Thomas had a large house built for himself in 1912 at 2423 Cambridge which features an interesting set of double dormers on the roof. It looks like the contractor took the plans for 2586 and 2588 Eton and doubled them up.

Walk to Eton and turn west.

On this short block of Eton Street there are some interesting and well-kept homes. It was a popular street because of the regular streetcar service that ran along Eton and McGill, and it's not hard to imagine the

red and cream BCER cars clanging along the tracks between Eton Street's towering oaks. At the end of the block, 2439 Eton was the creation of Alfred Bergquist in 1911. It cost him about $2,500 to build. Next door to Bergquist's house is the second gambrel-roofed house to be found in the neighbourhood—2451 Eton, which was finished in 1911 and was home to a Louis Ledic.

 ## Turn around. Cross North Kamloops and continue east on Eton

The 2500-block of Eton was one of the first blocks developed. In 1903 Frank Woodside was residing in the area and told Major Matthews that his house at 2594 Eton, erected in 1908, was the first two-storey house in the whole area. Woodside was a builder and dealt in real estate from an office at 275 North Penticton. After the Hastings Townsite became part of the City of Vancouver, he was elected to City Council. Others followed Woodside's lead and the tall Edwardians on the north side of the street are evidence of this. In amongst them at 2539 Eton is a little Craftsman cottage looking a little like a lost beach house. 2586, 2588 and 2590 and 2592 Eton are two sets of well kept twins.

At the corner of Eton and North Penticton at 2598 Eton is the apartment house and former Beacon Hill Grocery developed by Frank Woodside and Alfred Bergquist in 1911. Because of the streetcar line on Eton and the relative isolation of the area's residents it made perfect sense to build the grocery here. George Peters, living over on Trinity, ran the grocery in 1913. By 1923 it had its own sub post office.

Cross North Penticton

A number of modern stucco boxes have begun to appear in the Beacon Hill area and their lack of style and proportion contrasts with the cozy, well-ordered proportions of the Tudor Craftsman at 2651 Eton and its neighbours at 2675, 2681, and 2685 Eton. 2680 Eton, the home of the Hemphill Family, is on a very different scale from many of its neighbours. Take a look at the porch supports which are an interesting combination of river rock (or maybe collected from the beach nearby) and cut granite. Back on the north side at the corner of Eton and Slocan, 2697 Eton is lovely. There's a dash of 1930's modern around the front door with the glass block inserts and a little bit of Edwin Lutyens in the 'eyebrow' windows that animate the roof line.

Cross North Slocan

The 2700 block of Eton, the last block on the tour, has a couple of the cutest Arts and Crafts houses in the whole neighbourhood. 2725 Eton has a cottage feel to it with its interesting roof line. In 1912, Mr. Brothers bought two lots at 2778 and 2782 Eton and erected identical houses that might have been inspired by the trend towards 'rustic' Arts and Crafts designs. 2782 Eton, which survives in original condition, was sold to Alex Smith a draughtsman at B. C. Sugar, and wouldn't look out of place on the shores of a lake or as a lodge at a wilderness camp. From the large upstairs sleeping porch Mr. Smith would have enjoyed a great view out over Burrard Inlet. John Bentley, with the interesting occupation of auto polisher, moved into 2778 Eton.

The most interesting houses on the street have to be 2767 and 2769 Eton, a pair of identical bungalows from the 1920's with their long, shallow porch roofs. The front door has been pushed out onto the porch and surrounded by panels of stained glass.

Turn south on North Kaslo and walk to Callister Park the starting point of the tour.

14

Lakewood

T he wonderful bungalows found in the Beacon Hill neighbourhood are just a few examples of the style in Vancouver. A couple of blocks west of the neighbourhood at Lakewood and Hastings are six of the best California Bungalows in the city.

308, 316, 322, 430, 434, and 440 Lakewood were built over a period of three years, starting in 1910, at the height of the popularity of the California Arts and Crafts style. Vancouver's architecture was generally influenced by trends from south of the border instead of eastern Canada. California was a strong influence on the Pacific Coast so it's not surprising that while Henry Wilson began publishing *The Bungalow Magazine* in Los Angeles to promote the bungalow style, it was sold to Seattle developer Jud Yoho in 1912. Yoho and his Craftsman Bungalow Company became tireless promoters, believing that the bungalow would, and should, become the national style. Each issue featured a different bungalow design and included articles promoting the "bungalow lifestyle". Along with Yoho's magazine, the bungalow craze spawned a number of pattern books which offered plans for sale and the houses here, and throughout Vancouver, would have been copied straight from these publications.

The builders of the Lakewood houses, James Stephenson and W. A. Doctor, have certainly captured the essence of the ideal California Bungalow. They all have or had a spacious porch spanning the entire width of the façade, a wide, shallow-pitched roof and the deep eaves which shade the windows from the sun—great in California but it made for an exceptionally dark interior in a northern climate. "Japanesque" features so popular in California—ornate upturned rafter ends, the bump up of the roof ridge at the gable ends and the heavy timbers—give a sense of the Oriental origins of the style. Bungalow is a corruption of the Bengali word *bangala*, meaning small thatched house with porch.

What Stephenson and Doctor didn't achieve with their very suburban

arrangement of lots was the ideal of a house in subordination to nature, blending in and becoming part of the landscape. They just built the biggest houses that could fit onto their lots. But because of this the houses possess an imposing presence they might not have otherwise achieved.

There is one tantalizing piece of information contained in the building permit register for 316 Lakewood—the Craftsman Bungalow Company is listed under architect. It would be interesting to know whether this was Jud Yoho's Seattle-based firm.

15

Riley Park

T raditionally seen as the dividing line between east and west-side Vancouver, Main Street also manages to straddle the traditional and the new wave, especially on the dozen blocks centred around King Edward Avenue (after Edward VII, Queen Victoria's eldest son, British King from 1901 to 1910). There is much to explore and sample, including a great variety of restaurants and coffee shops, avant garde galleries like the Grind, and a myriad of old furniture and antique stores.

The residential streets on both sides of Main are equally interesting. Unlike the area west of Ontario Street (the eastern boundary of the CPR's land grant), which seceded from the Municipality of South Vancouver in 1908 to form the Municipality of Point Grey, these streets are informally planned and more diverse in their lot sizes and house types. Point Grey stood for orderly development, its residents willing to pay substantial taxes in order to enjoy good public services and amenities like parks and street trees, while South Vancouver had a more laissez-faire attitude (leading to its default on bonds in 1918 and subsequently its placement into trusteeship by the provincial government). Point Grey's major landowner, the CPR, only released new subdivisions for settlement when demand exceeded supply; thus, the land between Ontario and Cambie was only opened up in the 1930s, and has curving streets reflecting the suburban ideals of the time.

The BC Electric Railway Company spurred settlement of the area in 1904, by extending streetcar service south on Main Street, using Bodwell Road (now 33rd Avenue) to connect with the gates of Mountain View Cemetery at Fraser Street. Early maps call the area around King Edward and Main "Hillcrest," "City Heights" or "Sunnyside"; today the commercial area is usually called South Main and the residential area, especially on the west side of Main, Riley Park or Riley Park-Little Mountain.

The walk explores the narrow streets between Main and Ontario streets, then continues south through Riley Park itself to the Little Mountain public housing project, ending with a romp through Queen Elizabeth Park.

☞ Start at the corner of King Edward and Main, and walk west on King Edward

A few substantial structures, notably the Walden Building at 4120 Main, remain from the first real-estate boom. The Hopkins Block apartment building at the southwest corner of Main and King Edward is from the same period, built when piped water from the Capilano reservoir reached the area about 1910.

The three houses at 178, 172 and 166 East King Edward evoke old Vancouver, especially when seen from the west looking toward Main Street, with the backdrop of the Hopkins Block. They were built about 1910, as was the fine house at 97 East King Edward with its wraparound porch and finely detailed woodwork. Like many of the houses in this area, it's impossible to tell exactly who built them and when, and even who first lived there, as taxation records and water-connection permits for these blocks of South Vancouver are non-existent, and even the addresses have changed—directory information before 1913 or so being very spotty and inconsistent. However, it's a good guess to say that the three houses on the south side of the street were built by a carpenter, that is a small-scale developer, and occupied by married workers with good jobs downtown, either white- or blue-collar.

Observe in the distance to the west how modest "25th Avenue," also known as Arnold Avenue until South Vancouver and Point Grey amalgamated with Vancouver in 1929, widens into grand King Edward Avenue, with its central boulevard, a block past the Ontario Street boundary.

☞ Turn left onto Quebec Street and walk south

Narrow streets and short blocks characterize this little enclave. Two of the oldest houses are 133 and 136 East 26th, cottages built in the first decade of the 20th century.

Note the trio at 4204, 4214 and 4224 Quebec, by their permit numbers built in 1910 and jammed sideways onto two narrow lots. The houses first appear in the 1913 city directory, occupied by Joseph Barry, a clerk with the Vancouver Piano Company who had previously lived on Hamilton Street downtown, Rick Galbraith, a machinist with Canadian Fairbanks-Morse, and plumber Charles Henderson, respectively.

Next door, the 1913 Quebec Mansions at 111 East 27th is one of the handful of pre-World War One multifamily buildings outside the old city.

☞ **Walk east toward Main on 27th, then backtrack and continue west**

159 East 27th is stylistically the oldest house on the block, but wasn't hooked up to the water supply until 1911, the year after its neighbours. Probably there was a shallow well in the back yard, not very far from the privy. Note the two cottages, 125 with its gabled roof, and 119—a gem of an infill house.

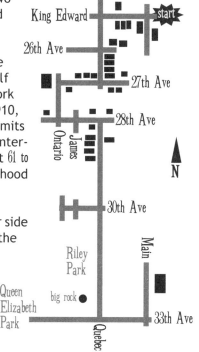

West of Quebec Street, the row of five gabled, stuccoed storey-and-a-half houses at 73 to 91 East 27th were all the work of an unknown carpenter, around 1910, who applied for water-connection permits for them all together. Next door, the interesting, unusual side-by-side duplex at 61 to 65 was an addition to the neighbourhood about a decade later.

At the head of the street, on the other side of Ontario, stands General Wolfe School (the namesake the victor of the 1759 battle at Québec that made New France a British colony). It is a "barbell school," its first part erected in 1910 and expanded in 1912, one of several brick schools erected in South Vancouver during the tenure of J.H. Bowman as official architect. Lord Selkirk Elementary, at 1750 East 22nd, is an identical design. Inevitably, there would have been a grocery and candy store nearby—it was the building on the southeast corner, 4300 Ontario at 27th, opened in 1911 by Robert McGregor. Note the concrete steps that once led to the corner door.

☞ **Walk south on Ontario Street, then turn left and walk east on 28th Avenue**

As stated above, the land west of Ontario Street belonged to the CPR, and typically the original houses there were 1940s and 1950s bungalows, interspersed now with retro-historic new houses such as 21 West 28th. The

South Vancouver surveys did not line up with the CPR surveys, especially at 27th where there is a distinct jog in the road. This misalignment is common along the entire length of Ontario Street from False Creek to Marpole (and along the western boundary, Trafalgar Street, north of 16th). Cross James Street (named for the influential pioneer realtor and civic politician James Welton Horne, namesake of the Horne Block at 311 West Cordova in Gastown), one of the short streets in the Riley Park neighbourhood .

Although not immediately evident to a casual glance, I am also certain that there are three much-altered BCMT&T prefabricated houses at 119. 143 and 151 East 28th, with newer houses infilled between them. The first is a Model "LL"—mirror image of a house on East 2nd Street in North Vancouver (page 183) and a two-story version of the Model "L" on West 13th (page 109)—recognizable by its shape although resheathed with modern materials. 143 is a "JJ." And 151 gives away its parentage by the panels visible on the side walls—horizontal narrow siding in panels separated by panels. As BCMT&T only manufactured prefabricated houses until 1908, it is possible these are early arrivals in the neighbourhood, or perhaps they were moved from elsewhere. 143 was connected to the water system in 1910; 151 several years later.

👉 **Turn right on Quebec Street and walk south**

The block of Quebec between 28th and 29th is one of the most intact historically and best cared for in the city. The herb garden at 4403 Quebec, the home originally of widow Mary Hay, supplied the legendary Mocha Cafe at Broadway and Granville in the early 1990s. 4446 is an unusual Queen Anne, built about 1910. The five houses with fine gardens at 4447. 4453. 4459. 4465 and 4473 are all pre-World War One. The blocks of Quebec, and of James, between 29th and 30th, have fewer interesting old houses and more unattractive modern infill.

👉 **Turn right at 30th and walk west to Ontario, then walk east again and cut through Riley Park along the right-of-way of James Street to 33rd Avenue.**

Riley Park was set aside by the Municipality of South Vancouver in the late 1920s. Clark Riley was municipal clerk. "He had just died when the naming was considered," his successor told city archivist J.S. Matthews, "so they named it after him." There was no money to develop it during the

Depression, but a 1937 newspaper report stated, "Brush around Riley Park will be cleared out, council has decided. This action was taken because of recent reports of molestations by morons."

Percy Norman Pool, opened in 1960, is named for the long-time coach of the Vancouver Amateur Swim Club and a talented marathon swimmer in his youth. In Norman's day, swimmers used the salt-water Crystal Pool on Beach Avenue at Jervis when they weren't cavorting in English Bay. Its erection climaxed a decade of controversy about the park's fate, with influential politicians and businessmen trying to get control of it for "non-neighbourhood" purposes. In the late 1940s, some wanted it to be the site of the baseball stadium. From 1950 to 1952, "Coley" Hall, the owner of the Vancouver Canucks of the Pacific Coast (hockey) League, tried to buy the park as the site for a $1 million arena. Then, the park almost became the site of the 1954 British Empire Games Pool—that ended up at UBC, next to Memorial Gymnasium on University Boulevard. Finally, by the time council approved the funds, there was enough money to make it into an indoor pool.

Across Ontario Street, with the verdant hillside of Queen Elizabeth Park as a backdrop, stands Nat Bailey Stadium, which has had more lives than a cat. The Sick family's Capilano Brewery, sponsor of the Vancouver Capilanos of the Western International League, built it in 1951 after selling old Capilano Stadium, originally called Athletic Park, to provide space for the Hemlock Street on-ramp and cloverleaf for the new Granville Bridge (page 73). Capilano Brewery ceased to sponsor baseball several years later and sold out in 1958 to Molson's (which retained for decades the former's "Old Style" beer brand and label and still operates its brewery at the south end of Burrard Bridge). Then, a syndicate of local businessmen headed by Nat Bailey, the founder of the White Spot restaurant chain who got his start selling peanuts at Athletic Park, bought the Oakland franchise of the Pacific Coast International League and moved it to Vancouver where, renamed the Vancouver Mounties, it played from 1957-62 and from 1965-69.

For the next decade, the stadium stood abandoned and vandalized, but was revived in 1977 with the Vancouver Canadians, sponsored by Molson's and named for one of its popular beer brands. The Canadians are part of the Northwest League, which is classified as "short-season Class A" or "minor league" baseball, and is affiliated with the Oakland A's. In the

1950s, it was the legalization of Sunday sport that helped the team; in the 1980s, it was paper cups of beer. With baseball always a minor-league affair in Vancouver, the stadium was never superseded by a bigger one, and few people have been willing to watch baseball indoors in barren BC Place.

Back in Riley Park, walk past the enormous granite boulder, a "glacial erratic," and along James Street to 33rd Avenue. The Little Mountain Public Housing Project, built in 1953 by architects Thompson, Berwick and Pratt, occupies the multiblock stretch of land between 33rd and 37th east of Ontario. The seemingly random placement of the apartment units, the lack of landscaping, and the pared-down institutional design all contribute to the feeling that the people living there are somehow different (that is, poorer) from the rest of the neighbourhood. Like the low-cost public housing projects attempted later in Strathcona (page 32), it was an idea that never caught on in Vancouver.

At this point, choose either a direct return to King Edward and Main by walking east to Main Street and proceeding north past all the interesting stores and cafes. If you do, admire General Brock School at 4860 Main, a 1908 design of architect W.T. Whiteway and one of the finest surviving wooden schools in the city.

Alternatively, walk west on 33rd and climb the hill to Queen Elizabeth Park, known to long-time Vancouverites as Little Mountain. A volcanic outcropping, it is the highest point in the city, offering spectacular views to every point on the compass. Equally spectacular, especially on Saturdays, are the elaborate wedding parties that use the viewpoint and the quarry gardens for photographs.

Little Mountain was the site of the South Vancouver rock pit, providing ballast for the BCER's cemetery line (a spur line ran to the quarry from Main Street) and crushed basalt for some South Vancouver roads and for all the roads in Shaughnessy Heights. The city bought it from the CPR in 1929. It was christened Queen Elizabeth Park in 1940, to commemorate the visit the previous year of King George VI and Queen Elizabeth ("the Queen mother"); her daughter, then Princess Elizabeth, planted a tree there in October 1951 as part of the development of the arboretum and rock gardens.

The observation deck and platform at the summit which supports the Bloedel Conservatory (a 1969 gift to the city from the lumber family)

cover two reservoirs, dug in 1908 to boost water pressure in South Vancouver. They were covered in 1965 due to concerns about air pollution and security.

The park is a pleasure to explore, with winding trails, grassy slopes which on snowy winter days provide superb sledding, and ponds home to serene waterfowl. Exit the park onto Cambie Street and walk north along the curve of the "heritage boulevard" with its huge sequoiadendron trees and view to the city, or explore the four winding streets north of the park—Midlothian, Nigel, Talisman and Peveril—which take their names from novel titles by Sir Walter Scott.

16

Brewing & the Reifel family in Vancouver

A Bicycle Tour. or . . . ?

Along or near the Arbutus Corridor
- Capilano (now Molson) Brewery at the south end of Burrard Bridge
- Vancouver Breweries site at 12th and Yew
- Houses on 13th Avenue west of Arbutus
- Harry Reifel home "Rio Vista" at 2170 South West Marine Drive
- George C. Reifel home "Casa Mia" at 1920 South West Marine Drive

Along the East-West Corridor

- Brewery Creek and buildings along Scotia Street (page 81)
- site of Athletic Park, *aka* Capilano Stadium, at 5th and Hemlock
- The 11th Avenue Greenway through the Vancouver Breweries site

Along the 37th Avenue Greenway
- headwaters of Brewery Creek in Mountain View Cemetery on the north side of 37th Avenue
- Nat Bailey Stadium, originally Capilano Stadium, at Little Mountain (page 105)

Other related sites
- Henry Reifel house, 1451 Angus Drive
- J.W. de B. Farris house, 3351 Granville Street.
- Commodore Ballroom, 870 Granville Street
- Vogue Theatre, 924 Granville Street
- George C. Reifel Migratory Bird Sanctuary, Robertson Road, Westham Island, Ladner
- Bellavista Stock Farm, Milner, Township of Langley

In the early years of the city, breweries were neighbourhood operations established on suitable creeks, the beer delivered by horse and wagon along muddy roads to nearby homes. The usual price for delivered beer at the turn of the 20th century was $1.50 for a dozen quarts, during a

time when a working man might make $10 to $15 a week. Typical were the Cedar Cove Brewery near the north foot of Victoria Drive, the Stanley Park Brewery on Lost Lagoon at Alberni Street, and the Cedar Cottage Brewery on the Gibson Creek at the southeast corner of Knight and Kingsway.

To the west of Gibson Creek was Brewery Creek, flowing in a northerly direction on the east side of what is now Main Street; it created a bog known as the Tea Swamp at about 15th Avenue and then drained from it into the upper reaches of False Creek. In 1888, a waterwheel was put into the creek at 7th Avenue near Scotia, and breweries under a succession of names, including Red Cross and Doering & Marstrand, used the combination of mechanical power and water to make beer. Charles Doering's brewery controlled most of the Vancouver bars, the Europe Hotel in Gastown being a notable exception. The commemorative cairns following the path of the creek commemorate that history (page 81).

Doering sold out to a Nanaimo group headed by Bavarian-born brewer Henry Reifel, and went on to run the Hat Creek Ranch near Cache Creek. Reifel created Vancouver Breweries Ltd., which bought the block bounded by 11th, 12th, Yew and Vine in August, 1909. Its neighbours included a couple of sawmills, a shingle company, a tile and brick works, a dairy (Jersey Farms Ltd.) and a prefabricated house plant, all linked by spurs from the B.C. Electric Railway's Lulu Island interurban and freight line. The brewery's nine-story brick tower straddled the rail line and became a neighbourhood landmark (it was demolished but has been replicated as part of the new development there, with Salal Drive following the route of the tracks). The brewmaster's house stood on 11th Avenue, now the Greenway, while other tradesmen, including the fireman and the carpenter, lived in houses on the south side of 12th Avenue. The brewery, soon under the control of Reifel's son George Conrad, employed from 80 to 100 men during the 1910s through the 1930s. They brewed "Cascade— The Beer Without a Peer."

On 13th Avenue, modest houses survive from that period. A Model "L" BC Mills, Timber, & Trading Co. prefab bungalow from 1909, erected by D.W. Hutchison, stands at 2167 West 13th, with a double-bay-windowed bungalow from 1915 next door. The four identical houses across the street, at 2144 through 2158, were all built in the summer of 1913 by carpenter Robert Riley, likely with financing from the Dominion Trust Company, whose spectacu-

lar bankruptcy the following year almost brought down the provincial government. Isaac Dolby, the first owner of 2177, signed his water application with an "X."

Other nearby landmarks included Lord Tennyson School (1911), Kitsilano High School (1917), Connaught Park (1912) and the Connaught Grocery (1912) at Broadway and Vine, both named for the Duke of Connaught, Queen Victoria's third son and Canada's Governor-General from 1911-1916.

During British Columbia's experiment with Prohibition, from 1916 to 1920, the brewery kept operating by making "temperance beer," nevertheless containing four percent alcohol. After Prohibition ended in a flurry of scandals, the Reifels were the primary architects of the provincial government's beer distribution policy, in which "a few breweries operating by agreement among themselves . . . [distributed] the business by friendly arrangement." The deal was struck between the brewers and the Liberal Attorney-General, J.W. deB. Farris who, following his retirement from politics, served as the Reifel's lawyer before his appointment to the Canadian senate in 1936. Farris' brother Wendell was chief justice of the B.C. Supreme Court.

In 1924, three years after the Volstead Act had made the United States "dry," Henry Reifel purchased the B.C. Distillery in New Westminster. Soon, he built and bought other distilleries and formed the Brewers and Distillers Corporation, where he remained president until his sudden resignation on July 26, 1934. On August 1, Henry and George were indicted by the United States District Court in Seattle on charges that they had violated U.S. customs and tariff regulations by smuggling more than 2,000 cases of assorted liquors by radio-controlled speedboat into the United States. Although the indictment claimed more than $17 million in damages, the Reifels agreed the following July to settle out of court for $700,000.

Evidence of those free-wheeling years remains in the Reifel sons' Marine Drive mansions, "Casa Mia" and "Rio Vista," built in "Hollywood Spanish" style at the onset of the Great Depression, and the Commodore Ballroom downtown, built in 1929 because, according to one story, Mrs. George Reifel wanted a respectable place to dance other than the Hotel Vancouver. George Reifel built the Vogue Theatre in 1940 as an investment, and used the Westham Island property beginning in the 1930s as a country retreat; it

was formally dedicated by his son, George H., in 1965, as a bird sanctuary. Henry Reifel's second son, Harry, was best known for breeding Jersey cows, and his country retreat, Bellavista Farm with its picturesque (though recently modernized) cottage, is still a landmark on Glover Road in Langley.

Carling's bought out Vancouver Breweries in the 1950s and a subsequent merger made it the Carling O'Keefe Brewery. Molson's became involved in yet another merger in 1989, and the old brewery buildings were demolished in the 1990s and replaced with housing. Molson's first came to the west coast in 1958 when they purchased the Sicks' Capilano Brewery, built in 1950 at the south end of the Burrard Bridge and still there today. Fritz Sick and his son Emil from Seattle entered the Vancouver brewery business in 1932 with the purchase of the Vancouver Malt and Sake Company, which had agreed with the Reifels in 1927 not to brew beer for 15 years in return for a free hand in the sake market. The ensuing legal battle lasted for two years and was won by the Sicks.

17

Locarno to "North of Fourth"

Beginning near Locarno Beach, this walk ranges from the water to the heights, taking in a great variety of buildings along the way. The climb up 8th Avenue to the park at Discovery Street is long and fairly steep, but offers as a reward one of the best views of Vancouver, its harbour and the mountains. Flatlanders can skip that end of the walk by turning north on Highbury Street instead of south and returning to the starting point using either 4th Avenue or Jericho Park.

☞ Start at 2nd and Trimble

Prosperous times and the newly invented automobile attracted a few wealthy residents onto the unsettled Point Grey peninsula. "Aberthau," at 4397 West 2nd, is the earliest surviving home, built between 1909 and 1913 for J.S. Rear, the general manager of the American Life Insurance Company. Like the other three estates from those years—the E.P. Davis house (now called Cecil Green Park) and the Graham house at UBC, and Brock House (see below)—"Aberthau" was designed by the illustrious partnership Maclure and Fox, the architects of a number of very fine Arts and Crafts homes in southwestern BC. It was a fashionable stop on the social circuit during its ownership in the 1920s and 1930s by Col. Victor Spencer, a member of the Victoria-based family that owned Spencer's department stores (bought out by Eaton's in 1948—its building on Hastings Street is now SFU's Harbour Centre campus). After use as the officers' mess for the Pacific Command of the Royal Canadian Air Force during the war and subsequently by the RCMP, "Aberthau" was bought by the City and has been since 1974 the West Point Grey community centre.

☞ Walk north on Trimble toward Locarno beach; turn right onto the footpath at Marine Drive and walk eastward through the park toward downtown

Observe, as Trimble Street joins Marine Drive, the former military buildings a block to the east at Discovery Street (see below).

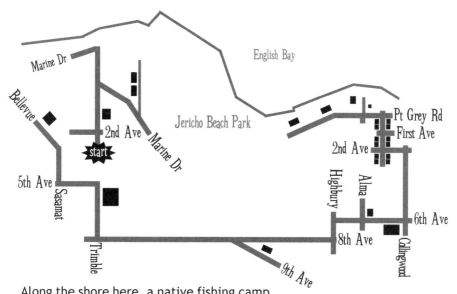

Along the shore here, a native fishing camp known as Ee'yullmough, meaning "good spring water," was occupied for about 2,500 years. A natural grassy clearing just to the east provided a break in the forest and waterfowl habitat that made it a good hunting ground. The name Spanish Banks, for the beach to the west of here, recalls the chance meeting in June, 1792, between Captain Vancouver's longboats (his ships, the Discovery and the Chatham, were left anchored at Birch Bay) and two Spanish ships, part of the Galiano expedition likewise engaged in surveying the coastline. The beach became part of the city's expanded park system late in the 1920s, Marine Drive having been completed before the war as "a scenic loop" around Point Grey. Locarno Beach got its name from the Locarno Pact of 1925, part of the efforts of the ill-fated League of Nations to ensure lasting world peace.

In its early rural years, around 1905, this district was known as Langara, named for the Spanish admiral. Until its demolition 20 years ago, a former feed and grain store stood at the corner of Belmont and Sasamat, a block to the west. On the logged-over headland leading to Point Grey, a man named John Stewart ran a dairy farm, his barn and home set on the "Plains of Abraham" between the first and second ravines west of Blanca Street.

The parkland along the beach east of Trimble and south to 4th Avenue had been set aside as a naval reserve in 1860, following the detailed

survey of Burrard Inlet the previous year by Captain Richards (which also reserved the Stanley Park peninsula for military purposes). On the slope to the south, the "best spars in the world" attracted logger Jeremiah Rogers, a New Brunswicker who had come to the west coast in the late 1850s to work with Captain Stamp, the founder of the Hastings Mill. His crews selectively logged Stanley Park and Point Grey, using as a base in 1865 a camp on the naval reserve. When he built his house there, the area became known as Jericho, either as a corruption of "Jerry's Cove" or of "Jerry & Co." The name first appeared in print in 1871 when the Chief of the Provincial Police, Tomkins Brew, cornered two murderers nearby in the "Battle of Jericho."

After Rogers' day, Jericho became a farm owned by J.M. Dalgleish, who leased it to the Vancouver Golf Club, founded in 1892 by Dr. Duncan Bell-Irving. Jericho thus became Vancouver's first golf course: nine sandy holes with a $35 fisherman's shack as the clubhouse, and access by rowboat or rented steam-tug. Abandoned in 1894 after a gale threw driftlogs across it, the land stood vacant until 1905, when McKiver Campbell purchased it and arranged a proper lease of 40 acres of the naval reserve. Rudyard Kipling played the new nine-hole course in 1907. It grew to 18 holes in 1924, when the club leased land south of 4th Avenue from the Provincial Government. Its clubhouse was a centre of Vancouver social life during the 1930s, but the course was abandoned when the Royal Canadian Air Force took it over at the outbreak of the war. The clubhouse burned to the ground in 1948.

There is really nothing left of the golf course, although you can imagine a couple of the back-nine holes from the trees on the hillside above 4th Avenue, but the military presence is still evident. Former RCAF buildings still stand at the corner of Discovery Street and Marine Drive, the 1937 barracks having become the city's youth hostel 30 years ago. Another is an arts centre, used primarily for theatrical productions. Seaplane hangars dating from the establishment in 1920 of the Jericho Air Station used to line the waterfront. Curtiss HS-2L flying boats landed and took off from English Bay, occupied mainly with aerial mapping, coastal patrols and chasing rumrunners intent on violating the United States' prohibition laws. In 1924, the base became headquarters of the Royal Canadian Air Force's Number One Operations Squadron, and in 1937 it became Western Air Command. The entire Jericho area, including all of the golf course, became the RCAF's Pacific Command base until the late 1940s. The eastern

end of the site is still headquarters for the Jericho Garrison of the Canadian army.

The city started to acquire the Jericho lands for a park in 1948 but, due to bureaucratic and political delays, didn't complete it until 1973. At that time, the hangars were still standing, and were imaginatively renovated in 1976 for Habitat Forum, the "people's" version of the United Nations conference on human settlement held downtown. Two years later, the first Jericho Folk Festival took place in the new park. In spite of increasingly loud protests, the Park Board removed the hangars to create today's unfettered landscape. The weeping willow trees, once a distinctive feature of Jericho Beach, have mostly been removed, too.

☞ Pass along the side of the Jericho Beach pavilion and turn left onto Point Grey Road

The large Arts and Crafts house on the beach side of the street is Brock House, originally known as "Thorley Park" and built in 1912. Its current name recalls its second owner, Reginald Brock, a noted geologist, dean of applied science at UBC (where he was namesake of Brock Hall), and commander of the first battalion of the Seaforth Highlanders. Brock and his wife were mortally injured in a flying boat crash on Alta Lake, near Whistler, in 1935, while returning from inspecting the gold mines at Bralorne, where his neighbour Victor Spencer held an interest. Now owned by the City, Brock House is a seniors' centre.

Past the lawn-tennis club, the Royal Vancouver Yacht Club occupies the shoreline, its moorage one of the few barriers to pedestrian access along English Bay. Founded in 1903 with a clubhouse at the foot of Thurlow Street on Coal Harbour, RVYC moved to Jericho in 1927. Many members still use moorage and boathouses that clutter Coal Harbour along its Stanley Park edge. The fleet numbers more than a thousand, evenly divided between sail and power boats. Perhaps its most famous commodore was the sugar refinery-owner B.T. Rogers, whose steam yacht *Aquilo* became the support ship for Premier Richard McBride's bizarre "navy" (consisting of two Seattle-built submarines) at the outbreak of the First World War.

The grassy sward between RVYC and Alma Street is known as Pioneer Park, reflecting the surprising presence there of the Hastings Mill Store. Constructed about 1865 on the Hastings Mill property at the foot of Dunlevy Avenue east of Gastown, the building became an orphan in the late 1920s

when Hastings Mill closed. In 1930, the Native Daughters of BC floated it on a barge through the First Narrows and reestablished it at the foot of Alma, where it remains today as a museum. It was Vancouver's first post office, library and community centre.

☞ Turn left on Alma, then right on Cameron Avenue, then recross Point Grey Road at Dunbar

There is little that is historic on Cameron Avenue's single block, other than the small house at 3690, probably built about 1905 and the last survivor of English Bay's summer cottages—retreats for Vancouverites from the heat and smoke of the city. It was connected to the water system only in the 1920s. By the time Front Street was renamed in 1911 for alderman William Cameron, Kitsilano was a rapidly growing neighbourhood with streetcar service just a few blocks away (the city banned camping on Greer's Beach, now Kitsilano Beach, only in 1908). The most dramatic of the new houses stands at the eastern end of the block on the water side, built for contractor Alvin Narod in 1973 and very controversial at the time because its footings sit on the public beach rather than higher up on the bank.

At the corner of Cameron and Dunbar, look east along the shoreline toward downtown. The rocky, log-strewn foreshore between here and Kitsilano Beach has its discreet nudists on summer days, and on summer evenings Greeks wade just offshore gathering smelt with nets. Note the retaining walls of the luxurious houses lining Point Grey Road. The foreshore almost fell victim to a plan, touted by mayors Bill Rathie and Tom Campbell as a suitable 1967 Centennial project, to build an "Ocean Boulevard" for unimpeded automobile access between West Point Grey and downtown.

A remarkable set of Craftsman houses—some of the most beautifully finished buildings in Vancouver outside of Shaughnessy Heights—lines the two blocks of Dunbar Street between Point Grey Road and 2nd Avenue. All were under construction during 1911 and 1912 by contractor Samuel W. Hopper, who built 1710 Dunbar for himself. In order of completion, they are 1724 in March, 1912; 1710 and 1717 in June; 1711 in September; and 1631 and 1661 in December. Although all were erected as single-family homes, most soon became rooming houses or were divided into suites, spurred by the housing shortage during World War Two. Because most of the "basement suite" conversions in Kitsilano were done illegally, it is hard to tell ex-

actly what happened when, but city permits document some of the changes that made Kitsilano a bastion of affordable housing, beginning in the 1950s for university students and, in the 1960s and 1970s for hippies. For example, 1631 was divided into four suites by 1957 and 1661 was home to "over 2 families" in 1961; 1710 had two families, one roomer, and two rooms to rent in 1940; 1717, the only one of the group not yet completely restored, housed three families in 1942. Hopper's own home had one family and 5 roomers, likely UBC students, in 1961. Hopper also built 1742, 1748, 1731 and 1741 Dunbar in 1911-1912. (The following year, he moved on and built 1955, 1965 and 1985 West 14th and 2046 West 13th in the "Talton Place" subdivision.)

☞ Turn left and walk east on 2nd Avenue, then turn right and head south on Collingwood

Every block in this neighbourhood, dubbed "North of Fourth" by its current residents, has interesting houses and gardens. A standout is the home at 1847 Collingwood, built in 1911 by the Harrison Brothers contracting firm (Ernest and Arthur Harrison lived at 1656 Parker in Grandview). The next owner was John McNiven, proprietor of the Alhambra Hotel in Gastown. After 55 years of occupation by the Abbott family, the house was bought almost 20 years ago by Basil Stuart-Stubbs and Brenda Peterson; the latter's splendid cottage garden is a neighbourhood icon, and has been featured in many garden magazines and programs.

In 1907, James Quiney became the first resident in this part of Kitsilano; his house stood in the forest at what is now the northeast corner of 4th and Dunbar. He had a bear cub for a pet, which he later donated to the zoo. Previously, he and his family tented at the foot of Balaclava Street, using the ancient trail along the bluff, now Point Grey Road, to transport groceries from the city. Quiney moved in 1909 to a small bungalow at 1820 Waterloo and began selling real estate for Robert Rorison, whose still-extant house is 3148 Point Grey Road. Quiney's bungalow was demolished in 2002, and his original house disappeared in the 1950s.

Cross 4th Avenue—there's a good "cybercafe" on the south side of the street if you feel the need to check your email at the mid-point of the walk. McBride Park, between Collingwood and Waterloo, is named for B.C.'s second-longest-servicing premier, Sir Richard McBride, who introduced party politics into the chaos of the BC legislature when he won the 1903 election and continued in office through the boom years, a depression, and the start of the First World War until his resignation in 1915.

☞ **Turn right at 6th Avenue and walk west**

Bayview is another of the set of handsome 1910-1914 brick schools that still grace Vancouver. It has been a "community school" since the 1970s, reflecting the non-conformist nature of many Kitsilano parents.

Alma Court, at the corner of 6th and Alma, is one of the Spanish Colonial "wedding cakes" in the city. A 19-suite apartment building, its construction commenced just as the Great Depression was beginning to bite. Designed by architect J.T. Alexander for engineer and developer H. Bellinger, it was completed in the summer of 1931.

Highbury Street, a block to the west of Alma, is the boundary of the Jericho army base. The modest family houses there, built in the 1940s and 1950s, are a stark contrast to the lushly gardened and ornamented houses on the surrounding blocks.

☞ **Turn left on Highbury and walk south to 8th, then turn right and walk up the hill**

The western extension of Broadway, a block to the south, is called 9th Avenue, and is curved to fit the contour of the hillside so that it meets 8th Avenue at an acute angle. Note the fine plane trees on the south boulevard of 8th; a magnificent double-row of them also lines 9th. At the corner where 8th and 9th meet, walk around to admire the faux Cotswold cottage at 3979 West 9th. Built by Brenton Lea in the early 1940s, it was apparently one of several, the other well-known survivor standing at 587 West King Edward. According to an oft-repeated rumour, the versatile architect Ross Lort helped with the design.

The view across the city to the harbour and mountains gets ever-more spectacular with each step westward. On the slope below 8th Avenue, the West Point Grey Academy (a recently established private school) and buildings of the old Jericho School for the Deaf and Blind spread across the former back nine of the Jericho golf course. All this land is the provincial government reserve dating from 1860. The first institutional use of the property was the Jericho Boys Industrial School, established in 1904, a reform school needing an isolated location; however, by 1920 the area had become too populated and the school moved to Coquitlam. Two years later, the school for the deaf and blind opened.

☞ Turn right and walk north on Trimble, then turn left on 5th and walk to Sasamat

At the crest of the hill, on Trimble, note the lawn bowling club with its charming clubhouse, and Queen Mary School, a 1914 design by architects Twizell and Twizell.

Sasamat Street is wider than the other north-south streets in the area because of the streetcar line, finished in 1910, which connected West Point Grey with Kitsilano: the line branched off from the Dunbar Heights line at 10th Avenue, climbed the hill as far as Sasamat, turned north, then continued west on 4th Avenue to Drummond Drive. Like all of Vancouver's streetcar routes, it disappeared in the 1950s.

☞ Walk north on Sasamat, then veer left onto Bellevue Drive

The vestiges of Sasamat Ravine lie below the road here. Bellevue Drive is part of a two-block subdivision developed in 1927 for Westmount Lands Limited. The significant house is "Kania Castle," at 4585 Bellevue, built in the middle of the Depression by stockbroker Joseph Kania and acknowledged as one of the best Vancouver examples of the Spanish Colonial style. Since its recent purchase by nurseryman and "garden guru" Thomas Hobbs and designer Brent Beattie, palms and other exotic flora have given it a tropical feel, and it has been repainted from its original white to a rich terracotta (Hobbs believes that a white house looks like a giant refrigerator in a garden).

From the triangular edge of "Kania Castle's" lot, walk eastward downhill to "Aberthau" at 2nd and Trimble—an English country house a block from a Los Angeles one.

18

Kitsilano

T he blocks of Kitsilano on either side of Macdonald Street north of Broadway are a well-preserved area of modest, middle-class housing from the years between about 1910 and 1925. To the east, due to apartment developments since the 1950s, few interesting blocks survive. Not surprisingly, the middle-class nature of Kitsilano becomes less apparent close to the beach, where a number of luxurious estates have existed since the turn of the 20th century.

Historically, the significant dividing line in Kitsilano is Trafalgar Street, originally called Boundary Road as it separates the Canadian Pacific Railway's 1884 land grant to the east from the lots owned by individuals which were developed in a more haphazard way.

In 1905 the CPR sought a name for its new suburb in the southwest part of what was then the City of Vancouver (the southwestern boundary of the city was Alma and 16th); it consulted with prominent citizens before deciding on "Kitsilano," after the legendary Chief Khahtsalanough of the local Squamish first nation. At the time, Khahtsalanough's grandson August Jack still lived at the village of Sun'auk on Kitsilano Point.

☞ Start at the corner of Broadway and Macdonald and walk north toward the beach

Streetcar service, an essential element of real-estate development a century ago, began in 1909 on 4th Avenue and in 1911 on Broadway, until that time known simply as 9th Avenue. Reflecting the prosperity of the times and the number of people moving to Vancouver, a great number of houses went up in a very few years, giving a consistency to the streetscapes unusual for such a boom-and-bust city. The long row of—at first glance—identical rooflines stretching down the east side of Macdonald Street between 7th and 5th avenues is very evocative of old Vancouver.

The four houses occupying the southern end of the block between 6th and 7th are examples of the Edwardian Vernacular (or "Vancouver Box")

style, and were completed early in 1912 by the carpenter Joseph Nixon. They are symmetrical, upright, rather formal houses, with the eaves surrounding the gable forming a well-defined triangle and a neat little pediment above a stoop at the front door. It was an out-of-date style, whereas the 12 houses occupying the narrow lots between Nixon's quartet and 5th, all built by the contractor/carpenters Lockie and Miller in 1911, were more fash-

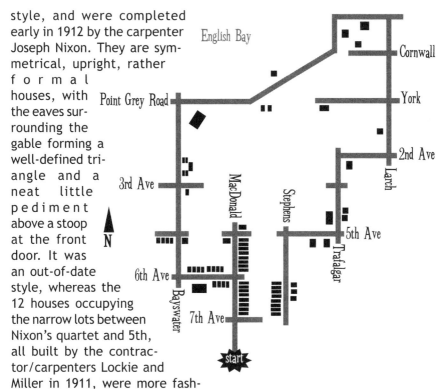

ionable. Note the hallmarks of their Craftsman style: decorative brackets along the eaves, wooden posts on full-width porches, exposed rafter ends and shingle siding (in some cases now covered with asbestos siding or stucco).

Two other Craftsman houses, at the southwest and northeast corners of 5th and Macdonald, are a variation usually called the Swiss Cottage or Swiss Chalet: their side gables and the rough clinker bricks set into the chimney add a rustic touch.

Turn left on 6th Avenue and walk west

The block of 6th west of Macdonald is an excellent example of the patchy development characteristic of Vancouver in the early years of the 20th century. A row of tall, pre-World War One houses lines the north side of the street to about mid-block; low bungalows from the 1920s and later

dot the south side; General Gordon School, built in response to the population boom just before World War One, was named for the British soldier Charles George ("Chinese") Gordon, killed at Khartoum. Builder John J. Keenlyside erected 2825 and 2831 West 6th in the summer of 1913—their hipped roofs and half-timbering on the upper storeys show the influence of the Arts and Crafts style.

2837, 2841, 2851 and 2855 West 6th were built in 1911 and 1912 by carpenters Thomas and William Pettigrew; they evidently sold the easternmost pair to finance the construction of 2851, where they subsequently lived, and 2855, which they also sold. 2837 and 2841 show Queen Anne influences, with their narrow eaves, tall windows, off-centre bay windows on the second floor, and oval glass doors, while the two later houses are slightly more fashionable, with Craftsman-style heavy wooden brackets. The elaborate Ionic columns on 2855 were added to the house by an early owner.

The Queen Anne style dates from an era before electric lighting became universal. The adaptation of the Craftsman style—California houses for bright light and hot climates—to northern climes was possible due to the availability of electric light. The main stylistic difference between Vancouver's (or Seattle's) Craftsman houses and the ones built in California is the height of the main floor, the former needing full basements for furnaces and fuel (coal or sawdust) storage, the latter typically sitting at ground level.

Other interesting houses on the block include a 1920s Tudor hybrid at 2869, a stucco-sided starter house from the 1930s at 2875, an early-1980s townhouse on the site of a grocery store at the corner of Bayswater, and a mid-1980s duplex with a large front-entry garage at 2861 to 2863. Everything more or less fits except for the duplex, which gives too much attention to the automobile in what is otherwise a street of pedestrians and gardens.

☞ Turn north (right) at Bayswater and walk to 5th Avenue

Note the Queen Anne at 2926 West 5th, built in 1911 for William Warner.

To the west of Bayswater, California Bungalows from the early 1920s line both sides of 5th Avenue. These simple houses reflected the "Pasadena lifestyle" that drew throngs to Southern California. Low-pitched roofs, solid porch posts, broad front porches and open-plan living areas—these

are practical houses set in manageable gardens. Note the mixture of sur-faces on the unrenovated houses: clinker brick on the porch posts and chimneys, textures of wood in the shingling and brackets, and carved bargeboards—all Craftsman features. Many have individual touches, such as the Japanese-inspired pointed peak and rounded brackets on 2970 West 5th Avenue, built in 1919 by Fred Melton. (In California, such rounded brack-ets and bargeboards were elements of the "airplane bungalow" style—two good Vancouver examples are in Kerrisdale, at 6592 Maple Street and 6795 West Boulevard.)

Melton, a Cornish-born contractor whose name survives on Melton Court at 2310 Cornwall, built the five houses to the west of the Bayswater corner between 1919 and 1921. The firm of Cook and Hawkins built the next six to the west, numbered 2980 through 3040, in 1921. A couple of them have been altered: in the 1970s, an iconoclastic owner modified beyond all recognition number 2996; in the early 1990s, in an attempt to retain the house but add some floorspace with a sympathetic modification, the owner of 3010 added a partial second storey.

☞ Continue north on Bayswater toward the beach

Development pressure has taken its toll on the small houses in this part of Kitsilano, although many new buildings attempt to fit in. Spaceworks Ar-chitects designed the turreted wooden duplex at the southeast corner of 3rd and Bayswater in the early 1980s while retaining in the backyard a 1909 cottage. Another infill house is 2890 West 3rd, designed in the late 1980s by Stuart Howard Architects.

Tatlow Court, at 1820 Bayswater. is a Tudor version of the bungalow courts that became very popular (sometimes as "auto courts") in western North American cities, especially Los Angeles, around 1920. Designed in 1927 by Richard Perry for developer H. Rosenblat, the president of a local Chrysler dealership, Tatlow Court arranges its practical, small homes in a "U" around a courtyard. Because of the lushness of the garden in the central court it is difficult to see the buildings surrounding it: there are four side-by-side duplexes, two on the north side of the court and two on the south, and a fourplex at the east (rear) end.

Immediately adjoining Tatlow Court's northern boundary is a stone wall surrounding a substantial 1950s apartment building; the wall dates from

1908 and the construction of "Killarney," a fine home on two-and-a-half acres built by John and Jessie Hall. He was the city's first notary public, and parlayed his early arrival in Vancouver, in 1885, and his real-estate and business acumen into a considerable fortune. His wife Jessie contributed to the city through charitable work and Conservative politics; her father, Sam Greer, unsuccessfully fought the CPR for title to Kitsilano Point, where his name is remembered in Greer Street, and went to jail in 1891 after shooting the sheriff sent to evict him (but he did not shoot the deputy).

 Walk eastward (toward downtown) along Point Grey Road

The park to the east of "Killarney" bears the name of Robert Garnet Tatlow, a member of the city's first park board who subsequently, until his death in 1910 when the horse pulling his carriage bolted, was a prominent businessman in fishpacking with the Bell-Irving family and a provincial Conservative politician—the minister of finance in the McBride government.

Note the two old houses with corner turrets behind the triangular "lamb chop" just east of Tatlow Park. 2830 West 1st is more or less intact, while its copy next door at 2840 is hidden beneath a muff of stucco.

The open lawn across the street from Tatlow Park has been created in the last 30 years since the demolition of some fine homes. The city's first official plan, by Harland Bartholomew in the late 1920s, recommended clearing all the buildings from the north side of Point Grey Road (and constructing Burrard Bridge) to create a grand automobile route to West Point Grey. "Seagate Manor," designed by Thomas Hooper for a lumber-company owner, occupied the land there until the late 1970s. Over the years, the city has purchased a number of lots along Point Grey Road to open up views and create small parks, but has never been able to muster the political will or cash to clear all the houses away, including the one occupied by Army & Navy owner Jacquie Cohen.

Remains of the stone wall along the north side of Point Grey Road beween Stephens and Trafalgar attest to the existence of "Edgewood," a very fine home built in 1904 by pioneering realtor T.H. Calland and demolished in the 1940s. The 1908 Ells House stands on the high side of the road on the flatiron lot formed by Stephens, Point Grey Road and York Avenue.

Observe on the hillside above the brick Wellington Apartments at Trafalgar and York Avenue. As it is west of Trafalgar, it was just outside the CPR's Kitsilano lands, where development was tightly controlled in the early years.

The first house built on the CPR lands along Cornwall Avenue is the Roy MacGowan house at 2575 Cornwall—a fine Colonial style building. Like "Edgewood," it was built in 1904, the year before streetcar service began from downtown to Kitsilano beach. MacGowan, with two brothers, ran a successful shipping and insurance business.

☞ Walk north (toward the beach) on Trafalgar, then east on Point Grey Road

At the foot of Trafalgar Street on a large lot, the W.H. Forrest house at 2590 Point Grey Road, built in 1908, could be a Shingle-style house in Massachusetts or Rhode Island.

Below Point Grey Road, a pathway cut into the bank connects the foot of Trafalgar with Kitsilano Beach. It is in fact the old railway roadbed for the CPR, which laid tracks to the western end of its land grant around 1900 when it was considering building a deepsea port at the tip of Point Grey (its other plan, to build a terminal on Kitsilano Point, was also terminated). Instead, in 1905 the BC Electric Railway took over the CPR railway tracks that crossed False Creek on the Kitsilano trestle and began regular streetcar service between downtown and the foot of Vine Street, helping create Kitsilano Beach as a popular summertime destination and making nearby building lots attractive for potential commuters.

The big Craftsman at 2530 Point Grey Road is a Honeyman and Curtis design built for Matthew S. ("Sea Wall") Logan, a lumberman who, as a park commissioner from 1916-1919, advocated the building of the Stanley Park seawall. A later occupant, General Victor Odlum, was the son of Edward Odlum of Grandview (page 85) and a noted soldier, politician, newspaper publisher and Prohibition advocate. The houses on either side, both 1970s infills, occupy its original gardens.

☞ Walk south (up the hill) on Larch Street

Cross Cornwall (looking both ways first) and walk up the hill past York Street, named for an uncontroversial Duchess of York, later Queen Mary, who visited Vancouver in 1901. This area began to convert from old houses and rooming houses into apartments in the 1950s, with highrises appearing

in the 1960s. Following vociferous protests in early 1974 against the tower called "Carriage House" at 3rd and Balsam (dubbed "Miscarriage House") and a proposal for a highrise on Cornwall, the city put a height limit on new buildings.

The 1908 Stearman House, at 2500 West 1st, retains its period look—complete with monkey puzzle tree, Araucaria araucana, a Chilean import common to Edwardian gardens—in spite of its conversion into suites and the construction of a connecting infill building in the 1970s. Stearman was a pioneer hardware merchant with a penchant for picturesque advertising, such as the sign on his Granville Street hardware store featuring a neon cow and the number "4" above his name: "Steer for Stearman's."

☞ Walk west on 2nd Avenue, then turn south (left) on Trafalgar Street

The Craftsman-style Mills house at 2590 West 2nd and the turreted 1911 Queen Anne at 2556 West 3rd, visible from Trafalgar, are two of the fine early houses remaining in this area.

Trafalgar Street between 4th and 5th again shows the differences in development on either side of the CPR boundary. On the CPR side, inspect the two 1911 houses built by the carpenter John McLeod at 2054 and 2060 Trafalgar, the latter having an elegant semicircular porch. The apartments across the street—the Panama Apartments and Panama Annex—were both built in 1911 by a contractor named George Robertson, who lived a half-block away at 2651 West 6th Avenue. A small grocery store once occupied the main floor of the apartment building at the corner; it and a half-dozen other small grocery stores within a few block radius have disappeared in the past 25 years, unable to compete with the 7-11's and other convenience stores attached to gas stations.

☞ Walk west on 5th Avenue, then south on Stephens Street

The restored 1913 Craftsman at 2622 West 5th was painted in its original colours through the Vancouver Heritage Foundation's "True Colours" program. The modern front-back duplex at 2646 to 2648 West 5th, which replaced a cottage, blends with the streetscape but unfortunately fills up the back yard.

Stephens Street between 6th and 7th, and the adjoining blocks of 6th Avenue and Macdonald Street, form one of the best heritage enclaves in

the city. (Stephens stood in for a Seattle street in the 1987 film "Stake Out.") The oldest house on the street is 2234 Stephens, completed late in 1911 by Island Investments, a company controlled by a building superintendent named Daniel C. Kay. Operating under that company name, Kay completed 2238 and 2242 Stephens early in 1912; the same year, under the banner of another of his companies, Canada West Developments, he built the remaining five houses on that side of the block. The eight houses across the street, all variations on the "Swiss Cottage" style, were built during the summer of 1912 by the contractors Bentley and Wear. In the 1970s this was a "funky" street—most of the houses divided into suites and rooms with Beetles and Volkswagen vans lounging against the curb— but it has since been restored and gentrified, having come full circle back to its respectable middle-class beginnings.

19

Delamont Park

he block bounded by Arbutus, Maple, 6th and 5th in Kitsilano was fairly typical of Kitsilano until the 1960s, when apartment redevelopment changed the face of the neighbourhood. Since then the block, now generally known as Delamont Park, has become extraordinary—the last survivor in that part of Kitsilano of the settlement at the beginning of the 20th century.

In the 1950s, the city bought up most of the properties as part of a land assembly for an arterial roadway to be called the Burrard-Arbutus Connector, one of the freeway-type links intended to pave the way for automobile commuters into downtown Vancouver via the Burrard Bridge. The connector was to follow the route of the old B.C. Electric Railway interurban on the slope from 6th and Burrard to Broadway and Arbutus. The interurban line, which operated from 1905 to 1952, was originally a branch of the CPR chartered in 1891 as the Vancouver & Lulu Island Railway, surveyed in 1900 and operated from 1902 to 1905 as a steam line to Steveston dubbed the "Sockeye Limited." It was used for freight for the past half-century.

By the time interurban service began there were a number of houses in the area, owned by people who walked to jobs along industrial False Creek or used the "Fairview Belt Line" streetcar at Granville Street to get downtown. There were two interurban stations in Kitsilano, at Broadway and at "Millside" (4th and Fir) but the trains terminated at the north end of the Granville Bridge rather than proceeding all the way downtown. (According to the 1908 timetable, Steveston was only 37 minutes away from the Broadway station!)

The plan for the roadway, along with the rest of Vancouver's freeway schemes of the 1960s and early 1970s, foundered on the shoals of pro-environmental, pro-neighbourhood public sentiment, expressed in the civic election of 1972 that brought in the reform council led by Mayor Art Phillips. Believing that this part of Kitsilano was short of open space,

the city then decided that the assembled houses could be demolished to provide parkland. A small area along the railway tracks, between 7th and 6th, was developed as Delamont Park, named after Arthur Delamont, the long-time leader of the Kitsilano Boys Band. But, as was the case with the Mole Hill area in the West End, no political will emerged to uproot tenants of the city-owned houses. The Delamont Park area remains in a sort of limbo today.

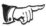 Start at Arbutus and 6th and walk east, circumambulating the block counterclockwise

The Arbutus Grocery, with its "boomtown front," is a 1907 building erected by Thomas Frazer, who had lived on the block since 1901 when he built a house next door at 2084 West 6th. His original house was probably a cottage, replaced about 1920 by the California Bungalow now on the lot. Frazer indicated on the water-permit application for the store that he would be using the water for a cow or a horse—probably the latter, for pulling a delivery wagon. A man named J.R. Murphy owned the 1901 house at 2078 West 6th. The house with the interesting porch across the street at 2085 West 6th was also built in 1901, for C.F. Jones. Other houses on the block are the Church house at 2075 to 7; the decorated cottage at 2059 built in 1913, a throwback to Victorian-era houses; and the bungalow at 2055, a very up-to-date design when it was built in 1905. With its daycare centre and allotment gardens, and the "City Farmer" demonstration gardens at 6th and Maple, the block has the cultural overlay of the 1960s and 1970s hippie era, when Kitsilano was Haight-Ashbury North.

Maple Street and 5th Avenue have a lot of spec-built houses, including the four on the east side of Maple Street, built by brothers John, William, Lewis and Norman Vernon in 1912. 2020 West 5th is the oldest house on the block, built in 1900 for a labourer named Thomas Brownlee and modernized since. A carpenter named Roy Cowan built 2032 and 2038, and the Vernon Brothers built 2062 and 2068, in 1910.

The grandest house on the block is the elaborate Queen Anne-style house at 2090 West 5th, built in 1905 for lumberman J.F. Boyd.

Boyd's neighbour to the south, carpenter Roland Scarlett, managed to cram three buildings onto his single 50 x 120 foot lot. He built 2134 Arbutus in 1901 and 2128 in 1907, then shoehorned the curious apartment building with its bay windows and wooden parapet onto the remaining

30 x 50 foot piece in 1910. Compare Scarlett's two houses with the Murphy house at 2078 West 6th; perhaps Scarlett built all three?

The block is also interesting for its views, especially the one looking east down the gentle slope of 6th Avenue from Arbutus. With the old houses, stone walls and period fences, the gravel swales on the edge of the curbless roads, and the railway crossing, the tableau is very evocative of old Vancouver.

20

Shaughnessy Heights

The most splendid collection of houses, gardens and trees in the city occupies the blocks south of 16th Avenue on both sides of Granville Street. Known as Shaughnessy Heights, Old or First Shaughnessy, or sometimes just Shaughnessy, it has been home to Vancouver's "old money" since the First World War years. It was a time of prosperity and ostentation, and of superb craftsmanship and love of architectural detailing. There have been rich people's suburbs since, but none approach Shaughnessy for the quality of construction or the lavishness of the landscaping.

Although there are now many areas of Greater Vancouver with curving streets and boulevards that follow the contours of the land, Shaughnessy Heights was the first. Its namesake was CPR president Sir Thomas Shaughnessy (1853-1923), a Milwaukean knighted in 1901 and named Baron Shaughnessy of Montreal in 1916. Many of the streets, some of which the walk follows including Osler, Matthews, Angus and Marpole, were named for CPR directors. A Montreal landscape architect and advocate of the Garden City movement named Frederick Todd worked with engineer L.E. Davick to lay them out. Since 1981, Shaughnessy Heights has had a special zoning and development bylaw, together with a design panel that has attempted to preserve the area's historic ambience while permitting infill coachhouses and sympathetic new homes.

Journalist Allan Fotheringham once quipped that Shaughnessy has a population density of six per acre, four of whom are gardeners. Few of the denizens emerge from their private enclaves, leaving the sidewalks clear for walkers and gawkers. It is like strolling through a splendid park, having it mainly to yourself because most ambulatory Vancouverites seem to prefer to jostle each other and dodge cyclists along the seawall. The walking tour below covers some of the historic buildings while addressing the challenge of crossing Granville Street without getting flattened by a speeding SUV.

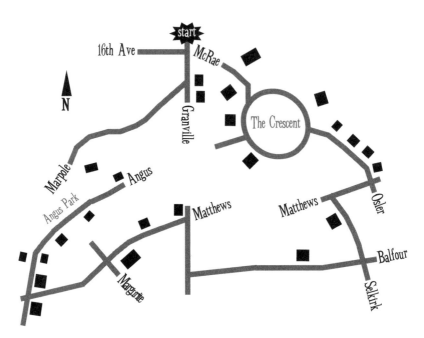

Start on the east side of Granville Street at 16th Avenue

Walk east, following the curve of McRae Avenue up the hill. The man-
sion—no other word fits—behind the wall is "Hycroft," since 1962 the home
of the University Women's Club. General Alexander Duncan McRae's busi-
ness was land colonization on the Canadian prairies. He came to Vancou-
ver in 1907 with an extraordinary $9 million fortune. His was among the
first Shaughnessy houses, begun in 1909 on five acres by the architect
Thomas Hooper, and he is the only resident to have his street named for
him (his was the only home on it). McRae served as quartermaster-gen-
eral for the Canadian army during the First World War, and had extensive
interests in fishing, lumbering and politics, including an abortive attempt
in the mid-1920s to lead a conservative "reform" movement called the
Provincial Party. He subsequently became a senator, but left "Hycroft"
behind for his "Eaglecrest" estate at Qualicum Beach. A legendary party
house in its day with a ballroom in the basement, "Hycroft" became a
military hospital during the war—an annex to old Shaughnessy Hospital on
Oak Street. There is an excellent garden started by his first wife Blanche,
including huge Sequoia, Atlas Cedar and Copper Beech trees visible from
the street.

Near the top of McRae, look right to see the Walter C. Nichol House, an "English country manor" by architects Maclure and Fox, built in 1911 for the Province publisher and future lieutenant governor. Its address is 1402 The Crescent. Walk west a couple of doors to 3351 The Crescent, the former Japanese consul's residence, purchased in 1926 for $35,000 and seized by the Canadian government following the outbreak of the Pacific war in 1941.

The houses lining The Crescent look out onto a park which is in effect an arboretum, with nearly 50 species of trees. Walk across its western edge to view "The Hollies" at the corner of Hudson and The Crescent. A very American, Classical Revival sort of house, it was built for railwayman George MacDonald and later owned by construction company and mining executives. For a time, it operated as a fashionable hall for wedding receptions, until slapped by an injunction by the property owners association, which steadfastly guarded the area's single-family zoning, even during the Second World War when the city was in the midst of a housing crisis.

Walk east (counterclockwise) following the line of horse-chestnuts to "Villa Russe" at 3390, just past Osler. Built for Misak Aivazoff, an expatriate Russian who made his money in construction, the house hosted many parties for visitors such as Sergei Rachmaninoff, whose tours included Vancouver concerts. Dal Grauer, the last president of the B.C. Electric Company, occupied the house from the late 1930s until his death in 1961 a few days before the provincial government took over the power utility and created B.C. Hydro. It was recently offered for sale for $6.8 million.

Walk south on Osler

There is a mix of housing, including some modest postwar infills, on the block between The Crescent and Matthews. New houses include 3402 Osler, which mixes Chinese and Craftsman flavours. (More substantial new houses include 3639, 3590 and 3688 Osler in the next block south.) Two prominent Liberal politicians occupied, at different times, 3450 Osler: Malcolm Macdonald's scandal-plagued tenure as the province's attorney general did not preclude him from becoming Chief Justice two decades later; John Hart, the premier during the Second World War and namesake of the highway in northeastern BC, also lived there. "Iowa," at 3498 Osler, was the home of American lumberman Frank Buckley—it is a rare Vancouver example of the Gothic Revival style.

☞ Turn right and walk west on Matthews, then turn left on Selkirk

The value of a privately-owned liquor business is demonstrated by "Rose-mary," the rambling manor house at 3689 Selkirk designed by Maclure and Fox and constructed during 1913-1915. Its owner was a young lawyer, Albert Edward Tulk, who named the home after his daughter. Note the charming garden cottage at the Matthews Street end of the property and the *Sequoiadendron Giganteum* in front of the house. Prohibition from 1916-1920, followed by government liquor control, ended Tulk's business. A later owner was J.W. Fordham Johnson (nicknamed "Can't Afford'em Johnson"), interim president of the B.C. Sugar Refinery following the premature death of Blythe Rogers, and later lieutenant governor. For many years until recently, "Rosemary" was the Retreat House for the Convent of Our Lady of the Cenacle. Infill construction by architect Richard Henriquez occupies part of the original grounds.

☞ Turn right on Balfour and walk west

Named for the British prime minister at the beginning of King Edward VII's reign, Balfour Street is decidedly less grand than the other streets on this walk. Its finest house, "Duart," survives only through its incised gateposts, at 1337 Balfour. The long-time home of lumber tycoon H.R. MacMillan, it was razed in 1977, the year after his death, and subdivided into three lots. Even his company MacMillan-Bloedel, for generations a mainstay of the BC economy, has disappeared following its purchase in 1999 by the American Weyerhauser company.

☞ Cross Granville on the crosswalk at Balfour, walk north on Granville to Matthews, turn left and walk along Matthews

The big Craftsman at the northwest corner of Granville and Matthews, 3589 Granville, is usually called the William Walsh House, after its first owner for whom it was designed in 1912, and is unusual for its iron roof-cresting. A later occupant was Frederick Begg, who with his brother Frank operated Begg Motors, the first car dealership in Vancouver. Lawson Oates, who became the firm's general manager in 1944, later formed a Chrysler Dodge dealership that was a landmark of sorts at Kingsway and Main in Mount Pleasant.

1563 Matthews, a house with beautiful "eyebrow dormers," was home to W.C. Shelley (page70).

Where Matthews meets Marguerite, lumberman W.L. Tait's "Glen Brae" rises above the lesser homes. It is now known as Canuck Place, a children's hospice supported by the Vancouver hockey team. Designed by Parr and Fee in 1910, it was something of a white elephant during Vancouver's rollercoaster economy in the post-World War One years. The Ku Klux Klan occupied it in the mid-1920s, then for generations it was a nursing home, often called the "Mae West House" due to its twin turrets. Its bequest to the city in the early 1990s, with the intention that it become a cultural centre, antagonized its influential neighbours, who finally accepted the hospice as a compromise use.

The house at 1789 Matthews, fronting onto Angus Drive, was home to Ernest Rogers, the president of the B.C. Sugar Refinery following J.W. Fordham Johnson's retirement in 1930. He was refinery-founder B.T. Rogers' second son (B.T. Rogers died in 1918 at age 53 and eldest son Blythe died just before his 27th birthday of illness prompted by a wartime accident). The house was nicknamed "Peterin," a takeoff on the name of his Bowen Island property "Peterout"—his relatives had believed his enthusiasm for a rural property would peter out after a few years. Ernest Rogers drowned off his yacht in 1939 in his 42nd year.

The impressive stone-faced house on the south side of Matthews at 3802 Angus is another Maclure and Fox design. Its owner, John Hendry, controlled the Victorian-era equivalent of MacMillan-Bloedel—the B.C. Mills, Timber and Trading Company, which ran the historic Hastings Mill and prefabricated houses. Hendry was also the front man of a syndicate tied in with the American Great Northern Railway system, the bitter rivals of the Canadian Pacific's Kettle Valley Railway. (Walk a block farther west to see the house, at the northwest corner of Pine Crescent and Matthews, where Hendry's daughter Aldyen lived during her widowhood. It backs onto "Greencroft," 3838 Cypress Street, where she lived with her husband Eric Hamber—banker, head of the family's lumber interests, UBC chancellor, lieutenant governor and namesake of the highschool at Oak and 37th. Their decision to marry in London in 1912 caused them to cancel their passage on the maiden voyage of the *Titanic*.)

Turn right and walk north on Angus Drive

With its central boulevard that opens into a wider park, Angus Drive is the western twin of The Crescent and Osler Street on the east side of

Granville. It was named for Richard B. Angus, president of the Bank of Montreal and a CPR director. He was the eighth of twelve children born in Bathgate, Scotland; the family moved to a town near Manchester but failed to prosper, whereupon the three eldest brothers—Forrest, Richard and James—pooled their money to send Richard, shrewdly acknowledged to be the brightest and most enterprising of them, to Canada to seek his fortune. Richard later encouraged the rest of the family to emigrate. James' daughter Mary Isabella became Mrs. B.T. Rogers; his youngest brother's only child Henry became a prominent academic, namesake of the Henry Angus building at UBC.

Mrs. B.T. Rogers spent the last 35 years of her long life at 3637 Angus. The legendary J.V. Clyne, a BC Supreme Court justice, UBC chancellor and chairman of MacMillan-Bloedel, lived for many years at 3738.

CPR treasurer William F. Salsbury—namesake of Salsbury Drive in Grandview—built 1790 Angus Drive, which has two splendid beech trees framing the view of it from the street. As an alderman, using the CPR's financial resources, he promoted the city and helped create facilities such as the Brockton Point Athletic Grounds, the Vancouver General Hospital, and the BC Telephone Company. His son Bill was murdered in 1921 in a botched robbery on Georgia Street.

One of the more interesting uses of a Shaughnessy home was as a gaming house. "Greyston," the Tudor at 1638 Angus, so operated until the tenant, 28-year-old Anne McCormack, and nine of her customers were arrested in 1951.

Continue walking on Angus Drive, admiring the view to the North Shore mountains across the park and imagining how dramatic it would have been before the urban forest grew up. The most historically significant house is Thomas Shaughnessy's at 1551 Angus. Designed in the style of an Irish aristocrat's hunting lodge by Honeyman and Curtis in 1909, it was only rarely visited by Shaughnessy, who nevertheless had died by 1916. Amusingly, it was marketed as "Lord Shaughnessy's hunting lodge" by realtors several years ago. Urban coyotes, raccoons and skunks would constitute the prey today.

If you haven't done so already, cross Angus to the north side then backtrack toward Marpole Avenue, after CPR western superintendent Richard

Marpole, namesake of the south Vancouver neighbourhood. 1675 Angus was once known as "Ardvar," the home of Major-General John W. Stewart. As a partner in Foley, Stewart and Welch, he built a large part of the Grand Trunk Pacific Railway and the PGE (now BC Rail). His experience made him invaluable to the war effort on the Western Front; after the war he was showered with honours, and as a gesture of respect the Prince of Wales, later Edward VIII, stayed at the home during his 1919 Vancouver visit. To promote his railway enterprises and Liberal political friends in the 1920s, Stewart bought the Vancouver Sun and promoted accountant Robert Cromie (page 171) to publisher.

Walk along Marpole to Granville

Only the tall hedges and gardens of the big Angus Drive houses are visible from here. However, at the end of the block there is the best view of the houses across Granville street.

The big white house with the loopy Mission Revival parapets is now called the "Five Cedars," and was the first house in Shaughnessy to be converted into condominums using the liberal zoning scheme created in the 1980s. First owner John West was an American who made his money during the Klondike gold rush.

The complex immediately to the south consists of the house of physician and city coroner William Brydone-Jack—the Tudor in the trees behind the blocked-off driveway—and a huge new building for the Chinese consulate. The latter is hard to miss due to the regular political demonstrations on the sidewalk. Norman Lang of the Powell River Paper Company owned the Brydone-Jack house until he died in 1926. The People's Republic of China, like Japan 60 years ago, is a controversial Shaughnessy resident.

Along the Interurban

21

Cedar Cottage

S itting just outside the City of Vancouver boundary, Cedar Cottage in the early 20th century felt and looked like a small town. This fledgling community had its own banks, post office, movie theatre, and even an amusement park with a small roller coaster. Prosperity was short lived, however, and by the middle of the First World War many businesses had closed or moved out to Kingsway which was rapidly becoming the dominant retail street.

The surrounding district took its name from the small cedar cabin Arthur Wilson built for himself on the south side of the Westminster Road (Kingsway) just east of Knight. At Kingsway and Knight Street, George Raywood used the water from Gibson's Creek for his new Cedar Cottage brewery.

The interurban line to New Westminster made it an easy and reliable commute to the city, so many people bought a lot out in the woods and set about building a house. The area appealed to a wide variety of people, from sawmill workers and tram drivers to businessmen. Many bought large lots for small scale agricultural uses—the Cedar Cottage Nursery's *News Advertiser* advertisement of 1890 offered roses, lily bulbs and hardy plants for sale. And the directory for 1911 listed 17 farmers in the area. In the years just before the First World War the ridge overlooking Trout Lake at 15th Avenue and Clark Park was briefly a fashionable place to build.

Today the relentless march of the stucco clad neo-Craftsman - the new Vancouver Special - has demolished much of the neighbourhood, but despite the changes Cedar Cottage still retains a character all its own.

The tour route is as eclectic as the neighbourhood.

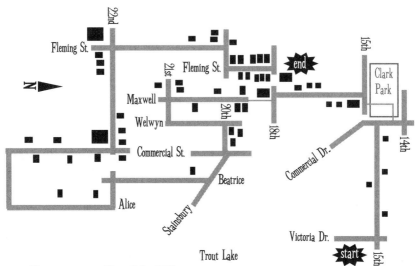

The tour starts at Trout Lake. Walk
from the park up to Victoria and 15th and head west on East 15th Avenue.

Trout Lake is the only natural open body of water in the city outside of Stanley Park. In the 1860's the lake waters were tapped by the Hastings Mill down on Burrard Inlet for its operations. Over the years peat was harvested from the surrounding bog and the area was logged off. By the 1930's debate was heating up on the future of the lake. One camp felt that the lake should be filled in to stop the swarms of mosquitos, another wanted to use the lake to replace the China Creek dump which was nearing capacity. It took Mr. and Mrs. Eric Hamber to step in and gift the lake and surrounding acres to the city as a park on the condition it be named for John Hendry, owner of the Hastings Mill, and Mrs. Hamber's father (page 135).

The streets east of the park were pretty well filled with modest Craftsman bungalows by 1916. In 1912 W. H. Marston, a tally man at the Hastings Mill, built a home for himself at 1785 East 15th Avenue, while on the next street over his brothers Thomas, Walter and Joseph Marston, also Hastings Mill employees, shared a house at 1678 East 16th Avenue. Just up the street was the Robertson Sash and Door Company located at 1758 East 15th Avenue, an indication of the mix of uses throughout much of the district. Look for the the charming 1930's house with castle turret entrance on the north side of the street—a much more common sight on the west side of the city.

Many of the original homes have undergone a variety of renovations, and a great many have become bulldozer-bait.

Cross Commercial Drive at the cross walk. Climb the stairs into Clark Park and walk to 15th and Fleming.

Clark Park was given to the city in 1889 by E. J Clark on the condition that it be developed and maintained as a public recreation place for Vancouverites. He had holdings in the area and hoped to spur development with his gift. It was once known as Buffalo Park (though there isn't any record of buffalos) but Buffalo was a "flag stop" on the BCER Interurban line so Major Matthews, the city's archivist, suggested a popular song, 'put me off at Buffalo', as the reason for the stop's name.

Clark Park sits high above the surrounding area and affords great views out and over the city. A stroll through the grounds reveals that the park possesses an interesting collection of native trees.

The southern end of the park is overlooked by the magnificent Californian Craftsman Bungalow Frank Smith, president of the lithograph company bearing his name, built at the southeast corner of East 15th and Fleming. Bungalow may be stretching the definition, but the house with its broad porch and long low profile has the hallmarks of the style. Even the modern vinyl siding doesn't detract from the home's overall presence. It sits on a double lot and is one of the largest homes of its type in the city. Smith's company specialized in "salmon, fruit and all kinds of labels".

Walk south along Fleming to East 18th Avenue.

Smith's neighbours included the Reverend William Meyers at 3262 Fleming, and the hydropathist William Telford at 3271 Fleming. Hydropathy was very popular in North America between 1820 and 1860. The idea was that ailments could be cured with copious amounts of water applied to the affected area of the body. At its height in 1850, 50,000 people subscribed to the movement's *Water-Cure Journal*. By 1918 Mr. Telford was a late practitioner of a system that had been largely dismissed.

3283 Fleming is an example of infill housing being used to preserve an original house on the property. The new dwellings are quite easily tucked in behind the existing house because of the lot's 200 foot depth. The lots on the southern end of Fleming are almost 100 feet across which has permitted some of the new development, in particular the housing project

behind the church. Here the neighbourhood again displays the subdivision quirks found in the old Municipality of South Vancouver.

At 1553 East 18th on the northwest corner of Fleming and 18th Avenue, St. Marks Lutheran, originally Robson Memorial United Church when it was built in 1911, reflects through its elegant design the hopes and aspirations people had for the area. Across the street the row of Vancouver Specials on Fleming are an early variation of the style. Built in 1972, they replaced the large 1911 home of Alfred Stewart.

Fleming continues along the top of a ridge and, at the bottom of the big drop down to the east, Gibson's Creek ran through the swamp and bog as part of the China Creek watershed a good chunk of which was owned by Moses Gibson in the 1890's. Gibson, one of the first settlers in the area, bought almost 20 acres of "ranch land" out here encompassing the area between Knight and Bella Vista and from 18th to 20th Avenues.

☞ Cross 18th, turn east to St. Joseph's Catholic Church and walk through the parking lot to the east to Bella Vista.

St. Joseph's striking essay in late-sixties Modern replaced an earlier church on Fleming and occupies the 47,000 square foot property originally known as 'Bella Vista.' The large home here would have afforded the occupants a bella vista (good view). The street that dead ends at the northern boundary of the church property takes its name from the house. Real estate promoters tried calling the district Bella Vista but it didn't stick.

Bella Vista is a short street with an interesting collection of houses all built within a few years of each other. 3462 Bella Vista dates from 1912 while the twin Craftsmans right next door at 3476 and 3492 Bella Vista were built two years earlier. Herman Flowerdew, a bookkeeper with Rand and Fowler, one of Vancouver's largest real estate firms (Rand was instrumental in setting up the BCER and was a partner in the Vancouver Improvement Company among other notable activities), lived at 3492 Bella Vista in 1910. At the end of the street the large home at 1619 East 20th on the northwest corner dates from 1906— it has been heavily renovated but could be spectacular in the future.

☞ Cross 20th, walk south on Maxwell to 21st Avenue and turn west.

South Vancouver street names seemed to change constantly as properties were resurveyed and subdivided. Maxwell Street was once known as Garltley Road and later Welwyn until the old Keystone and Vancouver Lumber Company yards were divided by a southward extension of Welwyn Street; then, the Maxwell name was transferred one block east from what is now Fleming. It makes research in this part of the world a challenge. 3605 Maxwell is an interesting house from the 1930's.

Many of the streets in Cedar Cottage have had their original homes demolished which in some cases leaves odd juxtapositions such as on 21st Avenue where 1662 East 21st, one of the area's few homes listed on the City's Heritage Register, stands out next to its neighbours. Across the street a large Edwardian stands in contrast to its neighbour to the west at 1645 East 21st, a 1930's house with the deco-inspired wall details.

☞ Return to Maxwell and continue walking to Welwyn. Turn north and cross 20th.

Because of the quirky subdivision patterns here the Maxwell Street properties have no lane and their rear yards face Welwyn, a pattern that is repeated throughout the neighbourhood. The Telus works yard opposite is part of the former Keystone (later Hodgson) Lumber Company's operation. Across 20th Avenue is 3572 Welwyn, built for the teamster Herman Crowe in 1914, and 3560 Welwyn, the 1910 home of Robinson Langdale. Both are both included on the Heritage Register.

☞ Return to 20th, turn east. Cross Commercial Street to Stainsbury Avenue. Turn south on Beatrice.

Commercial Street was the business district for the community of Cedar Cottage. That legacy remains today in the mix of residential and commercial uses along the street. On the northwest corner of Commercial and 20th the grocery store was once a branch of the Bank of Commerce, and a little farther down the street there was a branch of the Bank of Hamilton. Along the southern half of the street a number of woodworking shops and printing outfits occupied the storefronts.

Stainsbury joins Commercial Street at an angle parallel to the original alignment of the BCER tracks. The Lake View Station was just a short distance away at Victoria and Hull Street; its name is recalled by the Lake View Grocery store near the stop. Industry and residential mixed together here and it still does with the City works yard on the north side of Stainsbury.

The west side of Beatrice was built up by 1913 while the row of identical houses opposite were completed in the 1960's. There is a little Craftsman cottage which was completed in 1912 for John Mills, a typesetter for Western Press, hiding under the renovations at 3721 Beatrice.

☞ Turn east on 22nd and turn south on Alice to the park. Then turn west and follow the path beside the park to Commercial Street. Turn north on Commercial.

Alice and Beatrice Streets are named for Queen Victoria's daughters. Victoria Drive is just one block to the east. Both streets are quite long, again responding to the crazy quilt of subdivision in the area. Because of the narrow block many of the houses on the east side of Alice have their rear yards face onto the street, while others facing Victoria. About mid way on this block is 4055 Alice the home of Richard Tralford, a mechanic for the Ford Motor Company. Built about 1907, it is one of the first houses on the block and though it has been heavily renovated the shape of the roof peak gives an indication of its age.

Alice Street ends at Brewers Park, home to the Cedar Cottage Lawn Bowling Club in the 1930's. At the end of the path running alongside the park, Commercial Street must have some of the oddest lots in the city. The modern house at 4143 Commercial, which has replaced an earlier dwelling, actually sits on a narrow strip of land between the street and the lane to the west, it has no yard whatsoever. Under the renovations and stucco, 4120 Commercial is a rooming house from 1908, probably built to take advantage of the recently expanded streetcar service along Kingsway.

4115 Commercial was built in 1910 and shares the property with a house facing Miller Street to the west. Sometimes houses like these were built to generate extra income for the family but many times they are the original building on the site, providing a home while money was saved to have the main house constructed.

The paving, widened sidewalks and street trees were all part of a neighbourhood improvement program by the City in the 1970's which looks like it needs refreshing. 4078 Commercial is a nice example from 1946 of the type built by the Canadian Housing and Mortgage Corporation for returning servicemen after World War Two. Just up the street, 4062 Commercial is a perfectly intact house from 1910.

Near the school grounds the curious building at 3984 to 3982 Commercial started life as Alex Gordon's hardware store. Over the years the store front has been lost and the whole building stuccoed over, leaving few clues to its identity. At the rear a smaller apartment building sits facing Beatrice.

Turn west on 22nd and walk to Fleming

Lord Selkirk School, the first brick school in the municipality, opened in 1911 with Premier McBride as the official guest. South Vancouver invited school-children to submit names for a contest to select names for the district's schools, with the winners getting a chance to name their own school. The Selkirk students won with their suggestion that South Vancouver schools be named for famous Canadians. For their own school the students chose the man responsible for colonizing Manitoba.

Along 22nd Avenue the houses mostly date from after the First World War. 1727 East 22nd is from 1918 while across Welwyn 1697 East 22nd was built 10 years later. The house is an interesting renovation that has created a mix of styles from the Victorian to the Arts and Crafts. On the south side of 22nd the earliest house is 1616 East 22nd, constructed in 1905 from a stand-ard set of plans. Across Perry the three Craftsman cottages at 1594, 1586 and 1578 East 22nd were built in the 1920's.

The large multifamily project at the southwest corner of Fleming and 22nd sits on the site of St. Margaret's Anglican Church. Behind St. Margaret's, at the end of this huge lot, was the Terminal City Auto Camp which had 40 small cabins with an attached car port. Early auto tourists had basic accommodation with a wash house and lavatories near the cen-tre of the site. Auto Courts like these lined Kingsway, as it was Highway 99, the Pacific Coast Highway and the auto route into Vancouver. These simple auto courts eventually evolved into today's modern motel. Kingsway has one great surviving example of the bungalow-style auto court from the 1940's: the 2400 Motel at 2400 Kingsway, where the management has kept things as original as possible.

Turn down Fleming and walk to 20th

In the 1930's, by which time much of this area had been built up with streets of houses, the occasional agricultural use hung on, such as the greenhouse operation on the east side of the 3700 block of Fleming. Across

the street at 3741 East 22nd, carpenter Wallace Prouse probably lent a hand in the building of his 1910 house. At 21st the street becomes little more than a lane without curbs, gutters or sidewalks. Many streets in South Vancouver lack these items because the original municipality did not spent money on infrastructure improvements, preferring to spend it on community benefits such as schools and community halls.

Fleming descends into the former stream bed of Gibson's Creek and on 20th Ave it's easy to see why building on top of buried streams is a bad idea (see page 152). Some of the houses on the south side have taken on a severe list. Across the street, 1571 East 20th has a yard which as part of the stream course drops dramatically away from the sidewalk. Listen at the manhole covers—the sound of rushing water is the buried creek.

☞ Turn north on Fleming

Fleming follows a ridge and early residents would have enjoyed great views from here. In 1912 Albert Murray, the foreman of the mailroom at the Daily Province newspaper called 3575 Fleming home. Across the street and down a couple of houses at 3550 Fleming, an early house from 1906 lived Donald Reid. Still on the east side of the street, the bricklayer George Hawksworth lived in the 1907 house at 3516 Fleming.

Next door to the little Craftsman cottage at 3505 Fleming is Mosaic Creek, a community art project which provides some visual delight and a passage through the block joining up with 19th Avenue. Near the end of the block at 3473 to 3439 Fleming the row of Edwardian Builders from 1910—the Vancouver Specials of their day—contrast with the 1970's Specials across the street. Both styles of home are more similar than some would like to admit. Both are efficient use of the land with large floor plates and full site-coverage. On the inside there are high ceilings and simple floor plans with a good division of space. The Vancouver Special is still new enough to be considered merely old-fashioned, something the Edwardian box went through in the 1960's.

The tour ends at St. Mark's Lutheran Church at 18th and Fleming. It's an easy walk back to Trout Lake, by retracing the route along Fleming and through Clark Park. Or the intrepid can walk to the Skytrain station at Broadway and Commercial and head two stops east to do the Beaconsfield Walk at 29th Avenue.

22

Beaconsfield

B eaconsfield is the area around the 29th Avenue Skytrain Station first promoted by real estate developers in the early part of the 20th century. This walk takes in the rolling hills and streets between Nanaimo and Slocan Streets centred on 29th Avenue. The BCER Interurban trains stopped at the Beaconsfield Station just west of the current 29th Avenue Skytrain station, running a 30 minute service until 9:00 pm. Around the station a small group of homes, including a post office, could be found. A little farther away real estate promoters had "ideal country residences with city privileges" for sale. Small-scale orchards and other agricultural endeavours took advantage of the area's fertile soils.

Between Slocan and Nanaimo Streets, the land was rolling hills traversed with streams and rivers, quite unsuitable for anything but houses. With the success of the CPR's original 1908 Shaughnessy Heights subdivision, promoters such as William Astley, who had large holdings in the area, added "Heights" to their own properties and soon newspaper advertisements appeared promoting "Beaconsfield Heights". Major Matthews, the city archivist, even complained about the "heights insanity" where every little bump was suddenly a 'heights'.

Beaconsfield saw some early development before the First World War slowed things down. Promotion of the area picked up again in the 1920s and many fine homes remain from that era. However, the Depression put a freeze on things until the boom of the postwar years filled in the remaining lots. What's interesting about this sporadic development is the eclectic mix of houses it created throughout the Beaconsfield neighbourhood.

 Start the walk at the 29th Avenue Skytrain Station entrance.

29th Avenue was the boundary between the Hastings Townsite, annexed by the City of Vancouver in 1911, and the Municipality of South Vancouver. Before heading west along 29th Avenue to Gothard Street, cross 29th and head north up Atlin Street to 27th and turn east. 27th Avenue ends at

the Renfrew Ravine and becomes a causeway across the ravine. The creek at the bottom of this deep cut is one of the last remaining natural stream courses in the city, where the coolness of the forest, coupled with the sound of water is in such contrast to the surrounding city. This natural ravine gives a good impression of the landscape early residents were building on. Follow the trail on the east side of the ravine out to 29th Avenue.

👉 **Walk west on 29th Avenue, cross Slocan, walk to Gothard Street.**

On the way to Gothard there is a simple little Craftsman cottage sitting all alone on the north side of the street at 2765 East 29th Ave. It dates from the 1920's.

Gothard is a curious street. For the first few years of its existence it had no name until it borrowed the Gothard name from the street immediately to the west (today's Clarendon). Gothard is named for Ambrose Gothard, who owned property in the area and dabbled in real estate.

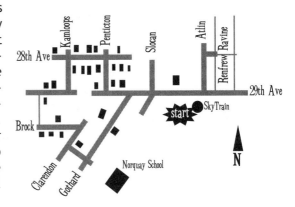

There was some development on the street in the early years—the most impressive house in the area has to be 4525 Gothard overlooking 29th Avenue and angled to take full advantage of the views across the city and Burrard Inlet. It took until the 1950's to fill in most of the lots. Early residents on the street included John and Matthew Dillabough. John was an electrician in 1910 but by the 1930's is listed as a steamfitter in the directories. Matthew worked downtown at the Crystal Theatre on Hastings between Abbott and Carrall before the First World War.

Part of the 1950's development included The True Jesus Church at 4580 Gothard, originally constructed in 1959 to replace the simple Shingle-style Beaconsfield United Church that sat on Slocan. The former church site is now a parking lot for the current building. Its new congregation reflects

the changing nature of the neighbourhood. The block is a mixture of pre-World War One homes, primarily on the west side of the street, 2619 Gothard being one example, and houses from the 1950's and 60's. 4627 Gothard is a standout with its large fieldstone chimney.

Turn west on Norquay to Clarendon

Norquay was cut through the block from Slocan in the 1920's. Look east along the street before dropping down to Clarendon for a fine view of the 1913 Norquay School. Sir John Norquay, a Metis and premier of Manitoba from 1878-1887, is the school's namesake. On school mornings the innovative 'walking school bus' can be seen weaving through the neighbourhood picking up students on its way to the school.

As Norquay heads down to Clarendon, 4226 Norquay stands on the north side of the street, a solid looking house from 1947. At the bottom of the hill the streets all meet at odd angles. That is because of a large shallow lake which used to lie between what is now Vanness and Kingsway. Once part of an early military trail to Burrard Inlet, Kingsway follows the route of earlier native trails that ran parallel to the lakeshore. In the 1860's Colonel Moody of the Royal Engineers took a fancy to the unnamed lake and laid claim to it and the surrounding land. As it was one of the first pre-emptions in an unsurveyed landscape the boundaries of the claim forced others to work around them. Hence the angle of Kingsway and the BCER Interurban line (SkyTrain).

Later, property speculators trying to avoid odd shaped lots surveyed perpendicular to Kingsway but at the ends of the old claim the streets clashed with the regular north south grid creating the irregularities seen today.

Turn north on Clarendon to Brock. Turn west on Brock. Walk to the lane before Nanaimo.

Brock is a short street named for Sir Isaac Brock, the defender of Upper Canada in the War of 1812. The houses along the street were largely built in the 1920's. Various house-plan companies, notably Sears Roebuck and their "Honor Bilt" homes, featured elements taken from an idealized notion of the English village. Many of these homes had steep roof peaks over the entrance and multiple dormers. These house designs were known as "Americanized English." A couple of examples of this style on the street stand out: 2536 and 2465 Brock. At the end of the block at the lane, 2442 Brock is interesting with its angled front door.

☞ **Turn north up the lane to 29th**

The dramatic drop to Nanaimo is the legacy of a ravine and creek that used to feed Trout Lake. On this block of 29th Avenue the 1914 Heal house at 2473 East 29th stands out. The house, which has seen better days, was built by the printer Stephen Heal who was probably attracted to the area by the reasonable $800 price for lots. According to the building permit, Heal spent just under $3000 to construct it. His immediate neighbour to the east, Mr. Williams, managed to spend only $500 for his house the year before. The Heal family included, bookkeeper Freda, shipper James, and Laura—a steno with the Kardex Company which manufactured (and still does) the Visible Record System.

On the south side of the block, 2440 East 29th is one of the better examples of the Craftsman cottage.

☞ **Walk to Kamloops, turn north to East 28th Avenue. Turn East and walk to Penticton.**

Before turning on to Kamloops, notice the large dip in 29th Avenue—the former stream bed of the creek which ran along Clarendon. Kamloops descends into the former stream course which can be traced by looking north and following the various dips in the streets. Here on 28th Avenue the mixture of house styles is quite representative of the different periods of building activity. On the block to the west, the first house was built by a Mr. Holmes at 2481 East 28th in 1911. That same year H.J. Pearce bought three lots in the 2500 block and spent $3500 to construct a one-and-a-half storey concrete bungalow at 2552 East 28th which has been demolished.

At the corner of Kamloops and 28th, 2505 East 28th is an example of the Americanized English house. Next door, the shape of 2511 East 28th and its very deep porch which would suggest there is an elegant Craftsman bungalow hiding in there under the stucco.

Along the street on the south side, 2556 and 2562 East 28th built in 1967 are sinking into the ground. They illustrate the perils of building on top of a stream bed. The houses directly behind them on 29th suffer from the same sinking feeling. (see page148). Across the street, 2545 East 28th is a good example of the English Cottage style with its shingles rolled over the eaves to imitate a thatched roof. This contrasts with the charming

Craftsman cottage barely visible in the thick forested lot at 2569 East 28th. This cute little house was the home of Mr. H. Childs who worked as a painter for the Pacific Paint Company on Seymour Street. Unfortunately the Childs house won't be long for this world given the penchant for knocking things like this down and replacing them with characterless stucco boxes.

The large Craftsman home with the deep porch at 2582 East 28th. has undergone a sensitive renovation.

 Cross Penticton

In 1912, carpenter Frank Sweetnam built the prominent house at 2614 East 28th for himself. Norman Sweetnam, a printer with the National Box and Carton Company lived there, too. In 1926 the Sweetnams sold the house and C. J. Fletcher, executive secretary of the B. C. Medical Association, moved in. For a time, Fletcher's next door neighbour was the mining engineer Thomas Bottsrill at 2630 East 28th. the house with the granite piers holding up the porch. Chauffeur William Cuff's house at 2636 East 28th was built to the same plans as Bootsrill's but has been renovated.

Across the street, the first house on the block was 2637 East 28th. built by Master Mariner George Shapland. In 1913 Shapland took out a building permit for an office and store at the same address though it's not clear if it was ever built.

In the 1920's three spec houses in the popular Craftsman style were erected at the end of the block on the south side of the street. 2658 East 28th and its neighbours are typical of the builders "specials" of the period.

Return to Penticton and turn south to East 29th Avenue.

As development encroached on the natural landscape, existing streams and creeks were usually culverted and buried. The only evidence of their continued existence, other than the occasional sinking house, is the sound of rushing water to be heard at various manhole covers. On the walk up to 29th Avenue take a listen.

At the top of Penticton and 29th the view to the north and the mountains is rather good. It explains the presence of large homes such as 2623 East

29th, which Robert Fisher and his wife Annie built in 1912. Next door at 2621 East 29th, Ala Willis, director of T. B. Cuthbertson Co. Ltd., enjoyed the view from the impressive Craftsman house he built in 1921. But by 1926 the mining business must have treated Thomas Bottsrill reasonably well because he decided to move up the hill from 28th Avenue and into the house.

Before returning to Slocan and the SkyTrain Station take a look at the very pleasant 1920's stucco cottage tucked behind the hedge at 2593 East 29th.

From here it is a short walk back to the SkyTrain station, or a few blocks south to Kingsway where there is a variety of places to grab a bite to eat and rest the feet. A block west of Slocan on the north side of Kingsway is the Vancouver institution of Wally's Burgers, the last true drive-in within the city limits and home of the delicious Deluxe Chuckwagon burger.

23

Wales Street

T he Municipality of South Vancouver was incorporated in 1892 by a small group of land owners scattered throughout a vast area between 16th Avenue and the Fraser River. Largely agricultural, much of South Vancouver's settlement tended to be clumped around the B.C. Electric Railway's interurban stations; the BCER had been running interurban trains from Vancouver to New Westminster since 1891. By 1910 local streetcar service had been extended along Kingsway to Joyce Road and along Victoria to 41st. Real estate developers built on the easy access to rail service and started offering lots for sale "a short walk from the carline." Many people moved out from the "crowded" City of Vancouver to cheap land and large houses.

As the popularity of the area grew many of the small farms and orchards were subdivided by their owners into lots and put up for sale. Development was steady, but not rapid, and over time many of the new streets were dotted with modest Craftsman homes. Though many of the agricultural uses remained (it wasn't uncommon to find a street of new homes overlooking a cow pasture, orchard or "chicken ranch") these were slowly being pushed out.

In contrast to the City of Vancouver, where the majority of the new city was laid out in a rigid grid system of streets and lots by the Canadian Pacific Railway's surveyor, the Municipality of South Vancouver largely left it to chance and individual owners. The legacy of the hands-off approach is that many parts of the former municipality possess an erratic street pattern filled with uneven lots and blocks. But this somewhat haphazard development has created some delightful and unexpected juxtapositions.

Today, in a small corner of southeast Vancouver it is still possible to buy milk from a dairy, and catch a glimpse of rural life.

 The walk starts at the Avalon Dairy 5805 Wales Street.

Wales Street (originally Wales Road, and also known as Cedar Road) takes its name from George Wales, a prominent land owner in the area. He came to South Vancouver in the 1870's and pre-empted District Lot 50, which encompassed an area bounded by Wales, Kingsway, Tyne and 45th. Wales farmed part of his land, leased some of it out for pasture, and laid out some streets in preparation for subdividing the property into lots.

Avalon Dairy—the oldest surviving independent dairy in British Columbia —was started by Jeremiah Crowley, who'd come out from Newfoundland, and rented property on Wales Street near Kingsway. He tried his hand at small-scale dairy farming and eventually moved in 1908 to a two-and-a-half acre property at 5805 Wales. Crowley worked at the Vancouver Furnace Company on Powell Street and ran the dairy part-time but by 1913 the dairy was a full-time business. At its height, the property supported over 30 cows and a flock of hens, ducks and geese. Crowley even leased land up and around Trout Lake and on the future Norquay Park to graze his cows.

Over the years, the dairy's fortunes have been a bit of a rollercoaster ride for the Crowley family; the cows left the property in the 1930's, city tax policies were set against agricultural uses, and even metrification was a threat for a while, yet despite it all the dairy survives—the only one of over 29 such operations in Vancouver past, and it still puts the milk in glass bottles.

Walk north on Wales to 41st Avenue

The east side of the 5700-block of Wales Street had been subdivided into 33 foot lots fairly early on, yet by 1925 only five of the lots had houses on them. Of those only one, 5744 Wales, remains on the block. Constructed in 1912, the Craftsman house is still there under under the renovations. Fire

insurance maps of the period indicate that some of the street's residents also kept chickens out back in pens.

On the west side of the street the pattern of subdivision is very different. Here the blocks are long and ran east to west between Wales and Clarendon. Samuel Gunning, owner of a hardware store on 41st at Victoria, bought two 50 foot lots at the southwest corner of 41st and Wales and in 1913 built himself a little hipped roof bungalow at 5709 Wales. The house and property survived intact until the 1990's when a 19-unit affordable housing development by First Lutheran Church, designed by architect Linda Baker, surrounded the Gunning house with a series of modern buildings inspired by the original. This design decision makes finding Mr. Gunning's house a little difficult—it's the one on the corner of Wales and 41st.

 Return to East 42nd Avenue, turn west and walk to the lane before Clarendon

The 1957 First Lutheran Church on the corner occupies five lots on the block and was built at a time when this area was enjoying a construction boom. Now many of the houses from the 1950's are being replaced at an increasing rate by the modern, stucco neo-Craftsman found throughout Vancouver.

 Turn south at the lane, walk down the lane to East 43rd Avenue

While streets such as Clarendon and East 42nd were subdivided into lots the land behind them remained as pasture. In part because of this, the lane behind Clarendon at 43rd still has open drainage ditches, which is something planning authorities are looking at as part of a green approach to development. Many of the streets and lanes in south Vancouver have 'soft edges' where local improvements haven't added curbs and gutters. In fact, the old municipality was never in strong enough financial shape to put much money into civic improvements like sidewalks. On the tour, look for dates stamped near the street corner of existing sidewalks: they are almost always after the 1929 amalgamation with Vancouver.

 Turn east on East 43rd and walk to Wales

At 43rd a row of almost identical Vancouver Specials takes up the north side of the street. Unlike earlier development which saw houses placed where

the owners wanted them, later bylaws insisted that houses like these had a consistent setback from the road.

The Specials were built in the 1970's when the Crowley family, owners of the Avalon Dairy, sold off their back pasture. While the Specials may look identical, a closer examination reveals small details, such as balcony railings, brickwork and entrances which set them apart. The Vancouver Special is soon approaching the age where they might need to be re-evaluated in terms of their heritage value. A ludicrous idea for some, this unique Vancouver house style is now over 40 years old, the same age that many of the buildings we consider heritage were when they were first considered for protection.

The south side of the street is a full block owned and occupied by the Vancouver School Board.

This section of 43rd ends at the back of the Avalon Dairy. The contrast between the two halves of this street is remarkable. After a short walk on the footpath beside the dairy, 43rd emerges again but is only half the width of the western section and feels more like a country lane, with its weeping willows and firs, than a city street. The country feel is enhanced by the driveway for the dairy on the opposite side of the road.

Look up into the fir trees on the driveway to see the remnants of a power pole that has been absorbed by the tree's trunk.

Opposite the dairy is the Vancouver School Board nursery and grounds maintenance facility. This large piece of property will be developed at some time in the future but for the time being pumpkins and other delights can be seen growing behind the fences.

At Wales, walk south to East 44th Avenue

In 1910 Frank Cooper, Canadian Pacific Railway commissary agent, settled in the neighbourhood and purchased a large property (the equivalent of 12 lots) at 5872 Wales. The wonderful 1919 Craftsman home, an 'A' on the City's Heritage Register, that sits squarely in the centre of the property today, is Frank Cooper's second house. He originally shared the property with John Graham and his wife Sarah whose house, addressed as 5896 Wales, survived until the late 1920's

On Wales Street some of Cooper's neighbours included, beside Jeremiah Crowley, longshoreman James Crowe at 5981 Wales, electrician Fredrick Fox, at 5992 Wales and J. T. Allcock around the corner at 2707 East 45th Avenue.

 ### Walk east along East 44th Avenue

Over the years the eastern half of the Cooper property was sold off for development. As a result where 44th meets Wales the street width is again narrower than regulations require—early plans note the street as 'half width'—and there are no curbs or gutters. A mature landscape of hedges and trees frame and sometimes hide the Cooper house from the street. At the end of the property the street widens out to a normal 66 foot wide street. The original homes on this street dating from the postwar period were similar to the bungalow with the delightful and whimsical show of whirlygigs and cut-out figures set amongst an array of flowers on the north side. The street is lined with some significant flowering cherry trees, whose trunks are as impressive as their show of spring flowers.

The Cooper property will be redeveloped at some point and it will take some careful planning to ensure that its special character is not lost to a typical subdivision.

There were several large properties near the Coopers. The largest extended north from 45th Avenue along Earles to the back of the Cooper lot. (The original, early 1900's, farm house at 2783 East 45th is still there, though surrounded by later dwellings.) Over time the owners would sell off bits and pieces of these blocks as the popularity of the district increased. But because of this piecemeal approach many of the streets do not line up and back lanes have to wrap themselves around various property boundaries, and at Earles and 44th this street misalignment is quite evident.

 ### Turn north on Earles, walk to East 43rd Avenue

Just east of Earles the streets all take a big dip as they cross the bed of a culverted creek. South Vancouver was once riddled with creeks and the course of some of them can still be followed by watching the rise and fall of the streets. Further east, near the Killarney Community Centre, the playing fields and surrounding neighbourhood sit on what was, and still is, a bog. Many of the houses built nearby have taken on some rather odd angles as they slowly sink in to the peat moss.

In the 1920s a large hen house—so called on the maps—took up the western end of the block between 43rd and the lane. 1912 advertisements in the Vancouver *World* newspaper promoting lot sales in South Vancouver showed that a number of chicken ranches were for sale in the area. A little to the south on Earles, the Deluca family settled into their handsome new house at 5913 Earles in the 1920's. In contrast to the Deluca house there is a lovely and very modern Japanese-inspired house across the street.

☞ Turn west on East 43rd Avenue

Before the Second World War few houses had been built on the surrounding streets. Three of those, 2762 East 43rd 5792 Rhodes, and 5762 Rhodes, built in 1912, are examples of the California bungalow. Only 5762 Rhodes, built for Morris New, a shipper with the Spencer's Department Store, remains largely intact. A very popular style in Vancouver, the California bungalow had many variations and came in all sizes and shapes. They were popular with builders and many local firms specialized in their construction.

☞ Walk on East 43rd to the Avalon Dairy where the walk ends

At the end of 43rd Avenue, the view is of Avalon Dairy's front lawn, house and, tree-lined drive. From this vantage point it's easy to imagine that the modern world has bypassed, for the moment, this corner of south Vancouver.

24

Kerrisdale and South Shaughnessy

I n the years before the First World War, Kerrisdale was touted as Vancouver's "sunny southern slope—the place for your permanent home," with easy access to the city by the BC Electric Railway's interurban system, which began operation on the CPR's old Vancouver-Steveston railway in the summer of 1905. A station called "Kerrisdale" was located at Wilson Road (41st Avenue) and the tracks. The only stop in the area in the CPR days was Magee Road (49th) due to its proximity to the farms on the Southlands flats. Soon, the BCER erected stations at Shannon (57th) and Strathcona Heights (37th), but the Kerrisdale one remained at the heart of the new neighbourhood.

Partly this was due to local politics, for the Municipality of Point Grey built its town hall at 42nd and West Boulevard, now the site of the Kerrisdale Community Centre, in 1908. Point Grey—the western half of the old Municipality of South Vancouver—seceded because the "east-enders" had a rather haphazard attitude toward public services, sidewalks, roads, building codes and tax collection. Even though two miles of bush and swamp separated Kerrisdale from Vancouver's city limits at 16th Avenue, piped water arrived in 1910 from the Capilano reservoir and electricity and telephone service could easily be procured by prospective homeowners.

The tour also rambles through an area of Shaughnessy, historically called Third Shaughnessy but now usually referred to as South Shaughnessy. First Shaughnessy (*aka* Shaughnessy Heights) occupies a tract of land bounded by Arbutus, Oak, 16th and King Edward Avenue and reflects the prosperous antebellum years of 1910. Second Shaughnessy, subdivided in the more straitened circumstances of the immediate post-World War One years, stretches southward from King Edward to 37th and has more modest lots and streets. Third Shaughnessy, between 37th and 41st Avenue, was sold to the public beginning in relatively palmy 1926, and has curving streets and ample lots rather like Shaughnessy Heights.

Although many streets, especially in Kerrisdale, lost fine houses, mature trees and gardens during the building frenzy of the late 1980s, enough of the area survives to evoke very effectively the dreams of the Garden City of a lifetime ago. A walk through the area is an excellent opportunity to examine the residential efforts of some of Vancouver's noted architectural firms, to compare them with the houses erected by the talented builders who used a combination of stock house plans and their own ingenuity to ply their trade, and to pass judgement on the houses of more recent years.

Start at the corner of 41st and East Boulevard and walk north

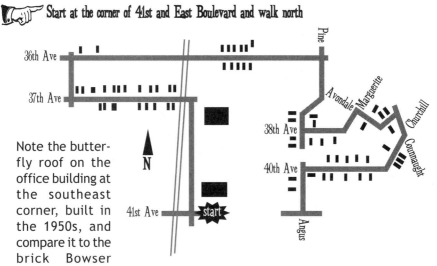

Note the butterfly roof on the office building at the southeast corner, built in the 1950s, and compare it to the brick Bowser Building (now called the Boulevard Building) on the other side of the tracks.

The Kerrisdale interurban station stood just to the north of 41st on the west side of the tracks until service ceased in 1952. Kerrisdale Arena is now named for hockey star Fred "Cyclone" Taylor who played for the Vancouver Millionaires, winners of the 1915 Stanley Cup; it was the wrestling venue for the 1954 British Empire and Commonwealth Games, and hosted memorable concerts including Bill Haley and the Comets in 1956 and the Yardbirds in 1967. The playing field behind it was originally known as CPR Gardens, a source of fresh vegetables for the CPR's hotels, ships and trains.

Point Grey School, designed in 1928 by Townley and Matheson, architects of City Hall, was the last school built by the Municipality of Point Grey be-

fore amalgamation with Vancouver. We who attended it always believed it was designed by a prison architect, a feeling confirmed when the school was one of the few in the city that had power and remained operational following the devastation of Typhoon Freda in October, 1962.

Note the house at 2057 West 37th, across the street from the school, easily identifiable because its brick chimney appears to be at the front. It was the superintendent's cottage for the CPR gardens, moved in the late 1920s out of the way of the new school and inserted sideways onto the lot.

Walk west along 37th Avenue to Trafalgar Street

The first two blocks west of the tracks are typical of Vancouver's neighbourhoods: a few houses from the years before the First World War (notably 2160 and 2232 West 37th, both in the Craftsman style), a handful from the 1920s and the balance from the 1930s through 1950s (2130 West 37th, with its octagon window, is a classic 1930s "starter house"). The 1960s was the era of the Vancouver Special—2166 West 37th. Then, in the 1970s, houses returned to a more vertical, angular look sheathed in cedar, such as those at 2178 to 2196 and 2332 to 2384 West 37th, which have fitted well into the neighbourhood due to their extensive landscaping. In the late 1980s, developers built "monster houses," such as 2175 West 37th—characteristically they have low-pitched hipped roofs, poor quality Palladian windows and fanlights above the entranceway, and either stucco or brick veneer as siding.

Built respectively in 1922 and 1921, 2185 and 2195 West 37th are California Bungalows, a style promoted initially in "bungalow books" that touted the Pasadena or Los Angeles lifestyle. The latter was the long-time home of Kerrisdale Theatre manager Ernest Lackey. Thomas Glover built the large Craftsman house at 2351 West 37th in 1914.

At the crest of the gentle hill on 37th between Balsam and Larch, there is an enclave of old houses around St. Mary's Church inspired by the Arts and Crafts movement. 2403 and 2427 West 37th were both designed by architect George L. Thornton Sharp, the latter for himself, the former for UBC professor F.E. Buck, a prominent advocate of the City Beautiful movement. Hard to see through the hedge, Buck's house is a small, shingle-covered Craftsman, while Sharp's is more "Arts and Crafts" with a simple hipped roofline and some half-timbering. As a partner in the firm of Sharp and Thompson, George Thornton Sharp created the master plan for the

University of BC (an assemblage of Gothic quadrangles never built due to the First World War), the pylons of Burrard Bridge, the Vancouver Club and the Cenotaph at Victory Square.

As well, Sharp and Thompson in 1913 designed St. Mary's Church, probably the finest Arts and Crafts-style Anglican church in the city. Its organist, Mrs. Beeman, ran the kindergarten in the cottage at 42nd and Macdonald (page171). Although appearing to be all of a piece, the church has in fact been added to several times, the original being only the nave and chancel with the bell tower at the western end. Sharp and Thompson added the side aisles, turning the nave's upper windows into a clerestory, in 1920, and four years later added the parish hall to the south; in 1946-7, architects Twizell and Twizell cut the church in two, spread it apart near its western end to add another section, and expanded the chancel to the east. Finally, in 1972, architect William Rhone added a narthex. A small, Sharp-designed house that stood at the corner of Balsam Street was moved in 1987 onto a vacant lot at 2526 West 37th; note also the original rectory, designed by Sharp, on the corner at 2500 West 37th.

To the west of St. Mary's, there are several interesting houses. Kitty-corner from the church, at 2503 West 37th, is the 1922 house built by A.J. Armstrong, a version of the Craftsman-style Swiss Cottage. For many years it was the home of Dr. Watson Dykes, health officer for the Municipality, who maintained an examining room in the house as part of his private medical practice. In the 1950s the house was a kindergarten operated by Mrs. Constance Grey.

Further down the block, note the mock-Tudor house at 2527 West 37th, probably built in the 1930s but moved onto this lot from parts unknown in 1953. Mr. A. Pringle built the house behind the stone wall at 2605 West 37th— it was the Dorchester School for Boys in the 1920s. 2645 West 37th, built in the late 1980s, manages to combine traditional English influences, including the eyebrow dormers, with a decidedly Japanese air. It was built on the site of a small cottage which, like the Dr. Archibald Smith house at 2677 West 37th, stood at the back of its lot; it is a good guess that the Smith house stood in the centre of a much larger piece of property and pre-dates its connection to the city water service in 1910, perhaps occupying a few hundred feet of frontage on both Whitehead and Taber roads (37th and 36th.).

Turn right at Trafalgar, then right again at 36th, and walk eastward along 36th

Architect Charles Moorhead designed the Craftsman-inspired house with Japanese influences at 5188 Trafalgar in 1991. The oldest house on the block is 2599 West 36th, built in 1912. East of Larch, 36th is lined with superb London Plane trees, usually called sycamores elsewhere in North America.

On the north side, midway down the 2100 block, there is a small concrete oval set into the ground witih "Ravine Park" affixed to it in iron letters. A pathway follows the course northward of one of the old salmon streams that used to drain into English Bay. It winds through patches of damp shade and bright sun from 36th to 33rd; worth exploring at any time of the year, it is especially enchanting in April and May, when many of the trees are in blossom.

Cross the railway tracks, or perhaps use the crosswalk at 37th Avenue, and continue eastward up the 36th Avenue hill

A row of horse-chestnut trees lines East Boulevard here.

Before the First World War, 36th Avenue at this point was known as Cen-tre Avenue—the centre of Strathcona Heights. Ironically, because CPR president Lord Strathcona's name appeared all over early Vancouver, it only survives today as the name of the neighbourhood east of Chinatown, on land the CPR never owned.

There are many beautiful examples of the "Swiss Cottage" Craftsman style—side gables, shingle siding, dormers on the front elevations with balconies that were originally sleeping porches—including 2071, 2031, 2027 and 2019 West 36th, all completed in the spring of 1912, built by unknown car-penters probably to stock plans. Don't overlook the fine Colonial Bunga-low at 2063 West 37th with hipped roof, bellcast eaves and front porch. The Craftsman at 2049 West 36th, completed in 1912, was almost completely rebuilt and doubled in size in a sympathetic 1991 renovation by architect Rick Fearn. Continue walking to Pine Crescent, on blocks with a myriad of housing styles.

Walk south on Pine Crescent, continuing across 37th onto Angus Drive

The Dutch Colonial-style Polson house at 5375 Angus Drive was designed by Henry S. Griffith in 1926. Polson owned a health-food company called Dr. Middleton Food Products, which manufactured Jo-To and Veg-O-Min, ironized whole-wheat flour and cereal products, Blue Ribbon White Bread, cookies, cakes and macaroons, all from its plant at 850 East Hastings. (The Afton Hotel, the building on East Hastings in which the famous Ovaltine Cafe operates, has a "Jo-To Stops Stomach Suffering" sign still visible faintly on the west brick sidewall.)

The Halterman house at 5391 Angus Drive is a C.B.K. Van Norman design from 1938. It is a simplified Cape Cod or Colonial-style house, showing early traces of the modernism which dominated his later practice. Van Norman had a thriving residential practice in the 1930s and 1940s, but is usually remembered for his big commercial post-war buildings, including the Burrard Building and the Customs House (demolished) which introduced the International Style to Vancouver, and large projects such as Park Royal Shopping Centre and Beach Towers.

In 1926, architect Henry Simmonds designed 5425 Angus Drive, also a Dutch Colonial, for construction company president William Greenlees. Simmonds also designed the Stanley Theatre, now restored on Granville Street, and with partner Hugh Hodgson designed the B.C. Electric showrooms at the corner of Granville and Pender, now restored as part of a new development.

Contractor W.J. Read, working with architects Townley and Matheson in 1926, built 5475 Angus Drive, a Tudor design. Note another large Tudor, behind the tall hedge at 1790 West 38th, a 1928 collaboration between architect Charles Day and builder A.Y. Thompson.

Walk east on 38th Avenue, turn left at Marguerite, then right onto Somerset, and follow the curve of Avondale to the left

Another Charles Day house, this one for the speculative builder C.J. Phillips, is 1749 West 38th (recently extensively renovated). 1735 and 1707 West 38th were also spec-built in 1926; arguably, they lack the proportions and detailing of the larger architect-designed houses in the neighbourhood, such as those on Somerset and Avondale crescents which took advantage of the narrow curving streets and expansive building lots. The W.E. Herger house at 1678 Somerset could have been lifted from the pages of England's

Country Life magazine; it was built in 1931 to the design of an unknown architect by Samuel Hopper, who 20 years earlier erected the Craftsman houses on Dunbar Street in Kitsilano (page 116). Contractor W.J. Read built the brown shingle-covered house at 1691 Somerset in 1927 for lumberman G.G.C. King.

Three houses on Avondale Crescent are by Townley and Matheson and constructed by W.J. Read. Fred Townley's own house is 1636 Avondale, a shingle-covered English cottage. The McCleery family commissioned the brick-fronted Tudor at 1639 Avondale, renovated and enlarged about 1990 by architect Ernest Collins. 1621 Avondale is a 1926 design reminiscent of the work of English architect C.F.A. Voysey. Townley's partner R.M. Matheson erected his own house nearby in 1930, in the Norman style, at 5237 Connaught Drive.

Probably the most "American" house in this part of Shaughnessy is 5326 Connaught Drive, a 1926 spec-built (by F.M. Willard) Cape Cod with features such as the "blind Palladian" windows and loggia reminiscent of eastern U.S. colonial-era buildings. 5376 Connaught is an undistinguished 1926 effort by architects Benzie and Bow.

The well-known architect Ross Lort designed the Georgian at 1608 Avondale for J.G. Anderson in 1928. Lort was Samuel Maclure's last partner, and designed Vancouver buildings in a number of styles: the Moderne terminal building at the old airport and Barber house at 3846 West 10th; according to rumour, the quaint "fairy cottages" at 587 West King Edward and 3979 West 9th Avenue (page 118); and the grand liquor-financed "Casa Mia" at 1920 South West Marine Drive (page 110).

👉 Walk south on Connaught Drive, then veer right onto Churchill Street

Developer Charles Woodburn erected 5515 and 5550 Churchill in 1926 and 5516 and 5584 in 1928, all variations on Tudor and Gothic house styles. Woodburn, who was designer, contractor and salesman, usually emblazoned his name on a basement beam. (This type of house was very common in the blocks of Kerrisdale just south of 41st Avenue, where the style evolved in the 1930s into an almost triangular profile, with the roofline extending downward in a graceful asymmetrical curve, sometimes called a "cat-slide roof," that became a flying buttress over an arched entranceway into the side garden. There are also rare examples in Vancouver of the "Hansel and Gretel style" with steeply pitched roofs and Tudor detailing, the best

being the 1923 Haley house at 1739 West 52nd Avenue, at the corner of Wilt-shire. All are worth a longer walk or a drive at the end of this walk.)

The house with the steep Elizabethan turret, hidden behind a massive copper beech at 1608 W 40th, is another 1926 project by Benzie and Bow. It was enlarged sensitively in 1991.

Turn west (right) onto 40th Avenue

Between Churchill and Angus on 40th, there are a number of houses by Charles Day and Frank Mountain, two architects with busy residential prac-tices specializing in period (aka revival-style) architecture during the 1920s.

Charles Day designed and A.Y. Thompson built the very fine Georgian at 1630 West 40th in 1926 for client J. Newbury. Phillips worked with Frank Mountain to build the Georgian at 1631 West 40th—the only non-Tudor design by him in this neighbourhood. 1655 is another spec-built Charles Woodburn house.

On the next block are three Frank Mountain-designed Tudors: 1742 and 1776 were both built by C.J. Phillips in 1927, while 1757 was built in 1926 by contractor Archibald Sullivan. The Georgian at 1758, built for Dr. Freeze in 1926, was designed by H.S. Griffith. The mushroom-shaped Camperdown Elm at the southeast corner of 40th and Marguerite is one of the out-standing trees in the area.

The Tudor at 5610 Angus Drive, at the corner of 40th, is a Bernard C. Palmer design for Mrs. Edward Douglas, widow of one of the partners of the Kelly-Douglas wholesale grocery business. Frank Douglas drowned in a Klondike-era shipwreck. Palmer, as well as being consulting architect for the Lions Gate Bridge, designed the earlier of the two liquor mansions on South West Marine Drive: "Rio Vista" for Harry Reifel about 1930. Palmer also worked for the Rogers family, completing "Shannon" on south Granville in the mid-1920s and designing "Fairweather" on Bowen Island in 1930.

Turn south (left) at Angus Drive

Architects Honeyman and Curtis designed the D.S. Montgomery house at 5629 Angus Drive in 1926. Now almost hidden by its garden, the house was recently repainted in its original colours with assistance from the Van-couver Heritage Foundation's True Colours program. Honeyman and Curtis

had a large residential practice, including the Logan house on Point Grey Road and Lord Shaughnessy's house.

Note the large building at 5669 Angus Drive. On the site from 1935 until 1989 there was a small but very finely detailed Georgian, framed by a clipped, formal garden. The demolition, together with the scale and design of the new place, prompted influential local owners to petition the city for a new zoning schedule that would protect the old architecture and garden ambience of the area. Known as the "Pitts-stop bylaw," after resident John Pitts, it set a standard for sensitive zoning that other Vancouver neighbourhoods have tried to emulate ever since.

25

Estates of South Kerrisdale

S tarting from the corner of 41st and Macdonald, this walk explores old estates, interspersed on the tree-lined suburban streets with blocks of modest cottages, in a part of Vancouver which has seen a lot of demolition and disruption in recent years. Fortunately, the era of the "monster house" is over and construction since the mid-1990s generally has better proportion, materials and colours, more respectful of the old houses and gardens in the area.

The boundary of the Canadian Pacific Railway's 6,000-acre land grant was Trafalgar Street, a block east of Macdonald. The latter, then known as Kaye Road, connected the McCleery, Magee and Mole farms on the Southlands flats with English Bay via the Boundary Road trail, now Trafalgar Street. Wilson Road was the early name of 41st Avenue, leading to "Wilson Heights"—the neighbourhood around East 41st and Victoria Drive.

The McCleerys and Magees were the first non-aboriginal settlers, in the 1860s; a few "suburban" settlers, notably the MacKinnons, Johnsons and Bowsers, built on higher ground shortly after the turn of the century, but the real boom began in the area around 1910 with the arrival of telephones and city water, which were extended south along Kaye Road to reach the Celtic Cannery at the foot of Blenheim Street. The Wilson Road streetcar, a single-track tram connecting Dunbar Street with the interurban line at West Boulevard, started operation in 1912; operators "passed the baton" to eliminate the possibility of collisions on the single track.

☞ Start at 41st and Macdonald: walk south to 42nd Avenue

The lots on the north side of 41st Avenue were very deep, as 48th Avenue was never put through; on the site of today's Crofton Manor was a large old house which served in the 1950s and 1960s as the boarding house for Crofton House School (see below). Murray Nurseries, now on the Southlands flats, occupied a long narrow lot just to the west.

Macdonald Street, named for Canada's first prime minister Sir John A., was originally named for an Englishman named Alexander Kaye who, in 1903, bought ten acres there from F.M. Chaldecott, the owner of District Lot 2027 (the east side of the road; the west side is D.L. 321) and name-sake of the park at the western end of King Edward Avenue.

Herbert Beeman, the first clerk and assessor of the Municipality of Point Grey, owned the property stretching from 41st to 42nd on the west side of Macdonald. Although the main house facing 41st was demolished and the property subdivided in the 1960s, the Beeman cottage (originally a summer guesthouse and built about 1920) survives at 5775 Macdonald; Beeman's widow Elsie (daughter of Vancouver's second public librarian) and sister-in-law ran a kindergarten there for many years.

☞ Walk west on 42nd Avenue

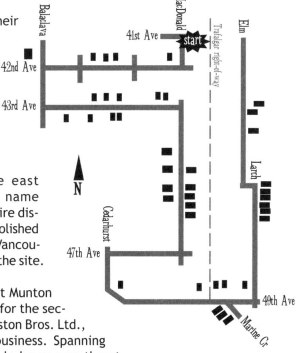

The MacKinnons built their house, "Kerrysdale," in the summer of 1903 on the newly cleared slope at 2941 West 42nd. Two years later, at the request of the B.C. Electric Railway, Mrs. MacKinnon named the new interurban stop several blocks to the east "Kerrisdale," and the name came to apply to the entire district. The house was demolished in the 1960s, and two Vancouver Specials now occupy the site.

2967 West 42nd is the Ernest Munton House, built about 1912 for the sec-retary-treasurer of Johnston Bros. Ltd., a wholesale drygoods business. Spanning two lots, the Shingle-style house was threat-ened with demolition in the late 1980s, but the owner chose instead to preserve it and erect a backyard cottage (by ar-

chitect Alan Diamond)—the first of its kind in this part of the city. The fine Colonial-style house at 2991 West 42nd was also built in 1912, probably for George White. It was deconverted from a rooming house a dozen years ago and has been restored, with six bedrooms, a library, and three fireplaces.

Visible to the north through the trees along Carnarvon Street, on the far side of 41st, is Kerrisdale School, designed in the 1920s by the firm Twizell & Twizell; the original school on the site opened in 1908.

A block west, Crofton House School occupies the ten acres between Balaclava and Blenheim. It was originally the Richard Byron Johnson estate, and his 1902 home (visible from Balaclava Street) is still used as the school's administration building. Alvo von Alvensleben, a flamboyant real-estate and stock promoter, bought the house at the height of the Edwardian boom, then lost it when he was forced to flee Canada for the USA at the outbreak of the war. Subsequently, it became the home of Sun publisher Robert Cromie until Crofton House moved there from the West End in 1948.

☞ Walk south on Balaclava, then turn east on 43rd

Kerrisdale School Annex, at the T of 43rd Avenue, sits on the 43rd Avenue road allowance so that the land to the south, part of the old W.H. Malkin estate "Southlands" and bequeathed to the city only for park purposes, could be used as playgrounds.

The blocks of 43rd Avenue between Balaclava and Macdonald contain a mix of houses, including 3160 and 3059, new houses reflecting traditional designs; a few nice cottages such as 2938 West 43rd by Arthur T. Dalton, built in 1921; and some 1920s Period-style houses. A number of very unattractive, large new houses, including 2928, were built following demolitions in the late 1980s; 2882, built in the early 1990s, is more sympathetically designed although rather over-decorated.

The mirror-image pair of Tudor cottages at 2827 and 2837 West 43rd were built in 1931 by contractor E.B. Keenlyside, probably a relative of the J.J. Keenlyside who was an active housebuilder in Kitsilano before the First World War.

☞ Turn right and walk south on Macdonald Street

In 1908, on the east side of Macdonald between 43rd and 45th, Frank Bowser established a ten-acre estate containing a very large, 2-1/2 storey Colonial-style house, stables and a water tower, set well back from the road. The Trafalgar Street right-of-way was his back property line. Not a trace of it remains today; however, his brick Bowser Building, now called the Boulevard Building, still stands at 41st and West Boulevard, and his 1895 house at 1164 Comox Street survives as part of the Mole Hill neighbourhood. (See page 63.) Bowser started as a customs agent before going into property development and becoming reeve of Point Grey; his brother William, nicknamed "The Little Napoleon," was BC's premier in 1916 and a powerhouse of Conservative politics.

The brick-veneered California Bungalow at 6011 Macdonald was built in 1919 for P.P. Brown, a consulting engineer. The white house at 6038 Macdonald is a fine 1921 Craftsman "Swiss Cottage" by architects Faulds, McQueen & Pearce, built for customs appraiser John Le Cappelan.

The aforementioned Arthur T. Dalton, the son of W.T. Dalton of the noted Edwardian-era architectural firm Dalton & Eveleigh, designed 6061 Macdonald in 1921. Built for Lawrence Hanbury, the sales manager of the Hanbury Sawmill at 4th and Granville on the edge of Granville Island, the house apparently won an "Ideal Cottage" award. It probably originally faced Macdonald Street on a larger lot, and was turned sideways due to a subdivision. The thespian Dorothy Somerset, a founder of the UBC Drama Department, was a later occupant. Dalton himself lived just down the street at 6369 Macdonald, in a house that has been remodelled.

In spite of a number of recent subdivisions and demolitions of historic houses, the long block of Macdonald between 45th and 49th retains many of its mature trees and some period landscaping. The two big "Stockbroker Tudors" on the west side just south of 45th date from the Depression years. Dentist Brent Anderson built 6135 Macdonald in 1930; two years later, Sun Life insurance manager Arnold Shives built 6187. Farther down the block, the Dutch Colonial house at 6287 Macdonald is a 1921 effort by architects Casement & Greer.

A developer named Christopher Foreman subdivided the east side in 1905 into lots that are 315 feet deep—about triple the Vancouver average. The lots run back to the Trafalgar Street right-of-way and share back fences, without lanes, with equally large lots on Elm Street. The three northern-

most original houses, at 6120, 6188 (demolished) and 6200 Macdonald (demolished), were built respectively in 1921, 1923 and 1920 by a contractor named Malcolm Griffith, probably (certainly in the case of 6120) designed by architect W.T. Whiteway, whose surviving buildings include the Kelly Building *aka* The Landing in Gastown and the Tellier Tower and Pennsylvania Hotel on Hastings Street. 6120 had 180 feet of frontage on Macdonald Street; its second owner, John Crawford, laid out a splendid garden with an orchard and woodlot behind formal herbaceous beds and a swimming pool. The property was infilled with new houses in a controversial project during the 1990s that retained the old house and many of the mature trees. The new houses at 6190 and 6200 are bigger than the originals but are sympathetic to the character of the block.

The Arts-and-Crafts house at 6238 Macdonald is the oldest on the block, built in 1911 for William Germaine, the general manager of the British American Trust Company. His phone number was Eburne 87R.

👉 **Turn right at 47th and walk west to Cedarhurst**

There is a charming, semirural quality to these blocks. Cedarhurst was only cleared in the 1920s and, on its west side, has extremely large and deep lots like those on Macdonald and Elm. Most of the old houses have been cleared away. 6450 Cedarhurst, built in 1928, was the home of the noted church and school architect R.P.S. Twizell.

👉 **Turn left on Marine Drive, and walk around onto 49th Avenue, continuing east to Marine Crescent.**

One of the first property owners after the Southlands farmers was the Baroness C.J. de Vos Van Steenwyck, who bought 20 acres at the foot of Mackenzie Street in 1906. Evidently, she never built anything there.

The brick-faced house at 2687 West 49th was designed in 1928 by Benzie & Bow for Dr. Robert H. Clark, a UBC professor of chemistry who was often quoted in the newspapers explaining scientific matters in layman's language. His son was a well-known professor of economics in the 1940s and 1950s.

The McCleery Park cairn at Marine Crescent and 49th commemorates the 1860s-era farms of Fitzgerald and Samuel McCleery. The farms stretched from

this corner to the Fraser River. Fitzgerald's 1873 house stood until 1957 at what is now the 11th tee of McCleery golf course; Samuel's 1891 house stood until 1977 at 2610 South West Marine Drive.

The big "Stockbroker Tudors" on Marine Crescent date from the late 1920s. F. Reginald Arkell, the vice-president of Kelly-Douglas, hired Bernard Palmer to design and Dominion Construction to build 2610 Marine Crescent in 1927. The following year, P.A. Woodward of the department store family built 2660 Marine Crescent, now infilled on both sides with smaller Tudors. 2688 Marine Crescent dates from 1927 and was built by Archibald Sullivan for Robert Leary, the American vice-consul.

The rambling Italianate house at northwest corner of Larch and West 49th Avenue dates from 1912, and was designed by R. MacKay Fripp for Henry A. Stone, one of the founders of the Vancouver Art Gallery and an early resident and promoter of Caulfeild in West Vancouver (page 191).

The recent Balsam Court subdivision a block to the east occupies the grounds of a fine 1912 house and garden built by Point Grey reeve Benjamin Cunliffe. Only the copper beech remains. It is one of the worst losses of heritage and mature landscaping in this part of the city.

Walk north on Larch Street

There are only scattered interesting houses on this street, but note the five cottages with neighbourly gardens at 6202, 6192, 6168, 6142 and 6126 Larch just south of 45th. The southernmost two, and likely 6142 and 6168, were built in 1925 by J.H. Whittacker. 6126 is the newest, and wasn't finished until after Point Grey amalgamated with Vancouver in 1929.

A few undistinguished blocks to the east at the corner of Vine, Ryerson United Church is an interesting Gothic building from 1927, with its manse standing on its west side. A better route back to 41st is to walk west on 45th Avenue to Elm, then turn right and walk north. Again, the block is a mixture of houses in age, style and quality, but note the fine early house, recently restored, at 6002 Elm.

The cottage at 5926 Elm is difficult to see within the shrubbery, but look closely to see its rustic "chalet" style, with wide overhanging eaves. Across the back lane at 5903 Larch is a second, larger house, very difficult to in-

spect due to the height of the hedge, with a low-pitched roof and rustic touches including exposed logs and stone and clinker-brick chimneys. Neighbourhood lore says they (and the altered house at 5938 Elm) were built about 1910 by Louis Diether, who with his brother ran Fairview Sand and Gravel and was known as "the wood and coal man of Vancouver." A Dominion Trust broker named F.C. Raney first occupied 5926 Elm, and C.H. Doctor lived at 5903 Larch; Diether moved to the latter after the First World War.

Elm Park, occupying the remaining blocks between 43rd and 41st, is used for soccer, Little League baseball and novel-reading at its north end, with tennis courts on the east side and the attractive lawn bowling club, established in 1915, behind the privet hedge. The shops and cafes of Kerrisdale are a few blocks away to the east.

North Shore

26

North Vancouver City

A trip on the SeaBus across Burrard Inlet gives the best "historic" view of North Vancouver—from the water. The SeaBus arrives at the foot of Lonsdale, the transportation hub of the old city. While still on the water, try to pick out, to the west (left) of the modern jumble of Lonsdale Quay (the "Q" sign), the twin spires of the St. Paul's Church at Ustlawn, the native village on the shoreline. The church is the only survivor of the mission and model community established about 1860 by the Roman Catholic Church.

Look also to the east (right) to the grain elevators of the Saskatchewan Wheat Pool. This was the site of Moodyville, the original European settlement on the North Shore, named for Sewell Prescott Moody, a lumberman who bought the three-year-old Pioneer Sawmill there in 1865. Moodyville sawmill closed in 1901, and 15 years later the remaining buildings burned to the ground, leaving no trace.

Twenty years before the transcontinental railway's 1886 completion to the coast, the first ferry service began. It connected Moodyville with the resort at New Brighton (now a park on the waterfront by the Pacific National Exhibition) at the end of the Douglas Road, cleared by the Royal Engineeers to provide access to Burrard Inlet from the colonial capital at New Westminster.

The first development in North Vancouver was another small resort: Peter Larson's Hotel North Vancouver, opened in 1902 on the Esplanade just to the west of today's Lonsdale Quay. It burned in 1929. The following year, the North Vancouver Ferry and Power Company, established with a combination of English and local capital directed by former Vancouver city solicitor Alfred St. George Hamersley, began operation. Real-estate sales in North Vancouver took off, and in 1907 the City of North Vancouver incorporated. In those eager, optimistic times it was often called "The Ambitious City."

Ferry service, which had expanded by the 1920s to include the transportation of cars, continued until 1958 (the Seabus commenced operation in 1977). Direct car access began to the North Shore in 1925, when a low-level bridge opened to the east of the modern Second Narrows bridge. Although primarily intended for trains, cars and wagons could pick their way across "the steeplechase" after paying a toll (the same situation persisted across the Fraser River at New Westminster from 1904, when the Great Northern Railway bridge opened, until the Pattullo Bridge was built in 1937).

It and the subsequent bridges seemed to be jinxed, attributed to the removal in 1923 of a small islet in the middle of the narrows called Hwa-Hwoi-Hwoi, allegedly the dwelling place of numerous evil spirits, to provide material to ballast Ballantyne Pier. A freighter knocked the span out in 1930, stranding many cars and prompting legal action when the Second Narrows Bridge Company claimed that, due to the Depression, it had no money to repair it. Then, in 1958, the modern Second Narrows bridge collapsed during construction, killing 18 (accordingly, the bridge is now officially named the Ironworkers Memorial Second Narrows Crossing). The original bridge, replaced in the 1960s and used solely to move railcars across the Burrard Inlet, was hit by a freighter in 1979 and knocked out of commission for a year.

North Vancouver is the terminus of BC Rail, which connects Vancouver with the province's north. Originally the Pacific Great Eastern (PGE) Railway, its modern terminus is at Pemberton Avenue, several blocks to the west of Lonsdale.

☞ Walk through Lonsdale Quay and exit onto Carrie Cates Crt; turn right and walk to Lonsdale, then walk up Lonsdale to Esplanade.

Examine the Cates ship-repair facility as you exit the quay, one of the last pieces of North Vancouver's working harbour. Charles Cates got his start with the Beach Avenue shipyard on land now occupied by the north piers of the Burrard Bridge in Vancouver.

At the corner of Lonsdale, visit the restored PGE station, moved from this spot in 1971 and returned in 1997. Inside is a collection of Len Norris cartoons from the PGE era, described as part of the Ambleside tour on page 186.

Note the view from the foot of Lonsdale toward the City of Vancouver. Until its recent dismantling the last of the North Vancouver ferries, converted into a seafood restaurant, was moored there. The relics of Burrard Shipyards, described below, occupy the land to the east.

The block of Lonsdale between Esplanade and 1st Street contains the greatest surviving cluster of commercial heritage buildings on the North Shore. The oldest is the 1903 Syndicate Block at 51 Lonsdale— the first commercial block in North Vancouver, home to a grocery store, post office (moved from Moodyville), the *Express* newspaper, and a dance hall and meeting rooms above.

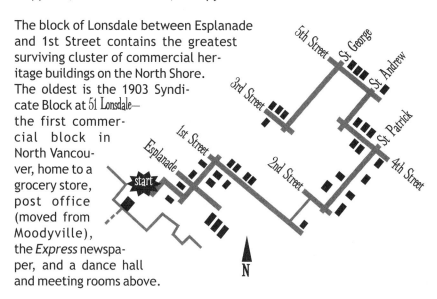

Walk west on Esplanade to the staircase just past number 111 to see in the lane a small, hipped-roof building, now occupied by Lonsdale Antiques. It began life about 1905 as the office of the North Vancouver Cartage Company, which maintained stables several blocks away on East 4th Avenue.

In 1910, two substantial buildings went up on the east side of Lonsdale. The Aberdeen Block, at 78 to 90 Lonsdale, housed the city administration and offices of the B.C. Electric Railway Company, which established electrical service and street-railway lines to spur growth in the new community. Designed by architects Mills and Hutton, the building was originally known as the Keith Block, after the developer who was namesake of Keith Road (explaining the "K" on the shield above the building's main entrance). Another long-time tenant was Paine Hardware, established in the building in 1914, renowned throughout the Lower Mainland for its old-fashioned ambience and selection of hard-to-find bits and tools. The Bank of Hamilton building next door, by the same architects, had the first passenger elevator on the North Shore—the bank merged with the Toronto-based

Bank of Commerce in 1923. Across the street on the southwest corner is the 1908 Keith Block, with finished facades on both 1st and Lonsdale

 Walk east on 1st Street

A combination of land speculation, economic downturns and the proximity of the Burrard Shipyards just to the south led to long delays in the redevelopment of the 100-block of 1st Street. The only substantial old building is the Mount Crown Block at 111 East 1st, designed in 1911 by architects Dalton and Eveleigh. The Falcioni house at 168 East 1st, built in 1908 for a labourer at the nearby shipyards and his wife, a packer at a candy factory, and the old houses at 174 and 204 East 1st also evoke the shipyard era.

The 200-block of 1st Street is the kind of industrial area now rare in the Lower Mainland, with loading bays opening directly onto the street. Harbour Manor, built in 1910 at 250 to 254 East 1st, was the first apartment building in North Vancouver. Beside it, and best observed from the lane, is the 1906 Emery house, built for a North Vancouver councillor. The house still has its original fretwork and fishscale shingling in its gable, visible through the screen of foliage in front of the house.

Walk down the hill on St. Andrews Avenue and cross Esplanade to get a closer look at the shipyard buildings; to the west of the foot of the street, there is the portal of the Vancouver Harbour Commissioners' terminal railway tunnel, marked with "VHC" and 1929, when Governor General Viscount Willingdon opened it. The tunnel allowed PGE trains efficient access along the waterfront between the Second Narrows bridge and its yards to the west.

The shipyards date from about 1906 and were founded by Alfred Wallace, who began in business by building salmon-fishing boats on False Creek in the early 1890s. The surviving buildings on Esplanade all date from the years after a 1911 fire that destroyed the original ones. Wallace's son Clarence, later a BC Lieutenant-Governor, expanded the firm and renamed it Burrard Dry Dock; it was a major employer and contributor to the war effort, producing "Victory"-class merchant ships. After the war and its purchase of the Yarrows shipyard in Esquimalt, the firm became known as Burrard Yarrows. Redevelopment of the site, including retention of some of its industrial heritage, is underway.

Farther along 1st, industrial becomes pastoral at 364 East 1st, the gardener's cottage for the Hamersley estate, built in 1904 and one of the rarest buildings in middle-class Vancouver—a purpose-built servant's dwelling.

☞ Walk north through Hamersley Park to 2nd Street, then walk east

Hamersley, whose business interests included the Union Steamship Company, real estate and hop farming near Agassiz, established his estate in 1904 on property bounded by the waterfront, 3rd Street, St. Andrews and St. Patricks. His home, with stone foundations and Arts-and-Crafts design touches, was originally called "Langton Lodge" and now has a 2nd Street address; it is a bed-and-breakfast. In spite of these investments, Hamersley soon lost interest in North Vancouver and returned to England in 1906, serving terms during the war as a Conservative member of parliament.
By contrast, a half-block east of "Langton Lodge" at 408 East 2nd, is the modest, 1906 house of a BC Electric Railway conductor named Jones. It is a rare model "LL" prefabricated house by the B.C. Mills, Timber & Trading Company, bought as a kit for $770.

☞ Walk north on St. Patricks Avenue

Note the "Vancouver Special" duplex at the northeast corner of 2nd and St. Patricks, a good example of 1960s suburban architecture.

Due to the proximity of the shipyards, which were running full blast during the war, the federal government in 1941 hired the architectural firm McCarter and Nairne to design and supervise the construction of several hundred small houses in the area, including two large bachelors' halls holding 90 men each at the corner of 3rd and St. Georges. The workers' family-houses, including the two at 240 St. Patricks and 402 East 3rd, had four to six rooms on a single floor, with a tiny front stoop and a simple, side-gabled roof. Compare them with 341 to 345 St. Patricks—a postwar duplex with a hipped roof, wide bevelled siding at the basement level and stucco on the walls above. A house from earlier, prosperous years is 405 East 4th, built in 1910 for civil engineer Arthur Henderson in a Dutch Colonial style.

☞ Walk west on 4th Street

Note the mix of duplexes, some side-by-side and some up-down from the 1950s and 1960s showing the influence of modern architecture and the International Style.

☞ **Turn north (right) at St. Andrews, then west (left) at East 5th Street**

302 East 5th, now a bed-and-breakfast, is a pre-World War One Tudor. The north side of the street has a few surviving Edwardian buildings. The Ward house at 246 to 248 East 5th dates from 1914 and has a single dormer set in its hipped roof—characteristic of the Edwardian Vernacular or Vancouver Box style. The Fred King house at 244 East 5th is a 1911 building. (Until its 1990 demolition, there was a 1912 house on the site of the bizarre pink duplex at 238.) Architect M.J. Beaton designed and built "on spec" 232 and 234 East 5th in 1911. Attractive new condos to the west are a harbinger of better design in the area.

Look along St. Georges Avenue to the St. Andrews Church some blocks to the north. Architects Alexander and Brown designed the Gothic Revival building for its Presbyterian congregation in 1912.

☞ **Proceed back to Lonsdale via St. Georges and 3rd Street**

The three houses at 156 (much altered), 152 and 146 East 3rd were built about 1905; the Hughes family owned the first two and rented 152 to the proprietor of a Lonsdale grocery store, while the westernmost one (note the Queen Anne tower at the rear) was erected by the Western Corporation. The curious apartment building at 123 East 3rd, known as the Law Block, took its name from its architect, Alexander Law, who designed it in 1913; Law moved on after the bust and by 1920 was living in California on an apple orchard, where he spent the rest of his life.

The very tall apartment building called The Observatory on 2nd Street west of Lonsdale replaced the old St. Alice Hotel, a neighbourhood landmark and watering hole whose clientele had become something of a nuisance by the mid-1980s. It is a contrast with 201 Lonsdale, a replica of the turreted 1929 Barraclough Block which burned down in 1998. Architect Michael Katz juxtaposed a very modern two-story addition beside and above the replicated facade. A plaque on the corner tells the tale.

Indeed, most of the new construction in the Lower Lonsdale area does not follow the example set by the highrise "Observatory." Instead, it reinforces the pedestrian character of the streets, which focus on the SeaBus and the Quay, unlike the car-oriented businesses further north on Lonsdale.

27

West Vancouver: Ambleside

U nlike North Vancouver, West Van has never had any sort of identity crisis. From the earliest days, its residents wanted to ensure that only people of means lived there. The few canneries, the lumber and shingle mills of its pioneer days, and even the summer cottages along the shoreline quickly made way for orderly, residential development and the adoption in 1926 of a Town Planning Act that banned industry and regulated new lot sizes. Its exclusive status was firmly cemented by the late 1930s, when Guinness interests built the Lions Gate Bridge in order to connect Vancouver with its new, racially exclusive British Properties on the slopes of Hollyburn Mountain.

Visually, West Vancouver is two communities. The older one, laid out on a grid in the Ambleside and Dundarave districts, was primarily served in the early years by passenger ferries and the Pacific Great Eastern Railway, which acted like a tram connecting with the North Vancouver ferry terminal at the foot of Lonsdale (page180). The grid's numbered streets run from the beach toward the mountain; the avenues, running east to west, ascend from "A is for Argyle" at the waterfront, Bellevue, and so on, with Marine Drive violating the alphabetical rigour.

The newer part of West Vancouver, to the west and north, has winding roads, steep hills and natural flora, and is the home of the essential "west coast lifestyle," lampooned for decades by the Vancouver *Sun's* cartoonist Len Norris, who dubbed the area "Amble*snide* and Tiddlycove." From the 1940s to 1960s, many International and "West Coast" style houses were built there. In this area, West Vancouverites are truly car-dependent, so not surprisingly it is next to impossible to lay out a walking tour, and many of the homes are, regardless, practically hidden in the shrubbery. An earlier version of this "non-grid" West Vancouver is Lower Caulfeild (the following tour).

The Park Royal Shopping Centre, designed by architect C.B.K. van Norman, opened on the north side of Marine Drive in 1950; it expanded to

the south side in 1962, framing the entry into West Vancouver, and has been restyled several times since. One of the first two shopping centres in Canada, it has overshadowed the old Ambleside shopping area but never managed to eliminate it.

☞ The tour begins in Ambleside at the bottom of 13th Street, where there is a convenient parking lot.

Walk out onto the beach, crossing the tracks of the PGE, now BC Rail, which were laid in 1914. Although intended to connect North Vancouver with northern B.C., the PGE managed only to get as far as Whytecliffe; the railway's other section began in Squamish and in the early years continued just to Clinton for, during the First World War, the company went bankrupt. The provincial government took it over in 1918 and went to work completing it northwards, being content to connect North Vancouver with Squamish by barge. During this period, the railway became known as the "Prince George Eventually," the "Province's Greatest Expense," and the "Please Go Easy." The line through West Vancouver was abandoned for so many years that, by the 1950s when the provincial government completed trackage along Howe Sound to Squamish, many residents had occupied the right-of-way with their gardens and fought vigorously against its reopening. Today, the long freight trains rolling past the deluxe houses and apartments are the only evidence in West Vancouver of any sort of industry at all.

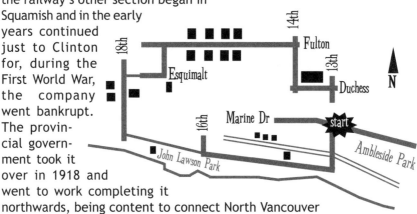

Ambleside Park, known as Swá´ywi to the Squamish First Nation, offers superb views of the First Narrows and Lions Gate Bridge. The latter, opened in 1938 as a privately owned toll bridge, has endured surprisingly well as a link between the north shore and downtown, and has become a symbol of Vancouver itself. A.J.T. Taylor, an engineer and the president of British

Pacific Properties Ltd., masterminded the construction and oversaw Guinness investments in the Lower Mainland, including the purchase of the Marine Building (page 46) and the development of the British Properties. He is the namesake of Taylor Way, the main route from Marine Drive to the "Upper Levels." Look to the north, up the slope, to see the British Properties on the cleared-off hillside.

The native statue on the point stares across the harbour to Stanley Park. Spot Siwash Rock (Sl'kheylish—"standing-up man rock"), a "transformer rock" in Squamish belief, standing just off the park's wooded shoreline. Closer to First Narrows near the Vancouver end of the bridge, Prospect Point is clearly visible.

Walk west along the pathway, noting the monument erected by the local Lions Club to celebrate the 150th anniversary of the July 1, 1791 visit to Burrard Inlet of the Spanish navigator Narvaez, "the first white man to visit the mainland of western Canada." Nearby, and truly an inspiration to people reading a walking-tour book, is a memorial to Clyde McRae, who walked across Canada in just 96 days during the summer of 1973.

Walk west along Argyle Avenue

The old Ambleside pier and the Ferry Building stand at the foot of 14th Street. John Lawson, who lived nearby in the Thomas house (see below), started the service in 1909; three years later, with the incorporation of West Vancouver municipality, the ferry service became publicly owned and ran between this pier (occasionally also to Dundarave Pier) and the foot of Columbia Street in Vancouver. The service ended in February, 1946, having been kept open during the war only because of gas rationing.

There is an attractive set of cottages along the shore just to the west of the Ferry Building, with allotment gardens now occupying some of the vacant lots. Their modest scale and proximity to public transit seem at odds with most of modern West Vancouver.

Near the bottom of 16th Street, Argyle Avenue becomes a footpath, passing through a pretty park. Walk out onto the pier and look back through the First Narrows—from this point, the view includes the bulk-loading terminal on the north shore and, on the park side, Brockton Point. This is

the best place to watch freighters come and go from what is the second-busiest port in North America (after New York).

The house at 1768 Argyle is very historic, though it takes some imagination to see it as such. Built in 1873 for "Navvy Jack" Thomas, it originally looked like a typical Victorian cottage, with a single steep gable centred in its front facade, horizontal board siding and a full-width front porch with elaborate "gingerbread" brackets on the turned columns. Thomas owned 80 acres on the waterfront east of 16th Street; he ran a ferry service on Burrard Inlet in the 1860s, married the granddaughter of the Squamish chief after whom the Capilano River is named, and had a gravel-hauling business, prompting his nickname—a navvy being a builder of roads or canals. About 1907, John Lawson bought the house and planted holly trees near it; as it stood by a "burn" (a creek, namely Lawson Creek) it was called "Hollyburn House," a name subsequently given to the mountain above. Some years later, new owners moved the house to its current site just west of the creek.

At 18th Street, a highrise apartment building on the waterfront, built in the 1960s, symbolically ends the historic part of the Ambleside waterfront.

Walk up 18th Street, turn right on Esquimalt

Above Marine Drive, note the juxtaposition of the Hollyburn Funeral Home and the Legion on opposite sides of the streets—many of West Vancouver's aged veterans have socialized at the latter before ending up at the former. Walk along Duchess Avenue to mid-block or so and then return to 18th—it is an attractive street of small houses from the 1920s (for example, the shingled "Hollytree Cottage" on the corner), '30s and '40s, well-landscaped and maintained. The monkey puzzle tree in front of 1847 is one of the healthier specimens in the Lower Mainland.

Lawson Creek runs through the ravine along the east side of 18th. A footbridge crosses it on the Esquimalt Avenue right-of-way.

At the corner of 17th and Esquimalt, the Gertrude Lawson house provides another link to that important early family. A daughter of John Lawson, she was a schoolteacher in 1940 when she began construction of the house, obtaining along the way the first mortgage granted to a woman in British Columbia. Built of stone that came as ballast on a lumber-carrying ship

from New Zealand, the house was the location for years of the meetings of the Ladies' Scottish Country Dance Society. It is now the West Vancouver Museum and Archives.

Walk up 17th to Fulton, turn right and continue along Fulton to 14th, turn right on 14th and walk down the hill to Duchess, then turn left

The Lawson house is an island in a sea of apartment buildings. You are probably best to walk up to Fulton and follow it eastward, as there is more visual diversity in the buildings and landscaping than on Esquimalt. Hollyburn School, the first part of which was built in 1913, occupies the block between 14th and 13th south of Esquimalt. It was the first purpose-built school building in West Vancouver, and evocative of the almost-rural nature of the community around the time of the First World War. It, the ferry and the Ambleside shops along Marine Drive formed the core of the community pre-Park Royal.

There are excellent cafes and delis in old (or should one say "olde"?) Ambleside, with the most interesting blocks being between 14th and 16th, worth a detour on the way back to the starting point.

28

West Vancouver Caulfeild

T he spelling Caul*feild* is not an affectation. Its namesake, Francis Caulfeild (1844-1934), purchased the romantically named Skunk Cove in 1899 and over the ensuing few decades established there a woodsy "poetical commonwealth." Initially very difficult to get to, with access only by the Union Steamships, private boat, the PGE railway (after 1914) or the newly invented motorcar, it attracted writers, artists and the independently wealthy as its early residents.

The best plan is to park on Marine Drive and walk the loop sketched out below in a counterclockwise direction. Due to the narrowness of the lanes, traffic moves one-way clockwise. Most of the historic buildings, as well as the new generation of vulgarities that are slowly destroying the community's rustic ambience, can be seen from the road.

☞ Start at Piccadilly Road South and Marine Drive

Before starting down the hill, note the house at the bus stop, 4580 Marine. It was the home of the botanist, adventurer, writer and journalist Julia Henshaw—there are commemorative windows to her and her husband Charles (a lesser light, nicknamed "Afternoon Tea Charlie" or "Pink Tea Charlie") in the church at the head of Caulfeild Cove.

Along the low side of Piccadilly Road South, there are three significant houses. "Stonehaven," built far back on its lot at 4648 in 1909, was home to businessman, artist and arts patron Henry A. Stone, who designed the aforementioned church and, with Caulfeild himself, provided philosophical inter-

pretation of the aims of their "little Cornish town." The promotional brochure stated that the community had been laid out "with the special object of preserving the natural beauties of the site, and thus giving opportunities for pleasant homes among unusually picturesque surroundings." Referring perhaps to gridiron Kerrisdale where he'd previously lived (page 175), Stone once commented that Caulfeild was "visible proof that town planning falls short of nature's planning."

"Greystones," at 4670 and the Cameron house, now called "Hillwood," at 4732, are 1920s houses (although the core of the latter dates from 1916). "Greystones" was home to Vancouver mayor Frederick Buscombe, whose china-importing company was locally renowned. Stuart Cameron was a contractor, specializing in power plants and bridges.

St. Francis in the Wood church, at the bottom of the hill, exemplifies the Arts and Crafts style and is the closest thing to English village Anglicanism in western Canada. Across the street, narrow Caulfeild Cove looks out onto English Bay, with the Point Grey headland and University of British Columbia in the distance.

Continue around the corner onto Pilot House Road.

Francis Caulfeild's own house, much-altered from his day, is 4768. Built in 1909, it served at one time as both store and post office for the community.

The historically significant house farther up the hill is 4719 Pilot House Road, built for John and Margaret McDonald in 1932. It is well-gardened, with good rock work reflecting McDonald's career as a stonecutter and the development of the Haddington Island quarries. Nearby, on the shore side of the street, is a monument to Francis Caulfeild himself. There has been much recent demolition along this stretch, with rustic houses and established landscaping making way for new mansions with views toward the rising sun and the towers of downtown Vancouver.